CW00407268

Revolutionary Tides
The Art of the Political Poster 1914–1989

Jeffrey T. Schnapp

Revolutionary Tides
The Art of the Political Poster 1914–1989

SKIRA

in association with

The Iris & B. Gerald Cantor Center for Visual Arts at Stanford University
Stanford, California

Front cover
Artist unknown,
People's Republic of China
*Strengthen Yourself by Confronting High
Waves and Mighty Winds!* (detail),
1966–69
No. 4

Back cover
Artist unknown, Germany
Pst! (detail), 1939–43
No. 63

Project Coordinator
Bernard Barryte

Design
Marcello Francone

Editors
Kathleen Preciado
Emanuela Di Lallo

Layout
Antonio Carminati

First published in Italy in 2005
by Skira editore S.p.A.
Palazzo Casati Stampa
via Torino 61
20123 Milan, Italy
www.skira.net

Distributed in North America
by Rizzoli International Publications, Inc.,
300 Park Avenue South, New York,
NY 10010
Distributed elsewhere in the world
by Thames and Hudson Ltd.,
181A High Holborn, London WC1V 7QX,
United Kingdom

Library of Congress
Cataloging-in-Publication Data

Schnapp, Jeffrey T.
(Jeffrey Thompson), 1954–
Revolutionary Tides: The Art
of the Political Poster, 1914–1989 /
Jeffrey T. Schnapp. 1st ed.
p. cm.
Accompanies the exhibition of the same
title held Sept. 14–Dec. 31, 2005
at the Iris & B. Gerald Cantor Center
for Visual Arts at Stanford University,
and Feb. 24–June 25, 2006 at the
Wolfsonian, Florida International
University.

ISBN 8876242104 (alk. paper),
ISBN 8876242368 (pbk.: alk. paper)
1. Revolutions—Posters—Exhibitions.
2. Political posters—Exhibitions.
3. Crowds—Posters—Exhibitions.
I. Iris & B. Gerald Cantor Center
for Visual Arts at Stanford University.
II. Wolfsonian–Florida International
University.
III. Title.
JC491.S363 2005
944.04'074—dc 22 2005042495

Printed and bound in Italy
First edition

This catalogue was published in conjunction with the exhibition *Revolutionary Tides: The Art of the Political Poster, 1914–1989*. The exhibition was organized by the Cantor Arts Center with the Hoover Institution at Stanford University, the Stanford Humanities Lab, and the Wolfsonian–Florida International University. We gratefully acknowledge generous support for this project from the Clumeck Endowment Fund, The Mariposa Fund, The Bernard Osher Foundation, and the Seaver Institute. Additional funding was received from Roger and Martha Mertz and Cantor Arts Center members.

Exhibition Itinerary
Cantor Arts Center, Stanford University,
14 September – 31 December 2005
The Wolfsonian–Florida International University,
Miami Beach, 24 February – 25 June 2006

Note to the Reader
Complete catalogue information for color-plate captions can be found in the Critical Apparatus, pp. 122–55. Unless otherwise indicated, all works are commercial color lithographs. In the measurements height precedes width precedes depth.

Contents

Revolutionary Tides
The Art of the Political Poster 1914–1989

Critical Apparatus

Foreword

In the fall of 2000 the director of the newly founded Stanford Humanities Lab (SHL), Jeffrey T. Schnapp, and his colleague Leah Dickerman conceptualized an ambitious project entitled Crowds. A prototype "big humanities" project, Crowds relies on a core research team comprising faculty and students from various disciplines—art history, classics, comparative literature, French, film studies, and history—at Stanford and the University of California, Berkeley, as well as collaborators from such partner institutions as the University of Pennsylvania, Johns Hopkins University, and the London School of Economics. Its outputs were to include a hybrid intermedia volume in print and digital form produced in collaboration with Stanford University Press as well as a website (http://shl.stanford.edu/crowds).

The exhibition *Revolutionary Tides: The Art of the Political Poster, 1914–1989* is perhaps the most public face of the Crowds project. When Professor Schnapp approached the Cantor Arts Center about joining the team, we accepted with pleasure. Not only were we enthralled by the graphic drama of the posters that comprise the exhibition, but also the scope of the project enabled the Center to fulfill an important part of its mission, to collaborate with faculty in teaching, learning, and research and to help bring the results to the public. We felt that *Revolutionary Tides* was a perfect match for our museum and we welcomed the opportunity to participate in this ambitious effort to demonstrate how an exhibition developed on the basis of high-level interdisciplinary humanities research, supported by web and media technologies, could have an impact on public discourse.

The Crowds project aims to tell the story of how modern life was transformed by the rise of multitudes and to promote critical reflection on the place of mass communications in contemporary society. As makers of political posters, artists were cast in the role of mass communicators, shaping and being shaped by a variety of political and social forces. Through its broad range of examples —works created in service to a variety of causes in some twenty countries over the course of a tumultuous century—*Revolutionary Tides* provides an ideal lens for examining in detail this crucial aspect of modern life.

We have been pleased to work closely with our colleagues at the Hoover Institution on War, Revolution, and Peace at Stanford. The Institution is a public-policy research center with an extraordinary archive of more than one hundred thousand political posters. It is from this diverse holding that the core of the exhibition's posters is drawn, and we are very grateful to Elena Danielson and her team for their support.

The Wolfsonian–Florida International University in Miami Beach is a museum and research center with an interest in examining the nexus between material artifacts and society. It looks at objects as both agents and expressions of the cultural, political, and technological changes that transformed the world in the late nineteenth to mid-twentieth centuries. It seemed only natural that this institution be invited to collaborate on the exhibition. In ways similar to the Cantor Arts Center, the Wolfsonian is also experimenting with means to integrate the teaching and research core of their university with the programming and research of the museum. The Wolfsonian has embraced *Revolutionary Tides* not only as a lender of key works but also as a partner venue for the presentation of the exhibition. Additionally, the Wolfsonian provided a research fellowship to Professor Schnapp, enabling him to study their collection.

The rich collaboration that developed *Revolutionary Tides* has involved many colleagues, students, and the entire staff of the Cantor Arts Center, the Hoover Institution, Stanford Humanities Lab, and the Wolfsonian. To all involved in this undertaking we are most appreciative. We are especially grateful to guest curator Jeffrey T. Schnapp for his vision and determination in realizing *Revolutionary Tides.*

We gratefully acknowledge support for this project from the Hoover Institution at Stanford University, the Stanford Humanities Lab, the Wolfsonian–Florida International University. We are deeply grateful for the generous support for this project from the Clumeck Endowment Fund, The Mariposa Fund, The Bernard Osher Foundation, and the Seaver Institute, and for additional funding provided by Roger and Martha Mertz and Cantor Arts Center members.

Thomas K. Seligman
John and Jill Freidenrich Director, Iris & B. Gerald Cantor Center for the Visual Arts at Stanford University

Cathy Leff
Director, The Wolfsonian–Florida International University

John Raisian
Director, Hoover Institution on War, Revolution, and Peace at Stanford University

Acknowledgments

Every exhibition is the product of collaboration and teamwork but uniquely so in the case of *Revolutionary Tides*. The exhibition represents the culmination of a long-term, large-scale research project, entitled Crowds, carried out within the framework of the Stanford Humanities Lab (SHL) since the fall of 2000. Leah Dickerman (associate curator of modern and contemporary art, National Gallery of Art, Washington, D.C.) and I initially devised the Crowds project. The project team has included numerous faculty, graduate students, and undergraduates at Stanford and the University of California, Berkeley, as well as at numerous other collaborating universities worldwide. Three present or former graduate students have played decisive roles in insuring its success: Matthew Tiews, coprincipal investigator, Marisa Galvez, project manager since 2003, and Heather Farkas, exhibition coordinator extraordinaire. Several other members of the Crowds planning team also deserve to be singled out for their outstanding contributions: Andrew Uroskie, deeply involved in the project since its inception; Haun Saussy; Joy Connolly; and Cherise Smith, for her important work during the early years of the project. These expressions of gratitude would be incomplete if they did not include a sincere thank you to the many undergraduate and graduate students involved in various iterations of the Stanford-based Crowds seminar not to mention the authors of the annotated entries for contributing both their time and their expertise. Particular thanks are due in the latter regard to Jason Glick, Abbas Milani, Todd Presner, Jordana Mendelson, and, above all others, to Maria Gough, whose impeccable judgment and critical acuity have proven invaluable in every phase of the design of the exhibition.

Generously supported by the Seaver Institute since 2002, Crowds was intended as a model project to showcase the revolution in humanities research and education for which SHL stands. That revolution aims at bringing the humanities disciplines, so to speak, "out of the monastery into the new millennium." This means going beyond craft-based traditions of producing and presenting humanistic knowledge in the name of a laboratory model of work where teamwork and hands-on, learner-centered training provide a complement to traditional classroom learning. It means partnerships between the research and teaching core of universities and public institutions, such as contemporary arts centers and museums, in this case between SHL and the Cantor Arts Center, the Hoover Institution Archives, and the Wolfsonian–Florida International University. It means exploring the potentially transformative impact of information technologies on humanistic research, teaching, and publishing. Most of all, it means taking on ambitious interdisciplinary questions that matter both inside and outside the walls of the academy. In short, "big humanities with a technological edge."

The Crowds project exemplified this approach from the outset. Alongside *Revolutionary Tides*, its other principal product is a multiauthor book, supported by a website and database, whose aim is to reconstruct the story of how modern life was transformed by the proliferation of multitudes (coedited by Matthew Tiews and myself, the book will be published by Stanford University Press). The Crowds website contains a database of writings on crowd psychology and sociology from the birth of the social sciences through the late 1920s and virtual galleries—curated by undergraduates, graduate students, and faculty as well as by artists and independent guest curators—on topics ranging from theater riots to crowds in film to the science of counting crowds. A digital accompaniment to the *Revolutionary Tides* exhibition will become integral to the website effective mid-September 2005 with the opening of the exhibition at the Cantor Arts Center and accompany its transfer to the Wolfsonian–Florida International University in 2006.

In closing, I wish to express my gratitude to Thomas K. Seligman, director of the Cantor Arts Center, for his unstinting support of the Stanford Humanities Lab and belief in the unique role of university-based art museums as points of contact between the worlds of academic research and the general museum-going public. It was with Tom's encouragement that I first set about trying to imagine an exhibition on multitudes in modern art. This initiative was fortunate to find an exemplary second partner in Elena Danielson, director of the Hoover Institution Library and Archives, without whose enthusiasm this exhibition built around some of the highlights from the Hoover Institution's vast poster collection would never have gained momentum. The partnership became complete thanks to my friends Cathy Leff, director of the Wolfsonian–Florida International University, and the museum's chief curator, Marianne Lamonaca, whose insights and support have proven invaluable at every juncture during the planning and development of *Revolutionary Tides*. Sincere thanks to all, as well as to their staffs, for their always excellent work, in particular to those most intimately involved in the exhibition: Bernard Barryte, Mona Duggan, Patience Young, Anja Seitz, Sarah Miller, Donna Mauro, Anna Koster, and, for her help with the preparation of this catalogue, Kathleen Preciado. The catalogue is dedicated to Alexander Simon Gough Schnapp, born on the two hundred and twenty-eighth anniversary of the American Revolution.

Jeffrey T. Schnapp
Director, Stanford Humanities Lab

Introduction

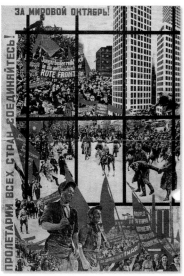

Fig. 1
Nikolai Dolgorukov (1902–1980),
Union of Soviet Socialist Republics
Workers of the World, Unite! For the
Worldwide October! (*Proletarii vskekh stran*
soediniaites'! Za mirovoi okt'iabr'!), 1932
56¹/₂ x 39¹/₂ in.
Printed by Central State Publishing
House and State Publishing House for Art
(OGIZ-IZOGIZ), Moscow and Leningrad
Hoover Institution Archives (RUSU2954)

Revolutionary Tides examines the artistic consequences of the triumph of popular sovereignty as a political ideal more than one hundred years after the French Revolution (1789). The exhibition and accompanying catalogue track the changing face of revolution from World War I (1914–18) through the year of the fall of the Berlin wall (1989) by means of more than one hundred political posters as well as a number of related sculptures and objects from twenty countries, drawn from the collections of the Hoover Institution and the Wolfsonian–Florida International University.

Whereas the conventional approach to poster art emphasizes classifications based on artist, period, political ideology, and nationality; patterns of influence; or the development of specific technical practices, *Revolutionary Tides* is instead concerned with the emergence of a common graphic vernacular for depicting multitudes as political actors on a worldwide scale and in a multiplicity of only loosely interconnected artistic, political, and historical settings. The exhibition proposes a macrohistory of the political poster, high and low, east and west, north and south, with microhistorical texture provided by the annotated entries assembled in the concluding section of the catalogue and by the *Revolutionary Tides* section of the Crowds project website (http://shl.stanford.edu/crowds).

The exhibition is organized into cells or clusters, each of which explores a particular graphic convention, iconographic element, or theme related to political crowds. Each cluster blends together works by such recognized artists as John Heartfield, Gustav Klucis, Valentina Kulagina, Norman Rockwell, and Xanti Schawinsky with works whose authors are forgotten or unknown.

How to represent the people as the cornerstone of the legitimacy of modern nation states, their institutions, and laws? How to translate the abstract notion of the popular will into concrete visual terms? How to portray the decisive role played by mass movements in effecting social change? How to depict the modern mass leader with respect to the multitudes and vice versa? How to transform the mass medium that is the political poster into an effective tool of mass persuasion and mobilization? These are the sorts of questions that the artists represented in *Revolutionary Tides* set out to answer, however divergent their artistic stances, political beliefs, or the historical context to which they belonged.

The exhibition's first three units are entitled The March, The Mass Ornament, and Anatomies of the Multitude. The first examines the presentation of crowds arrayed as armylike fronts. Modern political crowds typically march in loose formation as if they were the civilian counterpart or response to mass armies on the move (fig. 1). They occupy public thoroughfares, squares, and parks and target places of political significance in what amounts to the performance of symbolic acts of territorial conquest. Marches assume a central role in the art of the political poster.

The second cluster, The Mass Ornament, draws its title from an influential essay by the Weimar culture critic Siegfried Kracauer regarding new forms of mass entertainment such as chorus lines and synchronized group gymnastics (fig. 2).[1] The Mass Ornament is concerned with the abstraction of multitudes into decorative patterns or backgrounds. On the one hand, the collectivity finds itself transformed into geometrical figures either by the manipulation of

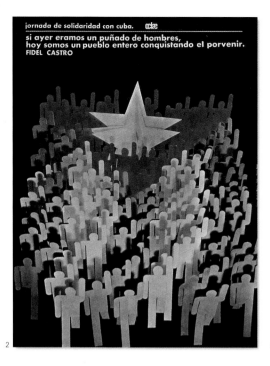

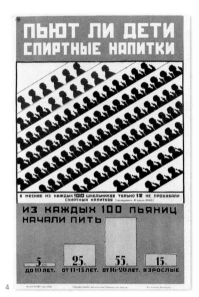

photographs or thanks to representations of crowds that have self-organized into signs or symbols (like marching bands at halftime shows). On the other, it is treated as an abstract backdrop: the multitude becomes the ground over which hovers the figure of the mass leader or the modern state. The third cluster, Anatomies of the Multitude, is the show's largest section. Crowds rarely appear in these images, except in the symbolic form of hands, arms, ears, and mouths, sometimes severed, sometimes attached (fig. 3). Anatomies demonstrates how the organs and extremities of the human body— all having a long history as symbols of the intent of gods, monarchs, or other ruling elites— become systematically identified instead with the actions, desires, and fears of the collectivity in twentieth-century poster art.[2]

The next three units—Statistical Persons, Mass Production / Mass Reproduction, and Kill Counts—emphasize the close ties between modern notions of political power and ideas of quantity: graphic equations between crowds, statistical data, industrial production, large-scale construction and destruction. The first cluster documents the interweaving of images of crowds with quantitative data, whether typographically manipulated arrays of numbers or devices such as pie charts and bar graphs (fig. 4). It examines how artists visualized personhood in statistical

terms in keeping with the practices in modern industrial societies wherein every individual is regularly subject to quantitative analysis and subsumed into quantitative data: opinion polls, economic figures, census data, and the like. The second cluster probes the connection between modern mass politics, industrialization, and mass communications. By the beginning of the twentieth century industrial development had covered the globe with networks of cities inhabited by multitudes in whose image and for whom mass communications media like posters were devised (fig. 5). The cluster studies areas of overlap between posters and other media such as radio, film, and television while exploring the poster's own identity as a mass-produced industrial artifact. Kill Counts calls attention to the ubiquity of mass death in the era of crowds. Behind every celebratory image of a marching multitude, it finds the haunting image of a mass grave, whether due to natural catastrophes, political savagery, or mechanized warfare (fig. 6).

The final triad of cells—Totems, Mass Leaders and Mass Deceivers, and the Man of the Crowd—explores the interaction between the image of the crowd and the icons of the collectivity, be they party emblems, the faces of leaders, or the bodies of exemplary mass men or mass women. Totems investigates those symbols that accompany the emergence of

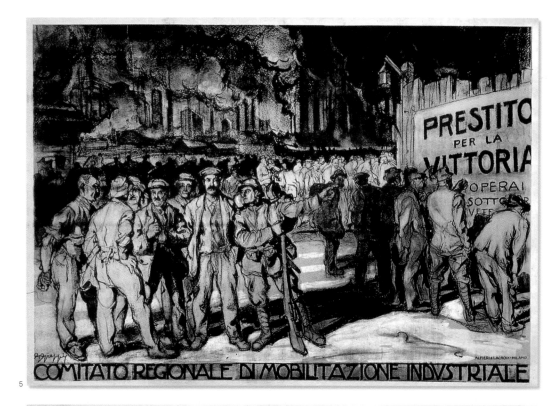

5

Fig. 5
Giovanni Greppi (1884–1960), Italy
Loan for Victory (Prestito per la vittoria),
1918
27 x 40 in.
Printed by Comitato Lombardo
di mobilitazione industriale
Hoover Institution Archives (IT90)

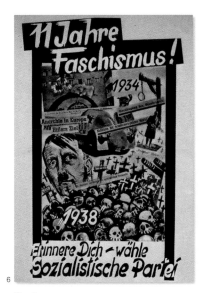

6

Fig. 6
Artist unknown, Austria
*Eleven Years of Fascism! Remember—
Choose the Socialist Party (11 Jahre
Faschismus! Erinnere Dich—wähle
Sozialistische Partei)*, 1946
24 x 17 in.
Hoover Institution Archives (AU357)

Fig. 7
Artist unknown, England
V—Freedom Shall Prevail! 1940s
20 x 30 in.
Printed by Fosh and Cross, Ltd., London
Hoover Institution Archives (UK2901)

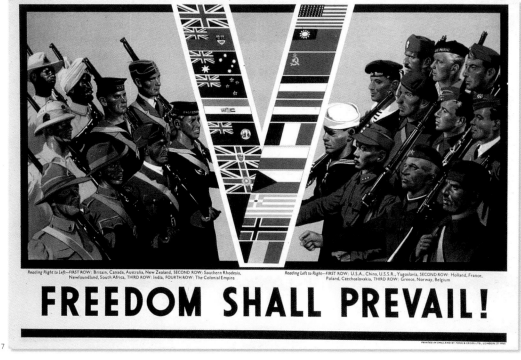

7

multitudes as political protagonists: symbols
(national flags, party icons) and figures (Uncle
Sam, Lady Liberty, Marianne) that provide a
sense of community in a world increasingly
characterized by extreme mobility and rapid
change (fig. 7).

Mass Leaders and Mass Deceivers shifts
the focus from abstract to human symbols. It
examines how the iconography of leadership was
transformed by the triumph of popular
sovereignty. No longer a god or monarch, the
modern leader must become a mass-produced
superior individual. Perceived as belonging to the
people, he or she must also be perceived as
possessing superior vision, persuasive skills, and
the media magic known as charisma (fig. 8).
The paradox translates into a variety of graphic
solutions that superimpose the mass leader's

15

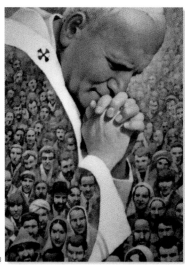

Fig. 8
Wieslaw Walkuski (born 1956), Poland
Twentieth Anniversary of Pope John Paul II's Pontificate, 1998
31 x 22 in.
Printed by Drukarina Archidiecezjalna Katowicach
Hoover Institution Archives

visage over drawn or photographic images of abstracted crowds.

The last of the exhibition's sequence of clusters draws its title from a short story by Edgar Allan Poe that was much admired by Charles Baudelaire, perhaps the nineteenth-century's leading poet of crowds.[3] It scrutinizes the figures who stand opposite the modern leader, as if in the mirror: the ordinary citizens who make up modern political crowds (figs. 9–10). Ubiquitous in political posters, often played by artists themselves posing as everyman or everywoman, they are represented both as standardized images of industrial-age humanity and as individuals bearing traces of social class or regional or national identity.

As this summary suggests, *Revolutionary Tides* is built around clusters (and not chronology) to allow for an overall mapping of the continuities in the graphic devices adopted by a heterogeneous group of artists working in a wide array of traditions of modern graphic art. It sets out to suggest that, considered together, such devices form a cohesive language, a shared vernacular. Like every vernacular, this one is not without "variations in dialect." Socialist poster artists, for instance, prove quicker to embrace abstract crowd images than artists in nonsocialist settings, who tend to treat figures in political crowds as individuals. Political posters produced in capitalist countries show an enthusiasm for commercial-advertising techniques that is absent in most noncapitalist counterparts. Artists of fascist posters tend to display a more acute sensitivity to the historical resonances of their typographical choices (gothic, roman, etc.) than do their liberal-democratic or socialist peers. There are also general trends like a gradual evolution away from narrative and typographical complexity toward graphic simplicity and economy.

These discontinuities are integral to the narrative structure of *Revolutionary Tides*. But the exhibition elects to place primary emphasis on continuities in the pursuit of two overlapping goals: providing a broad understanding of the past century of political-poster art and its historical context and inquiring into the implications of that historical past for an understanding of the present. The latter is the focus of After the Crowd with which the exhibition concludes. It asks such questions as: if the modern era is "the era of crowds," as French sociologist Gustave Le Bon remarked in his celebrated 1895 study on crowd psychology, to what extent is this still true in today's information-based society with its proliferation of virtual forms of assembly and political participation?[4] Has the age of the political poster passed with the rise of media that no longer require mass assemblies in city streets and public squares? If so, what are the consequences for political action and representative democracy? Rather than providing answers to these questions, *Revolutionary Tides* sets out to pose them from the perspective of the golden age of political-poster art.

Notes
1. Siegfried Kracauer, *The Mass Ornament: Weimar Essays*, ed. and trans. Thomas Y. Levin (Cambridge, Mass., 1995). The title essay of the volume is found on 75–86.
2. With regard to hand gestures and power in ancient society see Andrea de Jorio's classic 1832 study *Gesture in Naples and Gesture in Classical Antiquity*, ed. and trans. Adam Kendon (Bloomington, Ind., 2000).
3. The story is available online in the complete edition of the writings of Poe at http://eserver.org/books/poe/man_of_the_crowd.html.
4. "The Era of Crowds" is the title of the lead section of Le Bon's 1895 *Psychologie des foules*. The English title is conventionally given as *The Crowd: A Study of the Popular Mind*. All quotations from this work in the present volume derive from the Project Gutenberg Etext, February 1996 [Etext #445] version, available online at http://www.gutenberg.org/etexts/445.

Fig. 9
Artist unknown, United States
Produce for Victory! 1942
36 x 24 in.
Printed by Sheldon-Claire Co.
Hoover Institution Archives (US6565)

Fig. 10
Artist unknown, South Africa
Year of the Women, 1984
16 x 12 in.
Hoover Institution Archives (SA18)

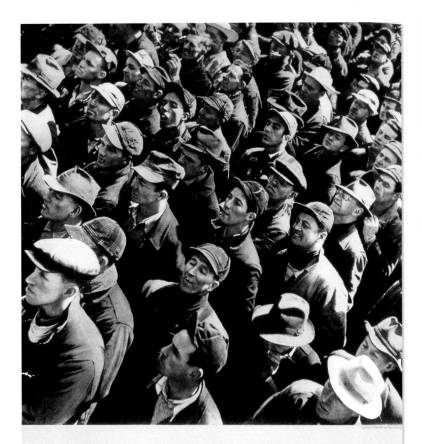

"No nation of slaves can match a nation of free men. We're doing more because *we want to* than they can because *they have to!*"

PRODUCE FOR VICTORY!

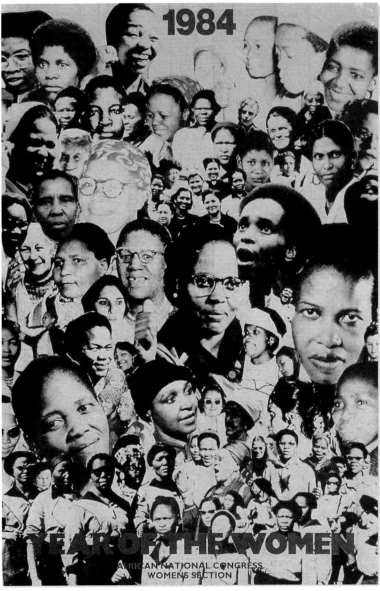

1984

YEAR OF THE WOMEN
AFRICAN NATIONAL CONGRESS
WOMEN'S SECTION

9

10

Revolutionary Tides

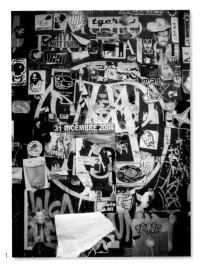

Fig. 1
Simultaneous media: the
chromolithographic poster surrounded by
"informal" rivals (stickers, photocopies,
silkscreens, laser prints, graffiti)
Milan, January 2005

In his 1791 treatise *The Rights of Man*, Thomas Paine was among the first to recognize that the face of revolution had been fundamentally altered by the events of the prior decades:

> What we formerly called Revolutions, were little more than a change of persons, or an alteration of local circumstances. They rose and fell like things of course, and had nothing in their existence or their fate that could influence beyond the spot that produced them. But what we now see in the world, from the Revolutions of America and France, are a renovation of the natural order of things, a system of principles as universal as truth and the existence of man, and combining moral with political happiness and national prosperity.[1]

Before 1776 and 1789, revolutions had been cyclical events like the dynastic struggles and hunger riots that regularly broke out in the course of early modern European history: literal acts of *revolutio*, of rotation as repetition, comparable to the orbiting of the planets and the cycles of nature. After 1776 and 1789, on the contrary, revolutions mark an irreversible break: the dismantling of the old regime and its replacement with a new one in harmony with universal principles and the "natural order of things." In the new order, government was no longer the property of a particular individual or family but that of the collectivity:

> Sovereignty, as a matter of right, appertains to the Nation only, and not to any individual; and a Nation has at all times an inherent, indefeasible right to abolish any form of Government it finds inconvenient, and to establish such as accords with its interest, disposition, and happiness. The romantic and barbarous distinction of men into Kings and subjects, though it may suit the conditions of courtiers, cannot that

> of citizens; and is exploded by the principle upon which Governments are now founded. Every citizen is a member of the sovereignty, and, as such, can acknowledge no personal subjection: and his obedience can be only to the laws.[2]

The face of revolution had been transformed from that of courtiers conspiring in the palace corridors or famished peasants assailing the royal granaries to that of a citizenry, endowed with natural liberties, assembling in public squares, affirming its right to modify or overturn any form of rule that "it finds inconvenient." Political power, the institutions of government, the law itself, now derive their legitimacy not from the divine right of kings but from the populace itself. The holders of public offices are transformed from servants of the court, beholden to a monarch or monarchical usurper, into public servants, representatives of the collectivity to which they themselves belong. Sovereignty attaches to and emanates from the people, and the people, whether understood as an abstraction or embodied by the actions of ruly or unruly multitudes, are the true protagonists of modern public life. As famously stated in Le Bon's *Crowd: A Study of the Popular Mind*, the modern era is "the era of crowds."[3]

The theory is simple. But who exactly are the people? Educated white males, every adult citizen of the nation, the international proletariat? And can the people, however defined, guarantee a more stable, just, or enlightened rule than hereditary leaders? Will their assemblies prove to be places of rational deliberation or, rather, incubators of irrationality, division, and violence subject to the machinations of demagogues? How to insure that the will of the multitude is one? From the start modern revolutions have

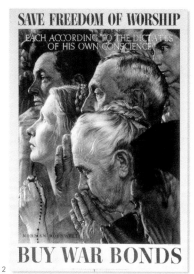

Fig. 2
Norman Rockwell (1894–1978),
United States
Save Freedom of Worship, 1943
40 x 28 in.
Printed by U.S. Government Printing Office
Hoover Institution Archives (US1662)

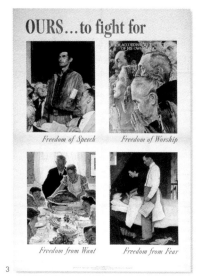

Fig. 3
Norman Rockwell (1894–1978),
United States
Ours...to Fight for—Freedom from Want,
1943
40 x 28 in.
Printed by U.S. Government Printing Office
Hoover Institution Archives (US1666)

depended on forms of mass persuasion and communication—everything from broadsheets to posters to radio and television advertising—to build consensus as well as to promote partisan causes, to educate as well as to mobilize and excite. From the start modern revolutions have proven Janus-faced, at times representing either the democratic promise of 1789, conveyed by the motto *liberté, fraternité, egalité*; or the irrationality, terror, and mob rule of 1792, symbolized by the guillotine.

The century and a half separating World War I from the French Revolution saw the rise not just of liberal-democratic systems like the one championed by Paine but also of various state forms, mass-based movements, and political ideologies that alter the liberal-democratic model in the direction of authoritarian rule or restrict the notion of sovereignty to an elite, a single nationality, or a single race. It saw the development of electoral politics and political practices (such as strikes, demonstrations, rallies, and marches carried out in public squares and city streets) and the concurrent growth of an expanding public sphere constituted by communications media such as broadsheets, pamphlets, newspapers, and magazines: virtual places of assembly in which opinions could be put forward and debated.[4]

All modern states and political movements, irrespective of whether they are liberal-democratic or authoritarian, elitist or populist, backward or forward looking in character, speak this same language of mass persuasion. For them and their contemporary descendants, public opinion counts, whether in the readily quantifiable form of votes or in less-quantifiable forms such as popular support, consensus, or nonopposition. Because public opinion counts, it must be informed in the didactic sense of providing information (about matters of politics, economics, culture, morality, and hygiene) but informed also in the sense of being provided with rituals, symbols, and narratives, with mobilizing signs, slogans, beliefs, and myths that insure social cohesion and promote participation in the life of the nation.[5] That such outreach may manipulate and deceive as it educates, that it may represent less an invitation to open debate than the soft lead arm of an effort to achieve mind control

over a civilian population, is understood. What remains a constant, however, is the necessity of reaching out.

Posters provide a literal, material bridge between the new public sphere constituted by mass communications and the public spaces that become the sites of modern politics as street theater. They were (and, in many countries, they remain) among the visual protagonists of the modern metropolis, repeated endlessly and on a dizzying array of scales, layered many deep and many high on kiosks, billboards, and walls like the strata of a mysterious socioeconomic geology whose tectonic shifts are measured in days and weeks rather than millennia. Linked to the typographical broadsheets of the eighteenth century, on the one hand, and to twentieth-century commercial advertising, on the other, these agents of mass persuasion come into their own with the widespread diffusion of industrial chromolithography at the end of the nineteenth century.

It is important to underscore that neither technology nor reductions in production costs alone fueled the emergence of posters as a key feature of modern life. Aloys Senefelder's invention of lithography dates to 1796. Chromolithography was patented by Gottfried Engelmann in 1837. Even after its triumph, some fifty years later, offset-color posters continued to find themselves in the company of more rudimentary predecessors such as woodcuts, screen prints, linocuts, line-block prints, and letterpress prints, in much the same way that cheaper successors like photocopies and stickers have accompanied them into the twenty-first century (fig. 1). Two other technological revolutions also predate the poster's triumph by several decades. Efficient paper-making machines began to surface as early as 1825. By mid-century the wholesale mechanization of paper production was underway due to the development of powerful wood-grinding machines that permitted a shift from rag pulps toward wood-based chemical pulps. Color printing too had become more economical by mid-century thanks to the acceleration of drying times achieved by adding coal-tar solvents such as xylene and benzene to printing inks.

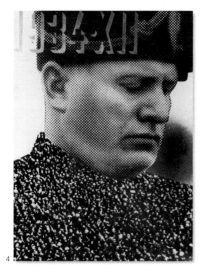

Fig. 4
Xanti Schawinsky (1904–1979), Italy
1934-XII, first version, 1934
42⁷/₈ x 30³/₄ in., letterpress
Private collection

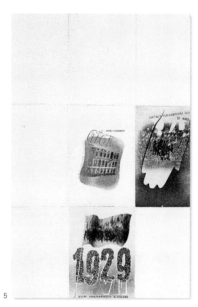

Fig. 5
Xanti Schawinsky (1904–1979), Italy
1934-XII, verso side of second version,
1934
42⁷/₈ x 30³/₄ in., letterpress
Private collection

None of these inventions were sufficient in themselves to bring about such widespread changes in communication. Rather, the rise to prominence of the political poster was driven by the emergence of a precise sociopolitical need, rendered acute as suffrage was extended to ever greater numbers of people. The state, political movements, labor unions, not to mention sellers of goods and providers of services, all required a fast and efficient conduit to the multitudes, multitudes that could not always be counted on to read newspapers. Before the advent of radio and television, that conduit was largely provided by posters.

Given the care with which linen-mounted vintage posters are now framed and safeguarded by collectors and museums as if they were unique paintings, it is easy to lose sight of the distinctiveness of posters as a mass medium. Four attributes immediately spring to mind: large print runs; low-cost, low-durability materials; scalability; and reworkability. All four place posters at the extreme opposite end of the spectrum from works of "fine" art.

Many of the posters included in *Revolutionary Tides* were printed in editions of five thousand to fifty thousand on highly acidic paper with industrial inks. Some editions exceeded one hundred thousand. The print runs were so large and, accordingly, so potentially visible within the public sphere that, in most countries, after an extended period of unregulated dissemination, posters eventually came under the authority of the state, usually a certifying agency or censor whose approval was required or a license tax that had to be paid in return for the right to post. Throughout most of the industrialized world controls were also gradually extended regarding the surfaces and locations on which posters could be mounted. The mere challenge of posting such enormous numbers of sheets required an army of well-organized and skilled affixers, often state employees or party militants working at dusk, able to deploy quickly and uniformly within a city. The affixing, usually involving paste, soap, and/or water applied to walls, had to be rapid and repeated to create an effect of saturation, simultaneity, and instantaneity; all the more rapid in the case of illegal or subversive

postings. The city as a whole was to awaken and find itself dressed up in a fresh set of clothes.

Such saturation tactics relied on a limited number of commercial poster sizes, themselves determined by standard industrial-paper sizes and by the formats readily accommodated by ordinary mechanical presses. But they did not exclude simultaneous printing on multiple scales—from billboards to placards suited for posting in public offices or in mass-transit vehicles. This variable scale corresponds to the susceptibility of posters themselves to reworking and repurposing. Frequent are cases where there exist multiple versions of the same poster, like John Heartfeld's *The Hand Has Five Fingers. With Five, You Will Strike Down the Enemy!* (nos. 45–46), a German Communist Party poster that began life as the cover of the 13 May 1928 issue of *The Red Flag* (*Die rote Fahne*) and was subsequently produced with red-and-white variants; or Wolfgang Janisch's *What Is Man?* and *We Are the People!* (nos. 25–26), which reuse the same abstract photographic backdrop for two different purposes. Norman Rockwell's paintings based on Franklin Roosevelt's "Four Freedoms" speech of 6 January 1941 first appeared as illustrations in *The Saturday Evening Post*, only subsequently to be transformed into posters of various sizes and formats in the service of the federal government's war bond campaign (figs. 2–3). Likewise, Xanti Schawinsky's *1934-XII* (no. 101) poster for the 1934 referendum on Mussolini's rule first appeared minus the *sì* photomontage (fig. 4). A later version of the work, produced after the referendum, includes the *sì* photomontage and was inserted as a looseleaf sheet in the magazine *La rivista illustrata del popolo d'Italia*. Whereas the first was a true poster meant to be affixed to a wall, the second was not. Double-sided, it was printed so that as it was unfolded the viewer would be led to view Mussolini's victory in the referendum, documented in the *sì* insert, as the culmination of a series of panels corresponding to key moments in fascism's rise (fig. 5). "Internal" updating of this sort corresponds to the standard practice of pasting external corrections or additions over political posters that have already been affixed, not to mention the practice of defacing them with

Fig. 6
Collage city
Milan, January 2005

graffiti or performing subversive *détournements*, a favorite antiestablishment tactic from dada to situationism to punk and beyond.

Just how long any poster campaign might be expected to endure varied from place to place: in some settings, a matter of days, in others, of months. But the typical result of successive layerings and juxtapositions was, to recall Colin Rowe's felicitous phrase, a "collage city," an environment saturated with patchwork patterns of repetitions and disjunctions, with the very materiality of poster-encrusted walls coming to embody the accelerated and compressed temporality and spatiality of modern life (fig. 6).[6] Conditions of viewing within these urban settings were, not coincidentally, the opposite of those provided by modern art galleries. Whereas by the end of the nineteenth century the latter were becoming well-lit places of silent contemplation and secular worship, where artworks could be placed at a remove from the world and experienced in their autonomy, the world inhabited by political posters was crowded, rapidly changing, and filled with noise. Artworks were framed and meant to endure. Political posters were framed only by other posters and exposed to the elements. Here today, they were gone tomorrow (by design).

Political posters had to communicate under pressure. They were forced to visually impose themselves on a blasé, distracted viewer by means of striking designs, repetition, ubiquity, and strategic placement. Because the physical space that they occupied could rarely be taken for granted, they were firmly affixed to walls. Theirs was space conquered as if in a battle zone. Manuals for posting routinely recommended the highest possible locations at the most heavily trafficked urban crossroads to insure maximum visibility and durability and minimum risk of being ripped, defaced, or covered up (fig. 7). Here the fundamental challenge was how to stand out amid the visual and acoustical din. Political posters mirror the dilemma of the modern individual with respect to society. Massed along the city boulevards, addressed to multitudes on the move on sidewalks, buses, taxis, and trams, each is a multiple but strives, nonetheless, to be more than a mere face in the crowd. Like the modern leader who provides the collectivity with

a group identity, with a distinctive face in an otherwise standardized, faceless world, the political poster strives to individuate itself within a sea of competing posters, to capture the public's attention, to shape the collective imagination and will. It is perhaps unsurprising, then, that its face so often merges with that of a leader.

To communicate under pressure meant (and continues to mean) to communicate quickly and efficiently with audiences equipped with varying degrees of verbal and visual literacy. This precluded traditional modes of argumentation, based on the rules of evidence and logical proof, and required instead the development of a highly simplified and immediately recognizable vocabulary of slogans, logos, icons, acronyms, and images, able to convey complex ideas with extreme economy and the highest possible impact. For late-nineteenth-century social scientists like Le Bon, this language was none other than that of modern mass politics itself:

> Whatever be the ideas suggested to crowds they can only exercise effective influence on condition that they assume a very absolute, uncompromising, and simple shape. They present themselves then in the guise of images, and are only accessible to the masses under this form. These imagelike ideas are not connected by any logical bond of analogy or succession, and may take each other's place like the slides of a magic lantern which the operator withdraws from the groove in which they were placed one above the other.[7]

Magic-lantern shows were the film and television of Le Bon's era. In place of logical connections, they supplied a form of "primitive" thinking: startling jumps, magically improbable connections, compressed image-thoughts with all the intensity and immediacy of dreams.[8] "Crowds," Le Bon writes, "are to some extent in the position of the sleeper whose reason, suspended for the time being, allows the arousing in his mind of images of extreme intensity which would quickly be dissipated could they be submitted to the action of reflection."[9] Such are the very multitudes on whom the fate of the modern nation state depends.

For most early social scientists the compressed, dreamlike economy of contemporary political discourse was a source of worry. It suggested that "image thinking" would lead inexorably to tyranny, mob rule, and a return to archaic patterns of religious thought, not to Paine's triumph of a rational system of universal values. For the poster artists of *Revolutionary Tides*, "image thinking" represented, on the contrary, a challenge to innovate and invent: an invitation to translate into chromolithographic terms the "polychrome and polyphonic tides of revolutions in modern capitals."[10] To this end, they devised a tool kit of typographical objects; a repertory of signs composed of anatomical fragments, symbols, and acronyms; a rhetoric of simplified geometrical

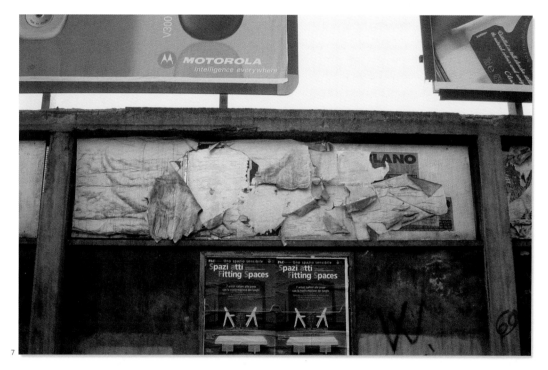

7

Fig. 7
Communication under pressure
Milan, January 2005

forms. They developed a grammar for combining these elements into highly readable multiplex emblems, visual-verbal hieroglyphs for modern times. Their aim was to surpass discursive modes of persuasion and argument in the pursuit of a bold new language that, for better or worse, could fulfill the wants and needs of the era of crowds. Whether or not the golden era of political-poster art has passed, there can be little doubt that this language, even when stripped of its paper support, continues to flicker throughout the contemporary media landscape.

Notes

1. Thomas Paine, *The Rights of Man*, in *The Communist Manifesto and Other Revolutionary Writings: Marx, Marat, Paine, Mao, Gandhi, and Others*, ed. Bob Blaisdell (Mineola, N.Y., 2003), 86.
2. Ibid., 86.
3. Gustave Le Bon, *The Crowd: A Study of the Popular Mind* (available online at http://www.gutenberg.org/etexts/445.
4. Gabriel Tarde's essay "The Public and the Crowd" represents the first effort to theorize the difference between physical and virtual forms of assembly. See Gabriel Tarde, *On Communication and Social Influence: Selected Papers*, ed. Terry N. Clark (Chicago, 1969), 277–94.
5. The classic study of such new traditions is the collective volume *The Invention of Tradition*, ed. Eric Hobsbawm and Terence Ranger (Cambridge, Mass., 1983). See in particular Hobsbawm's two chapters: "Inventing Traditions," 1–14, and "Mass Producing Traditions (1870–1914)," 263–307.
6. Colin Rowe and Fred Koetter, *Collage City* (Cambridge, Mass., 1978). Long a favorite subject for photographers, strata of peeled-off posters, referred to as "décollage" when the peeling becomes deliberate, assumed particular prominence in the context of new realism and pop art as, for instance, in the work of Mimmo Rotella.
7. Le Bon, *The Crowd*, bk. 1, ch. 3, sec. 1.
8. Elsewhere Le Bon writes: "The images evoked by words being independent of their sense, they vary from age to age and from people to people, the formulas remaining identical. Certain transitory images are attached to certain words: the word is merely as it were the button of an electric bell that calls them up" (ibid., bk. 2, ch. 2, sec. 1).
9. Ibid., bk. 1, ch. 3, sec. 3.
10. The quotation is from Filippo Tommaso Marinetti's founding manifesto of futurism, reproduced in *Teoria e invenzione futurista*, ed. Luciano De Maria (Verona, 1968), 10.

Revolutionary Tides

The Art of the Political Poster 1914–1989

The March

The emergence of multitudes as the protagonists of public life after the great revolutions of the eighteenth century corresponds to the rise of a new language of political persuasion: a language of group organization, coordination, and mobilization; of strikes, rallies, assemblies, campaigns, and marches; of acts of symbolic or real aggression and self-defense. In prior centuries the populace as a whole rarely found itself within the circle of power. It had two main options given its irrelevance to political decision making: to passively endure the whims of rulers or to riot. In the modern era an array of intermediate forms of protest and persuasion develops that allow the populace to express its will beyond electoral politics. These forms draw their inspiration from religious and military practices. Mass rallies build on longstanding traditions of assembly for religious festivals; marches are based on processional and pilgrimage practices that have as their targets places of symbolic significance. Political multitudes stride in formation like modern mass armies on parade, with banners and uniforms establishing identities and ranks within an overall unity, with song and the ritual chanting of slogans indicating that the marching multitude speaks with a single voice. Formations, whether linear, quadrangular, or wedge-shaped, become the mark of the collective's power, expressing clarity of intention and unanimity of will. As such, they become dominant features in the art of the political poster.

1

Bogdan Nowakowski
*Look Where the Socialists Are Leading
the People!* mid-1920s
39⁵/₈ x 28¹/₂ in.

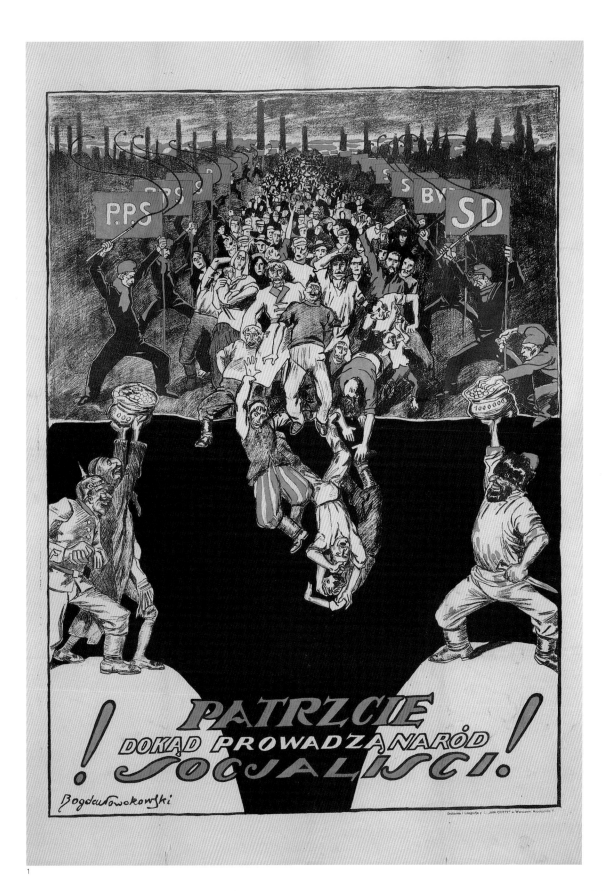

1

ПОСТРОИМ ЭСКАДРУ
ДИРИЖАБЛЕЙ
имени ЛЕНИНА

ОГИЗ—ИЗОГИЗ Москва 1931 Ленинград

3
Artist unknown
Buy War Bonds, 1942
40 x 30 in.

Opposite
2
Georgii Kibardin
*Let's Build a Squadron of Dirigibles
in Lenin's Name*, 1931
40³/₄ x 28⁷/₈ in.

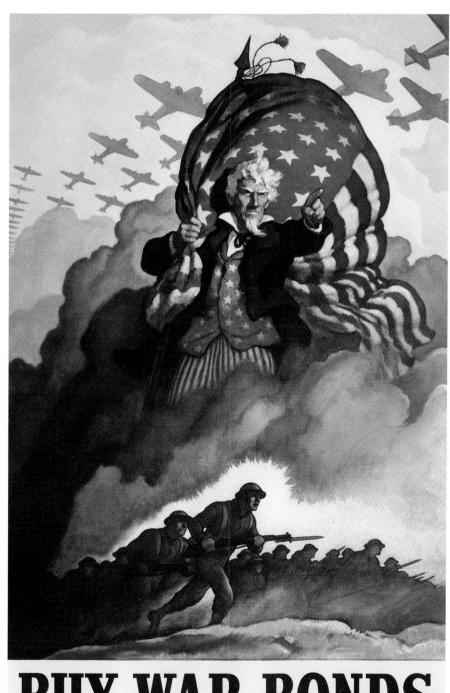

3

4
Artist unknown
Strengthen Yourself by Confronting High Waves and Mighty Winds! 1966–69
30¹/₄ x 42 in.

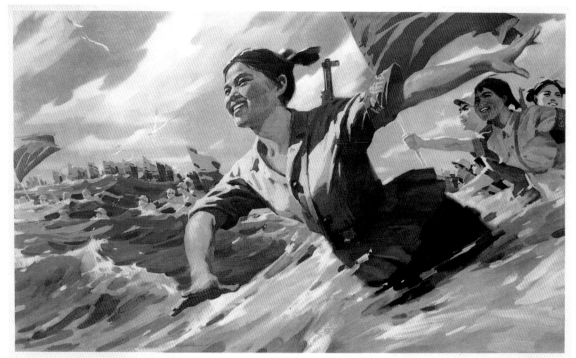

5
Artist unknown
Step into Your Place, 1915
20 x 30 in.

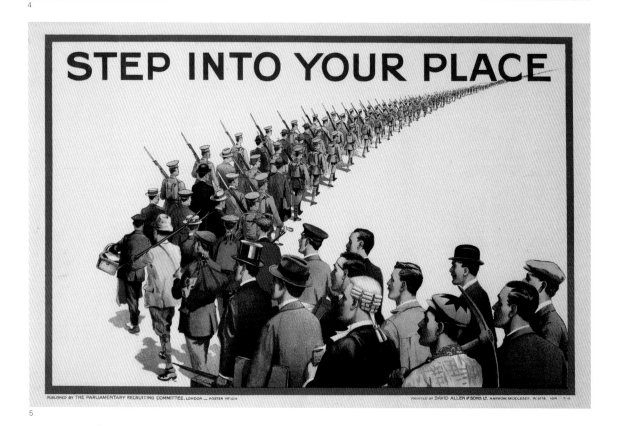

6
Attributed to Iosif Ganf
*Social Democracy and Fascism Are
Two Links in One and the Same Chain
of Capitalist Exploitation,* 1932
29 x 19¹/₂ in.

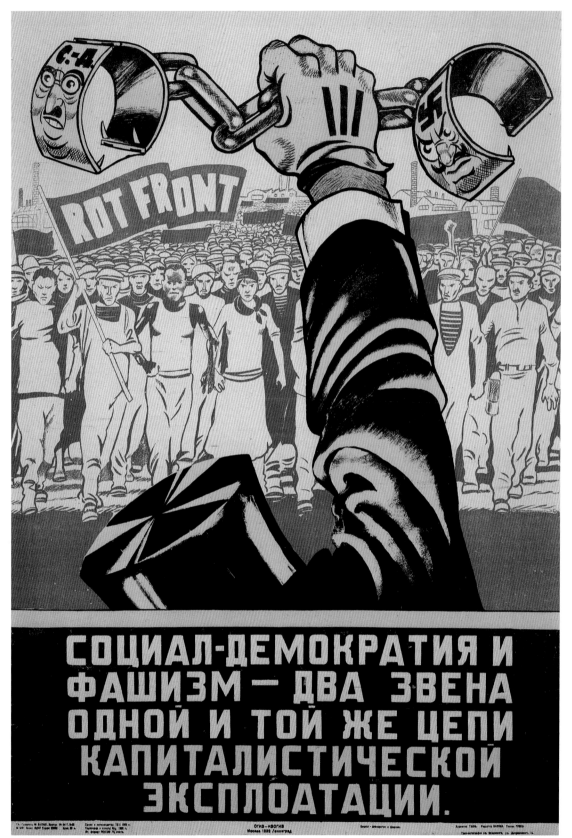

6

7
Lewis Rubenstein
*Washington Hunger March
(December 1932)*, c. 1933
Gouache, conté crayon, and graphite
on paper, 19 x 10³/₄ in.

Opposite above
8
Nikolai Kochergin
*Ever Higher the Banner of Leninism—The
Banner of the International Proletarian
Revolution*, 1932
42 x 29¹/₄ in.

Opposite below
9
Artist unknown
A Truly Great Wall, 1967
21³/₈ x 30¹/₂ in.

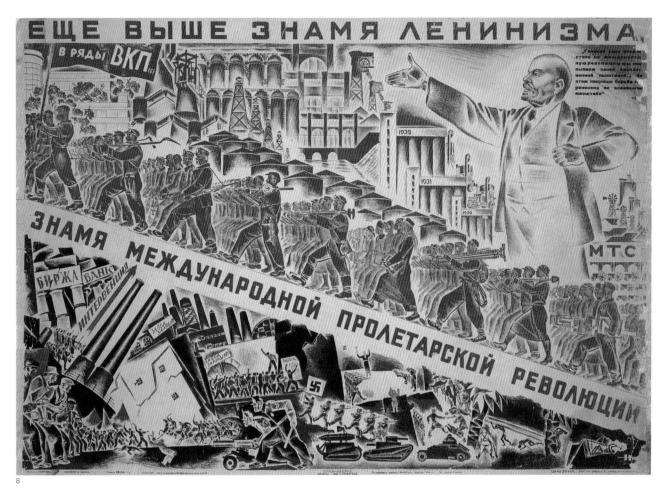

8

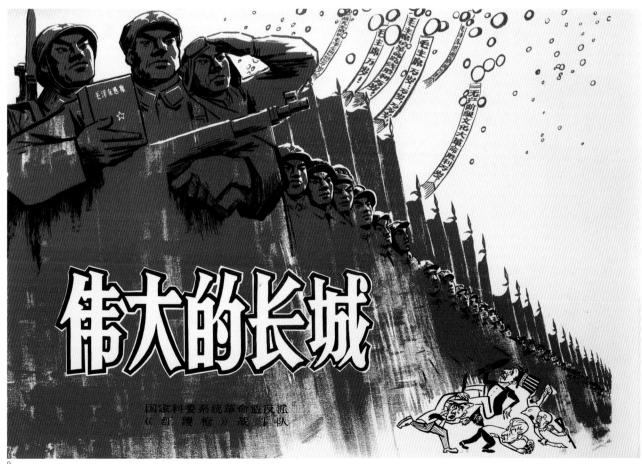

9

10
Georges Goursat [Sem]
To Triumph, Subscribe to the National Loan,
1917
45 x 31 in.

11
Ernest Hamlin Baker
For Every Fighter, a Woman Worker, 1918
42 x 28 in.

Opposite
12
Valentina Kulagina
1905—The Road to October, 1929
41 x 28¹/₂ in.

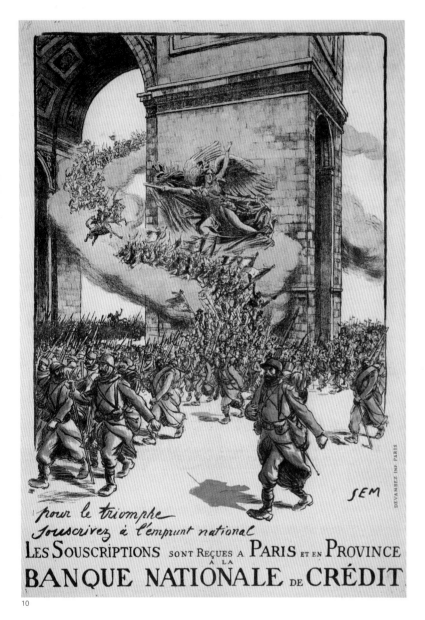

10

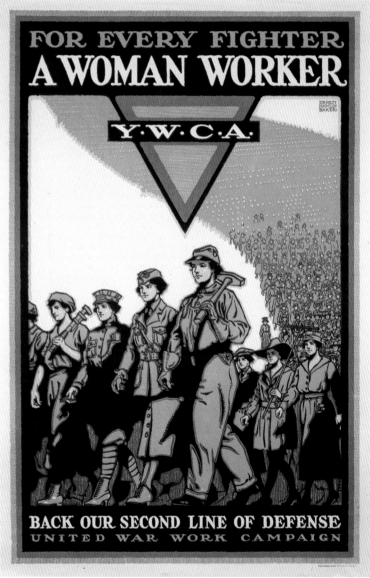

11

Opposite

13
János Tábor
Red Soldiers Forward, 1919
50 x 37 in.

14
Artist unknown
*The Martyr El-Basheer El-Ahlawi, Shot
Down on 8 March 1974. Martyr for a Free
and Independent Sahara. Day of the
Martyrs, 8 March 1977*, 1977
23 x 16 in.

15
Artist unknown
*The Organization of the Dispossessed
of the Islamic Revolution*, 1979–82 (?)
27 x 18 in.

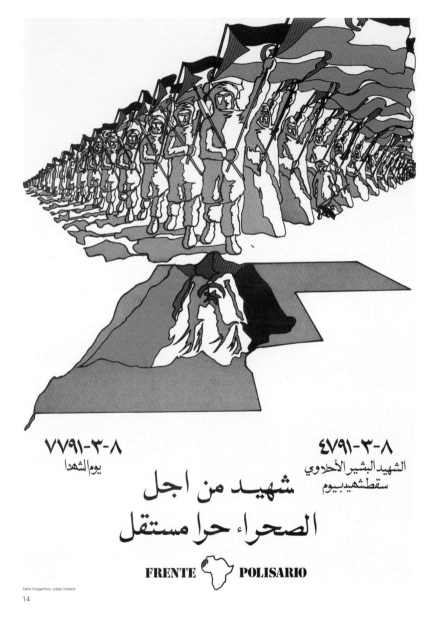

14

15

The Mass Ornament

If political posters reach out to a mass audience by visual means, the absorption of the image of the multitudes themselves into the visual vernacular of poster art stands as a logical corollary. Everywhere in twentieth-century political-poster art, whether in the service of an international organization, a nation state, a political party, or a protest movement, the poster becomes an idealizing mirror in which the collectivity can gaze upon itself either in action or as the necessary background for social change. Its actions are rendered in a wide array of geometrical forms, created either by external means—as photographs are manipulated by the artist for insertion into a composition—or by internal means (in configurations resembling chorus lines or halftime-show marching drills in which a symbol or sign deliberately takes shape). The people's foundational role in modern politics is rendered instead in the form of backdrops, abstracted fields of individuals merged into a cohesive whole. All such mass ornaments can be understood as allegories of the collectivity's united desires and social aspirations.

16

Sergei Sen'kin

Long Live the First of May, 1929

42 x 28 in.

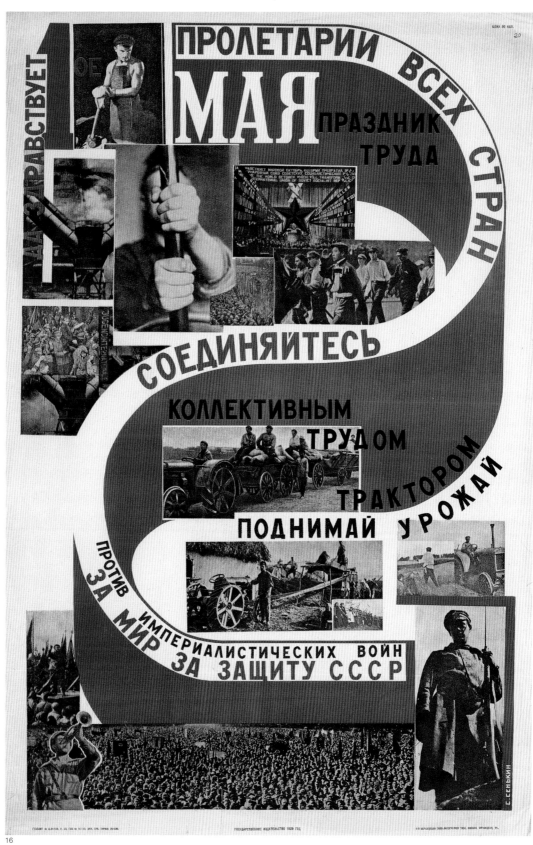

Above
17
Jules Grandjouan
White-collar Misery, 1919
16 x 47 in.

Below
18
Artist unknown
War, War until Victory! 1983–85 (?)
9 x 24 in.

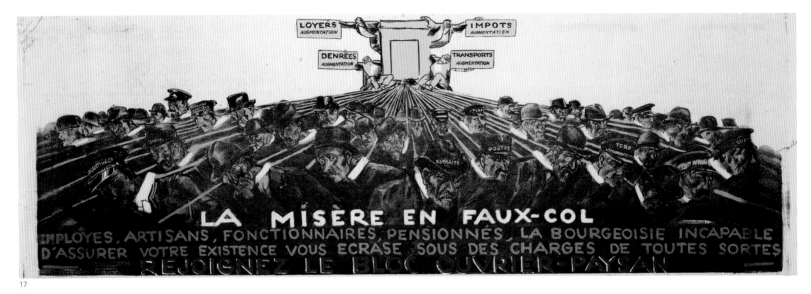

17

18

19
Artist unknown
1 May: Holiday of Worker Solidarity, 1980s
$19^{3}/_{8}$ x $26^{5}/_{8}$ in.

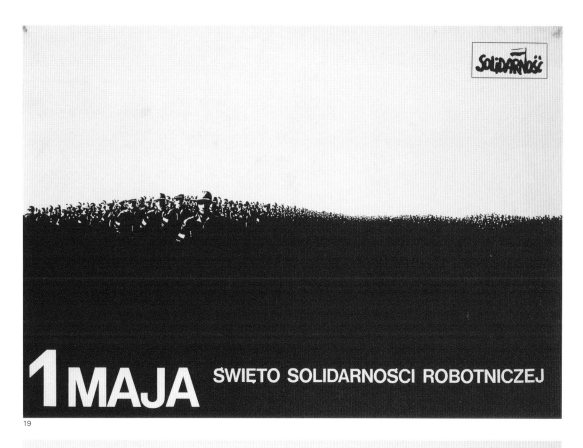

20
Artist unknown (possibly Krol
and Marczewski)
Vote with Us, 1989
20 x $26^{5}/_{8}$ in.

21
Hattingberg
We'll Do It with the Manual, 1937
33 x 24 in.

22
Artist unknown
Red Army Go Home, 1992
17⁷/₈ x 10¹/₄ in.

21

22

23

KGK Brigade: Viktor Koretsky,
Vera Gitsevich, and Boris Knoblok
*Free Working Hands of the Collective
Farms into Industry*, 1931
28 x 39¹/₂ in.

23

24

Artist unknown
*Victory. Fighting in France for Freedom!
Are You Helping at Home?* 1917
16 x 19 in.

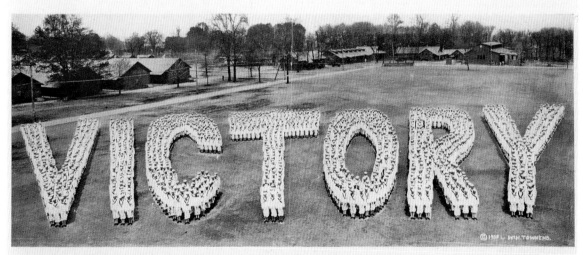

24

Wolfgang Janisch
What Is Man? 1988
Black-and-white lithograph, 23 x 16 in.

Opposite
26
Wolfgang Janisch
We Are the People! 1989
Black-and-white lithograph, 23 x 16 in.

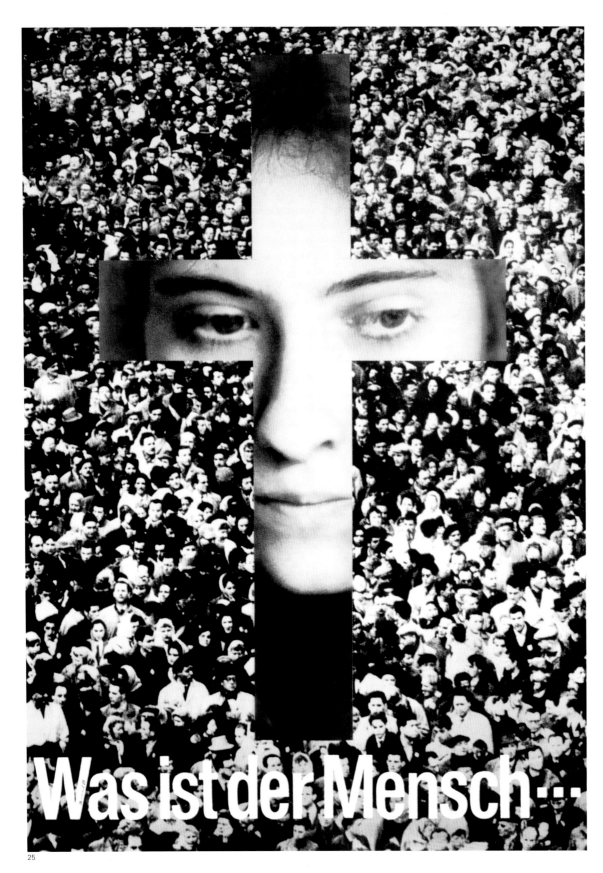

25

WIR sind das Volk!

Anatomies of the Multitude

Analogies between the human body and the organization of human societies are one of the founding figures of thought stretching back to ancient Greek political theory. They crystallize in the metaphor of the body politic. In traditional societies the body politic was understood as a hierarchical structure in which different social classes were assigned the functions of the hands, the feet, and the head, according to an unchanging natural law. In the modern era these assignments become mobile and the multitudes come to animate the body politic's every extremity. Such figurative considerations helped poster artists solve an otherwise intractable problem. How to represent the collective will, group actions and reactions, the crowd as mass audience of political messages or as source of collective speechmaking? The solution was to identify single features of the human body with single actions of the collectivity; to create a symbolic anatomy of the multitude here reduced to seven operations involving hands, arms, ears, and the human voice. These anatomies of the multitude secularize and ascribe to the people what were once the attributes of gods or kings. The legion of hands in medieval and Renaissance art pointing from on high as markers of God's direct intervention into human history are transformed into signs of humanity making history by acting on itself.

The Fist

Clenched, the hand is reattached
to the arm so that together they may
assert their strength, their defiance,
their potential as a weapon. The fist
rises up directly out of the people
with the scales of justice; it bursts
the chains of injustice; it lends
its strength to the national army;
it inflicts the enemy's brand on the
innocent.

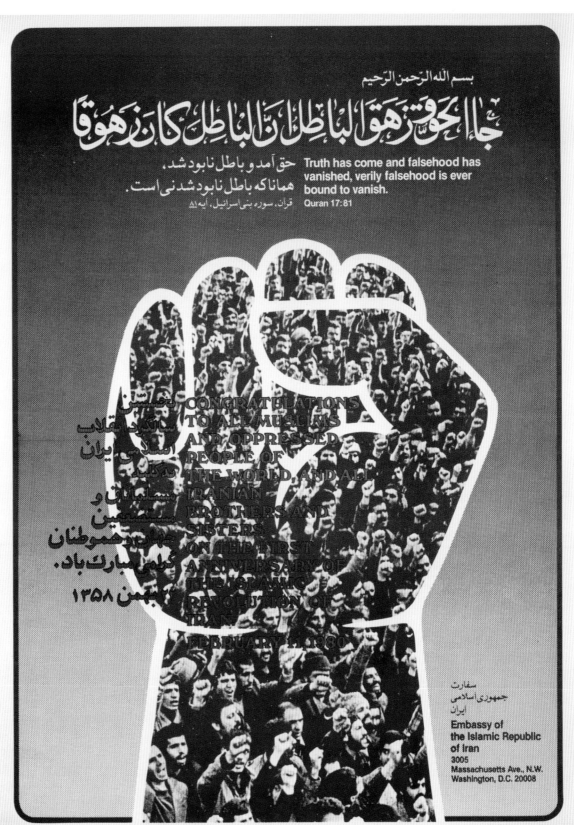

27

28
Artist unknown
Forward, 1943–44 (?)
29 x 20 in.

29
Artist unknown
Model for a Monument, 1930s
Painted plaster on wood,
21$^1/_8$ x 18$^1/_4$ x 18$^1/_4$ in.

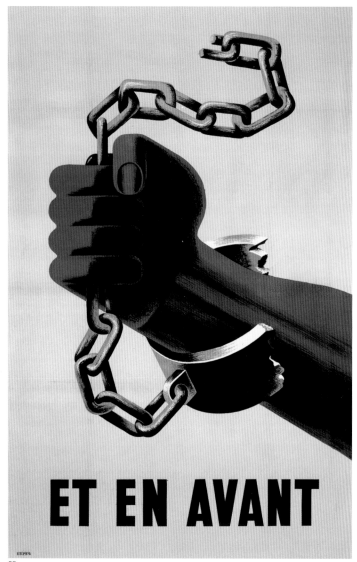

28

29

30
Bahman Sehhat-Lou
Untitled, 1970s
14¹/₂ x 10¹/₂ in.

31
Artist unknown
The Deposed Shah Must be Tried in Iran,
1980
27 x 19 in.

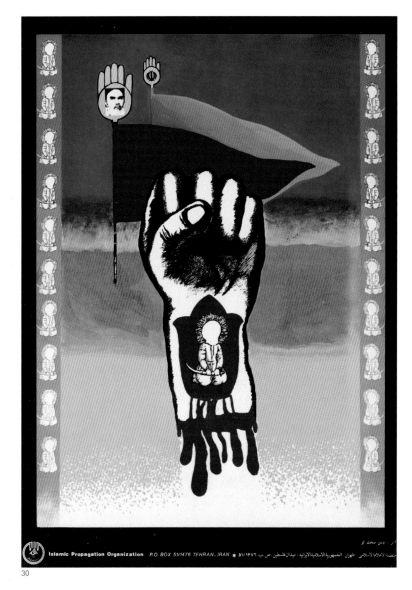

30

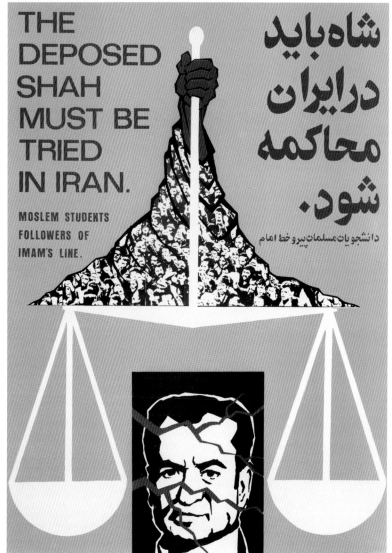

31

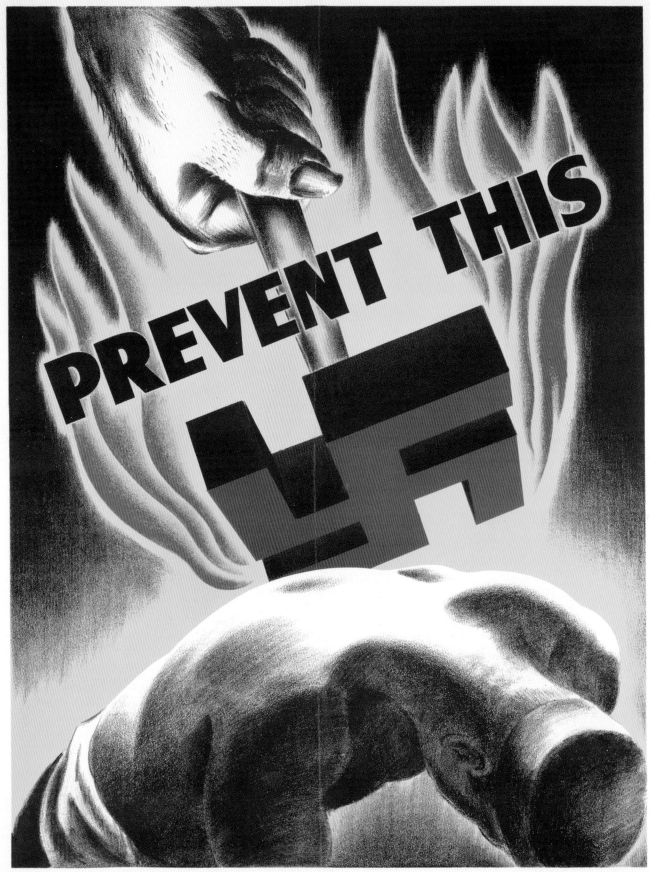

PREVENT THIS

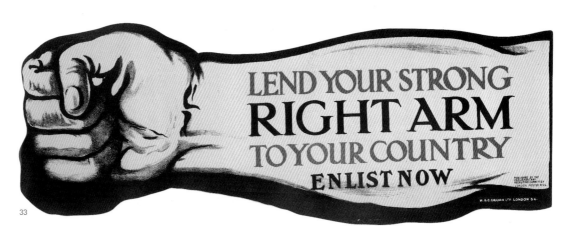

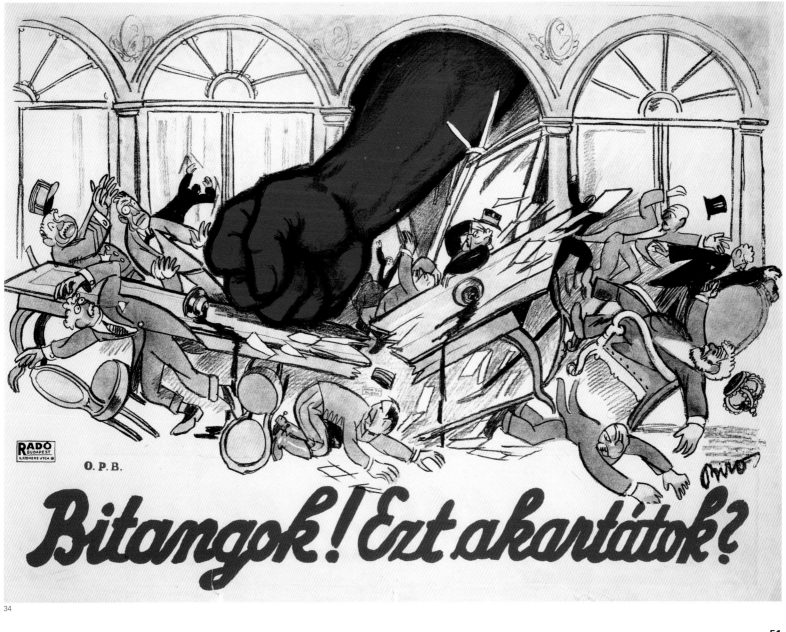

35

Karol Sliwka
*Independent Self-Governing Trade Union
of Individual Farmers "Solidarity,"* 1981
26⅝ x 19¼ in.

36

Rafael Tona
*P.S.U. To Smash Fascism Enroll
in the Air Force,* 1936
43⅜ x 31⅝ in.

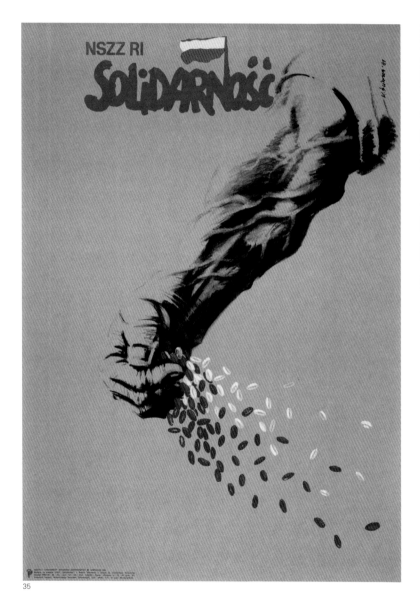

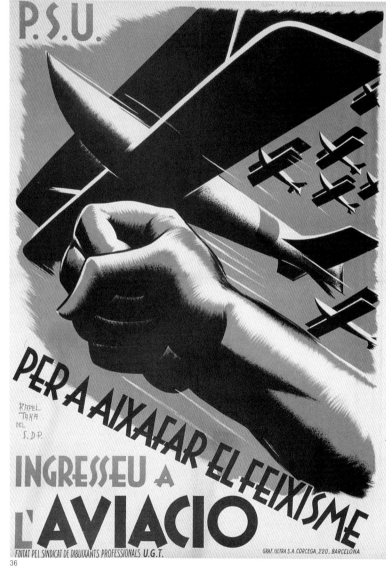

35

36

The Salute
The fist opens up into a proliferation
of signs: of peace, of victory, of
recognition of the sacred bond
between individual citizen and leader.

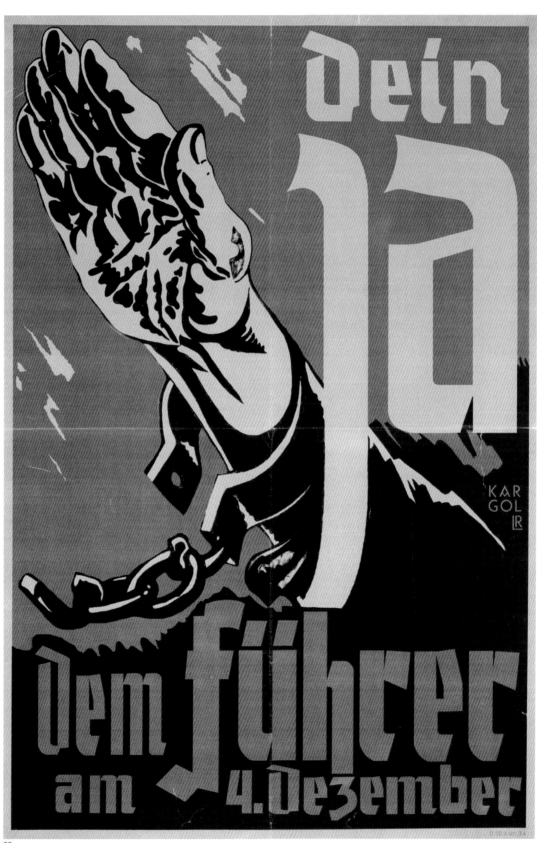

37

38
Artist unknown
The Islamic Revolution Party:
Congratulations on the Victory, early 1980s
28 x 19 in.

39
Artist unknown
We Will Triumph! 1979
26 x 19 in.

Opposite
40
Sergei Sen'kin
For the Many-millioned Leninist Komsomol,
1931
39³/₄ x 28 in.

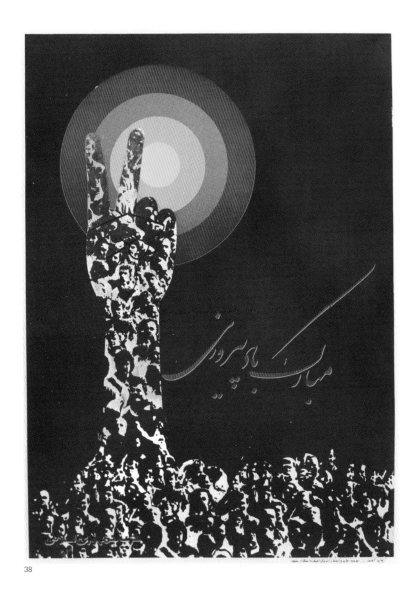

38

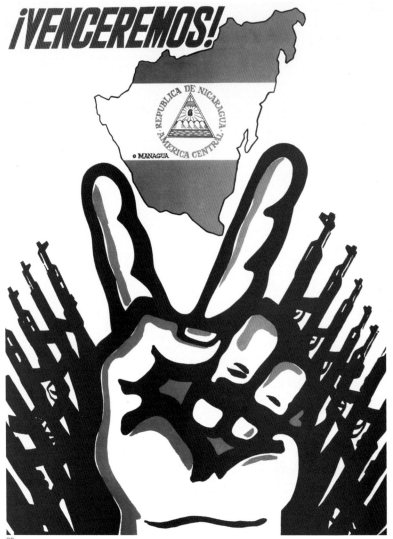

39

ЗА МНОГОМИЛЛИОННЫЙ ЛЕНИНСКИЙ КОМСОМОЛ

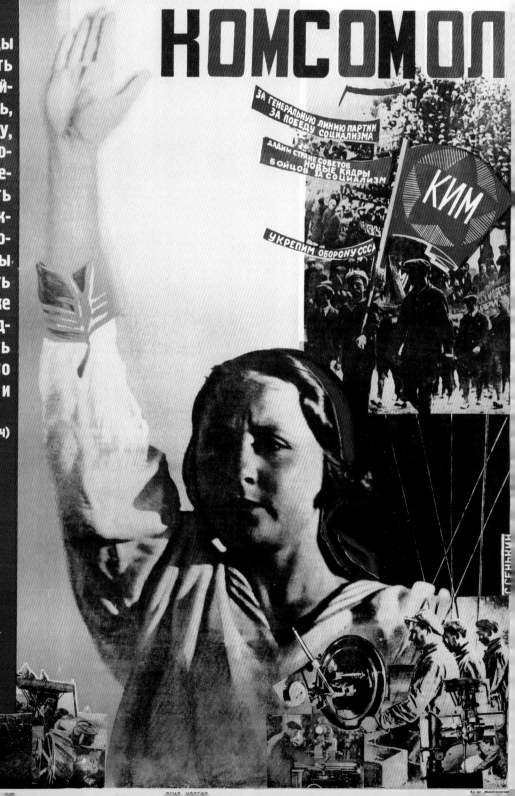

„Комсомольцы должны изучать конкретную действительность, факты, технику, проводить рационализаторские мероприятия, уметь не только критикнуть, но и добиться того, чтобы уметь проводить в жизнь свои же собственные предложения, уметь брать не только героизмом, но и знанием дела".

(Каганович)

ЗА ГЕНЕРАЛЬНУЮ ЛИНИЮ ПАРТИИ ЗА ПОБЕДУ СОЦИАЛИЗМА

ДАДИМ СТРАНЕ СОВЕТОВ НОВЫЕ КАДРЫ БОЙЦОВ ЗА СОЦИАЛИЗМ

УКРЕПИМ ОБОРОНУ СССР

КИМ

Pointing the Finger

The finger points as an expression of the popular vote; it denounces enemies and traitors; it underscores key political objectives and causes. What was once the hand of God becomes the hand of the body politic.

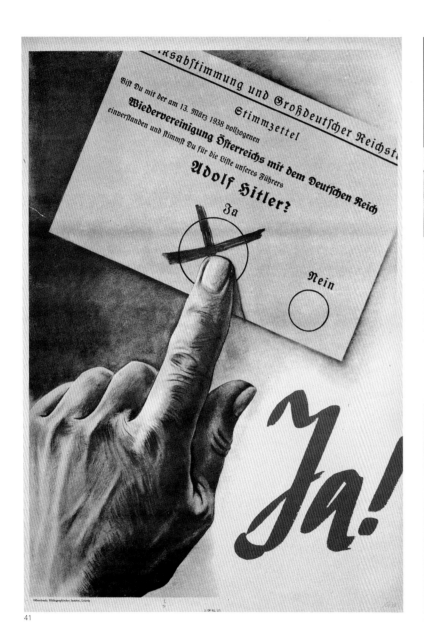

41

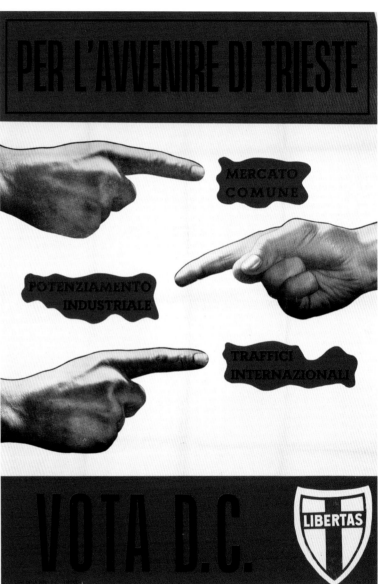

42

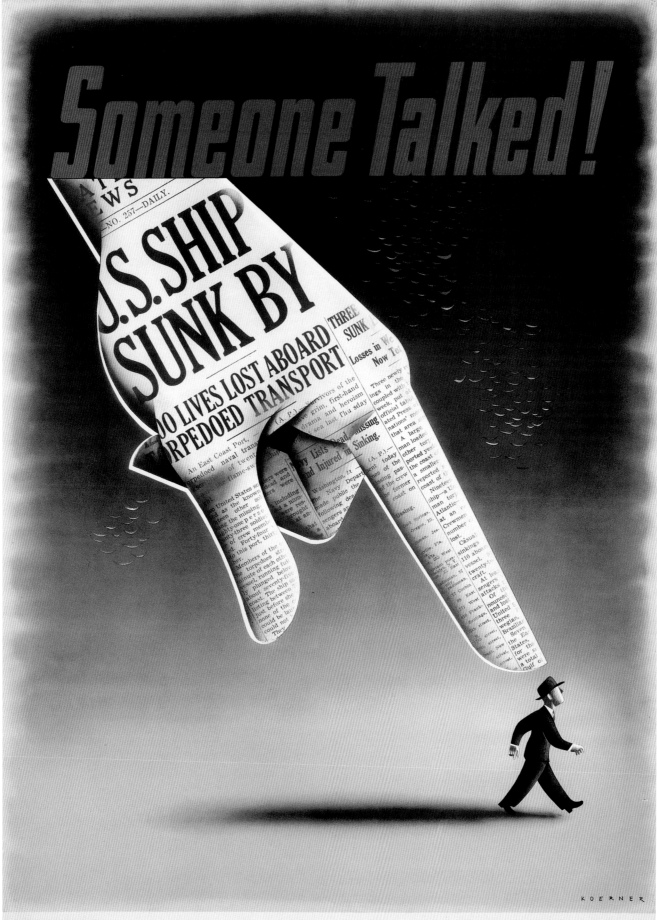

Someone Talked!

43

44

Art Studio No. 62
*To Assist the Industrial and Financial Plan,
Let's Organize a Production Comrades'
Court*, 1931
40⁷/₈ x 27¹/₂ in.

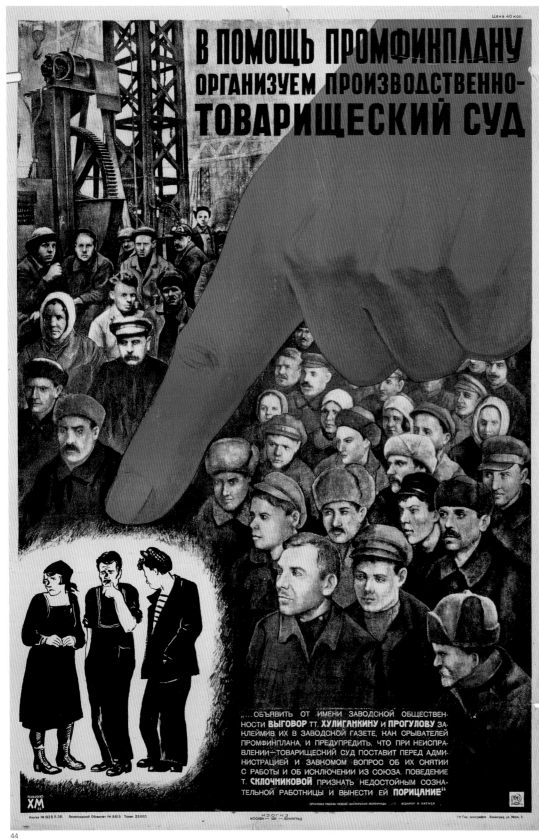

The Open Hand

The hand leaves its traces on a wall in the wake of a massacre; its fingers extend a welcome, becoming an invitation to vote for a given party's election list; it pushes back and pushes off. Endowed with claws, it becomes the grasping hand of an enemy collectivity, whether socialist forces from within or an army invading from without.

45
John Heartfield
The Hand Has Five Fingers. With Five, You Will Strike Down the Enemy! Choose List Five, the Communist Party! 1928
35 x 24 in.

46
John Heartfield
The Hand Has Five Fingers. With Five, You Will Strike Down the Enemy! Choose List Five, the Communist Party! 1928
35 x 24 in.

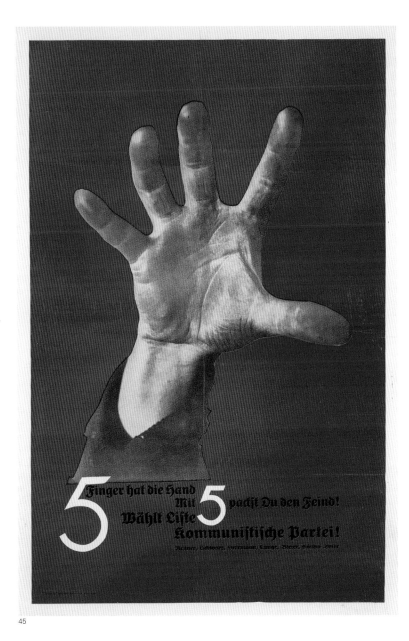

45

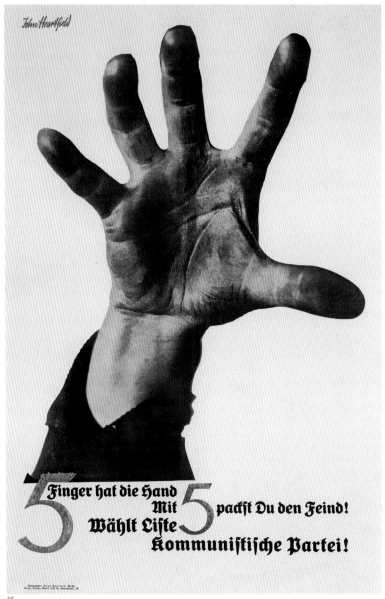

46

47
Artist unknown
The Islamic Republic Party, 1980s
28 x 19 in.

48
Chlad
CSU: The Choice that Means Security,
c. 1953
24 x 16 in.

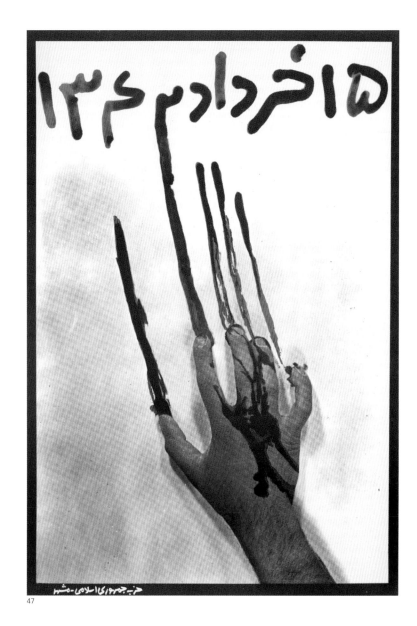

47

48

49
Artist unknown
Defend the Fruits of Your Labor, 1948
39 x 27³/₄ in.

50
Amado Oliver
*The Italian Invader's Clutch Tries
to Enslave Us*, 1937
39³/₈ x 27⁵/₈ in.

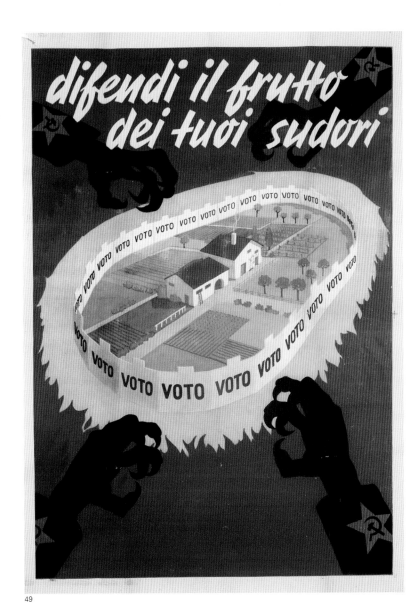

49

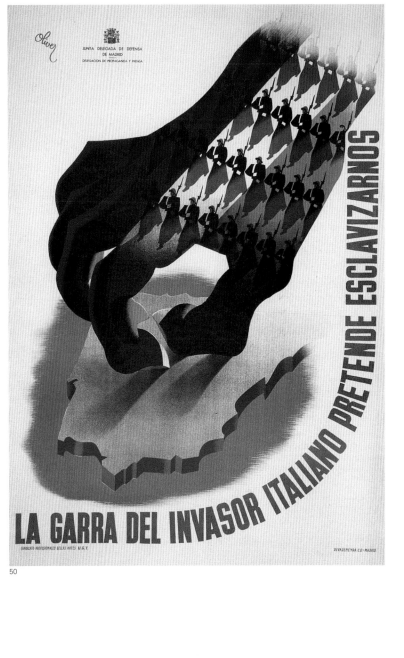

50

51
Antonio Arias Bernal
Unity Is Strength, late 1930s
40¹/₂ x 29 in.

Opposite
52
Artist unknown
The Third Decisive Red Front, 1931
39³/₄ x 27³/₄ in.

The Handshake

When two hands meet, a social pact comes into being: among workers themselves, between social classes, between labor and industry, the army, the state or the nation. A handshake seals the deal.

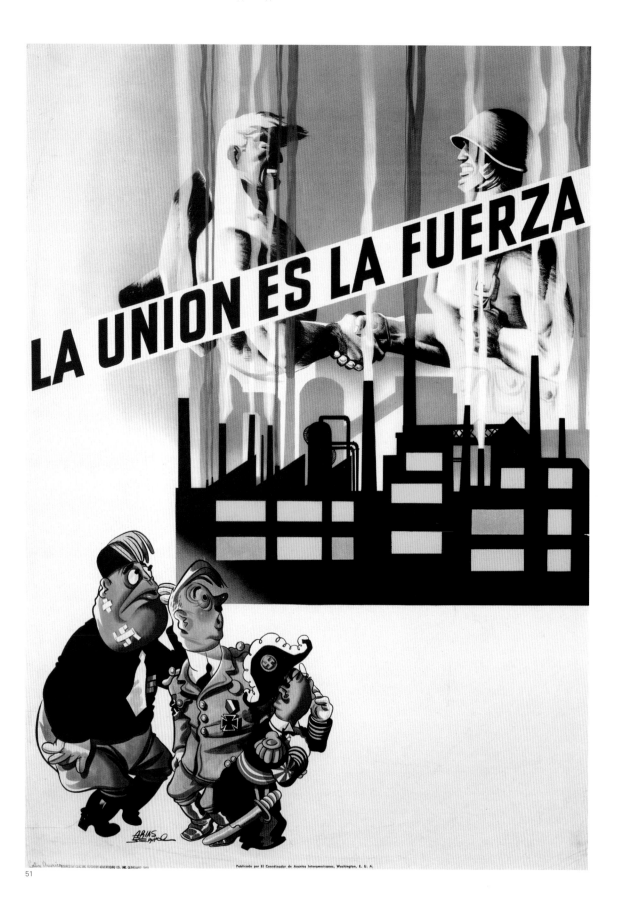

51

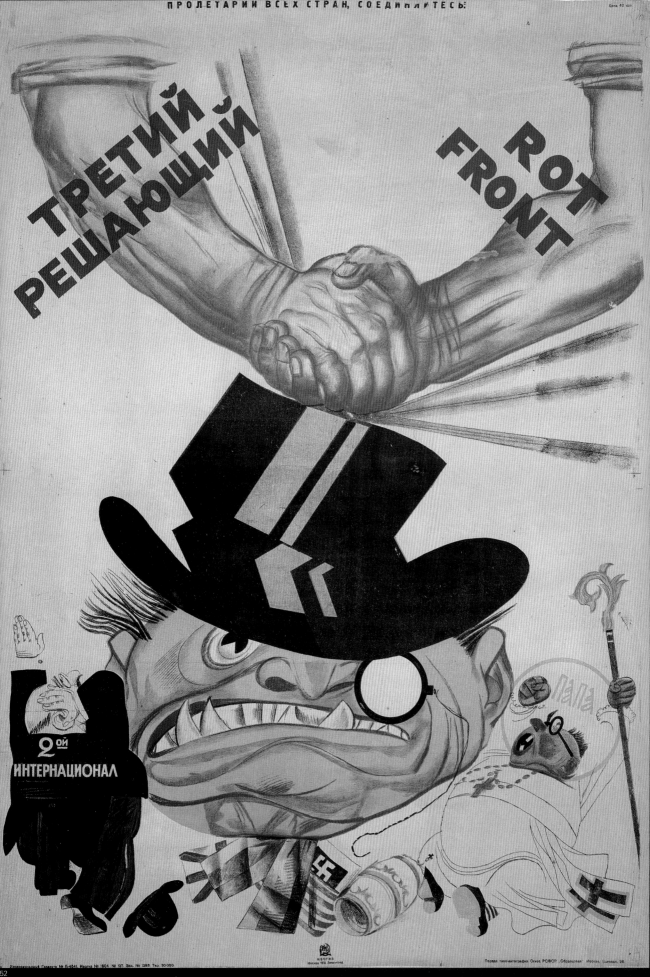

ТРЕТИЙ РЕШАЮЩИЙ

ROT FRONT

2ой ИНТЕРНАЦИОНАЛ

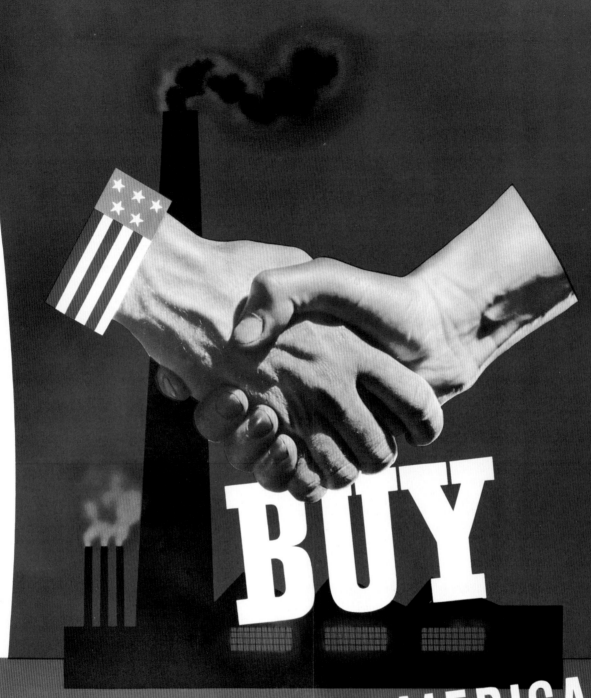

Opposite
53
John C. Atherton
Buy a Share in America, 1941
28³/₈ x 20³/₄ in.

54
Artist unknown
National Workers' Council, early 1940s
Screenprint, 36¹/₂ x 27¹/₂ in.

55
Sabinsky & Vesely
*Without the Russian October Revolution
There Would Be No 5 May*, 1945
36¹/₂ x 24³/₈ in.

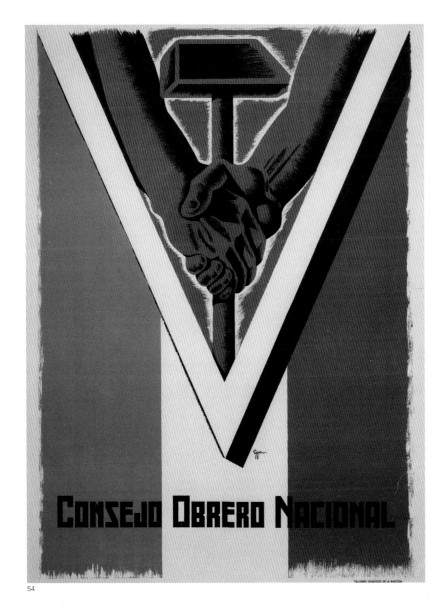

54

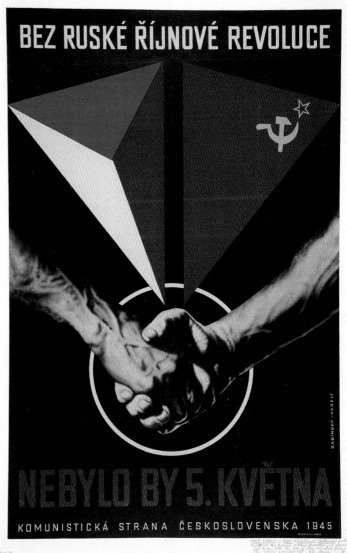

55

56
Heinrich Vogeler
*Support Red Aid! The Five-Year Anniversary
of the International Revolutionary Fighters
Aid*, 1928
29⁷/₈ x 21 in.

The Crowd's Voice and Ear

Ideally, the political crowd speaks
in the single voice of virtue and truth,
either as a chorus or as an individual
entrusted with the task of
representing the collectivity. In reality,
it is a realm of differences and debate,
animated by a mix of facts, opinions,
impressions, gossip, public secrets,
and private information that can
become an object of scrutiny both
by the state and by its enemies,
particularly during times of social
turmoil and military conflict. Exposed
to the vast proliferation of information
and technologies of eavesdropping
and surveillance, the public receives
a mixed message. Exercise your
freedoms; discipline your mouth
and ears.

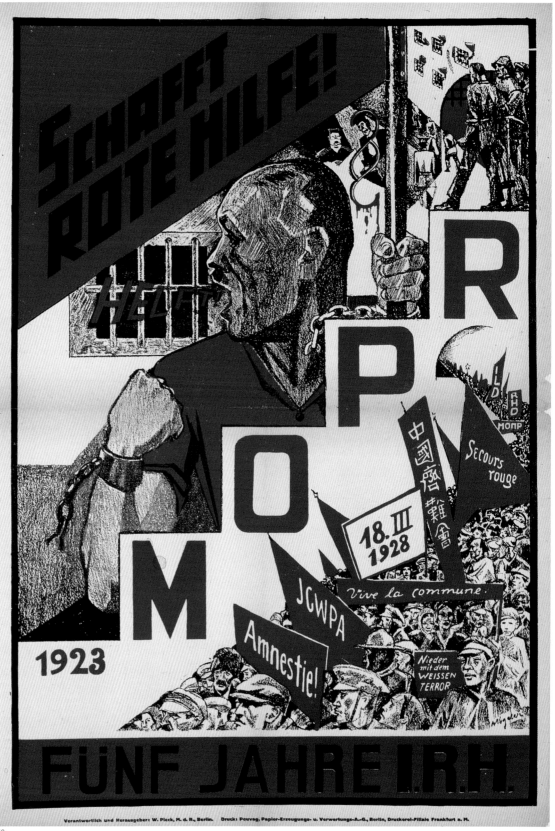

Artist unknown
*1 October—All-Union Day of the Shock
Worker,* 1931
42 x 29 in.

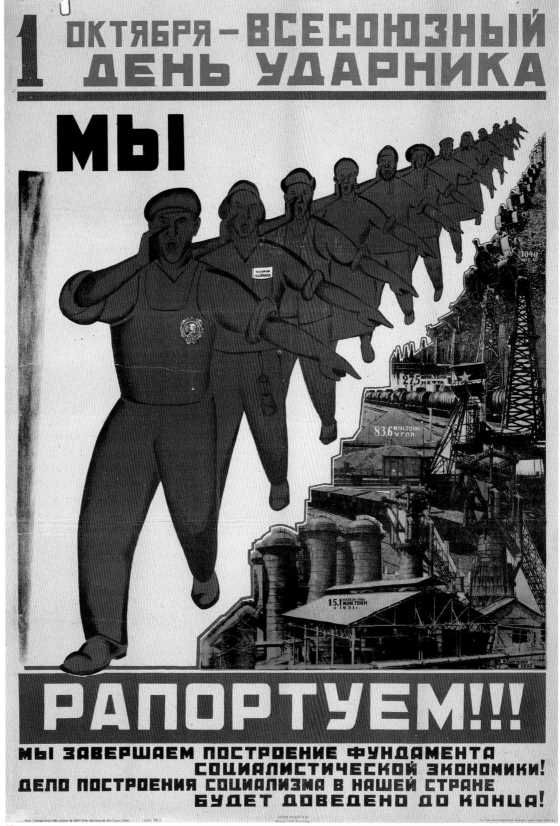

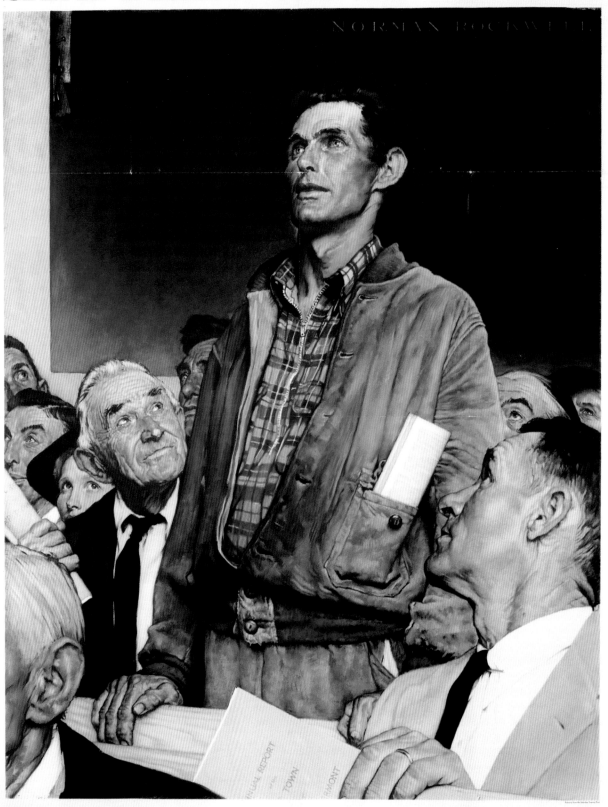

59
Artist unknown
Youth Accuse Imperialism, late 1960s
31 x 22 in.

Opposite
58
Norman Rockwell
Freedom of Speech, 1943
40 x 28 in.
Freedom of Speech © 1943 SEPS

59

61
Charles Howard
Serve in Silence, mid-1940s
Serigraph, 22 x 17 in.

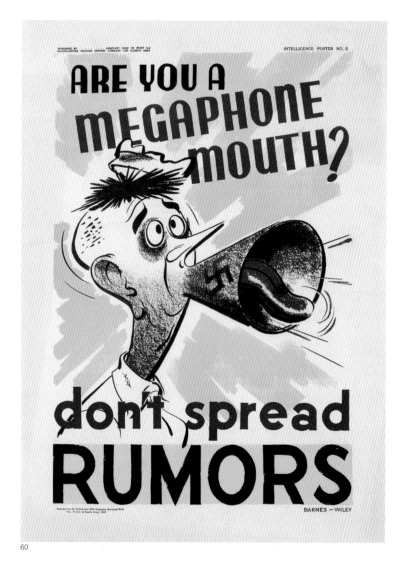

60

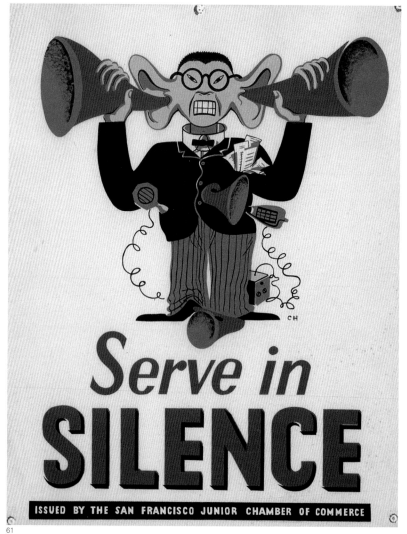

61

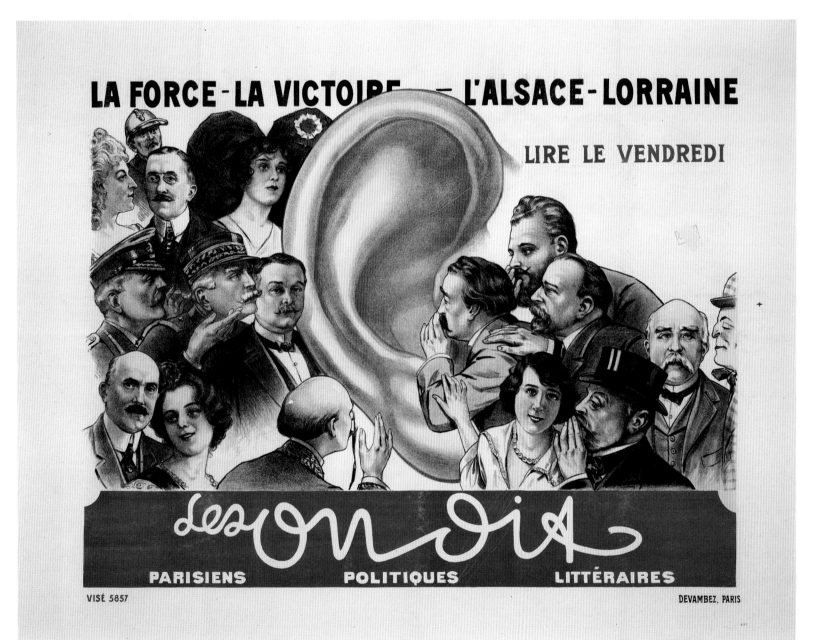

62

63
Artist unknown
Pst! 1939–43
33 x 23 in.

64
Artist unknown
Warning! Walls Have Ears. Be Careful of What You Say! early 1940s
19 x 12 in.

Opposite
65
Ralph Iligan
Enemy Ears Are Listening, 1942
14 x 26 in.

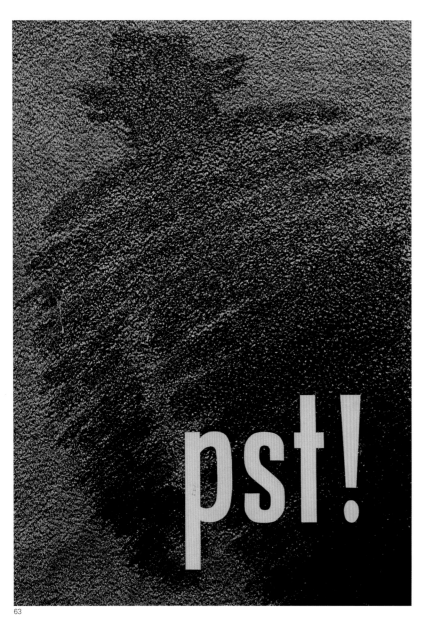

63

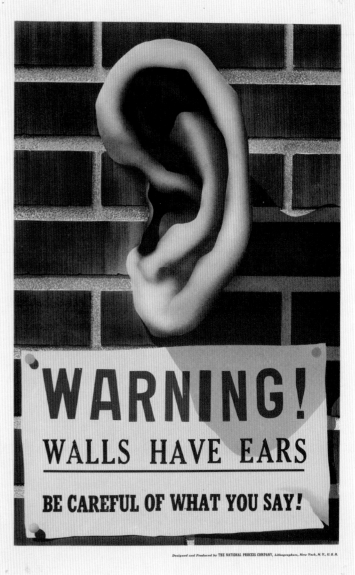

64

ENEMY EARS are listening

Statistical Persons

In modern societies every individual counts and every individual is counted. Census statistics and polling data are produced on a regular basis to create knowledge about demographics, productivity, socioeconomic patterns, health and sickness, literacy, public morality, public opinion, tastes. Individual lives are translated into proliferating identification numbers, data sets, and records that become objects of statistical analysis for government, police, social scientists, political activists, advertisers, and retailers. The success or failure of public campaigns of every kind is measured in numbers. As a result, quantitative data is deeply intertwined with the image of multitudes in political-poster art. Pie charts, tables, bar graphs, histograms, scatter diagrams, and the like become essential graphic features, along with typography, photographs, illustrations, and cartoons in the visual vernacular wielded by poster artists. The poster itself often lays bare the fact that, as a measure of its persuasive use of statistical hype, it too is a quantitative artifact printed in editions sometimes exceeding one hundred thousand.

66

Artist unknown (possibly Josep Renau)
*Before: Poor Hungry Farmers; Now
the Farmer Works and Is Happy*, 1937
Photomechanical print, 41³/₈ x 28⁷/₈ in.

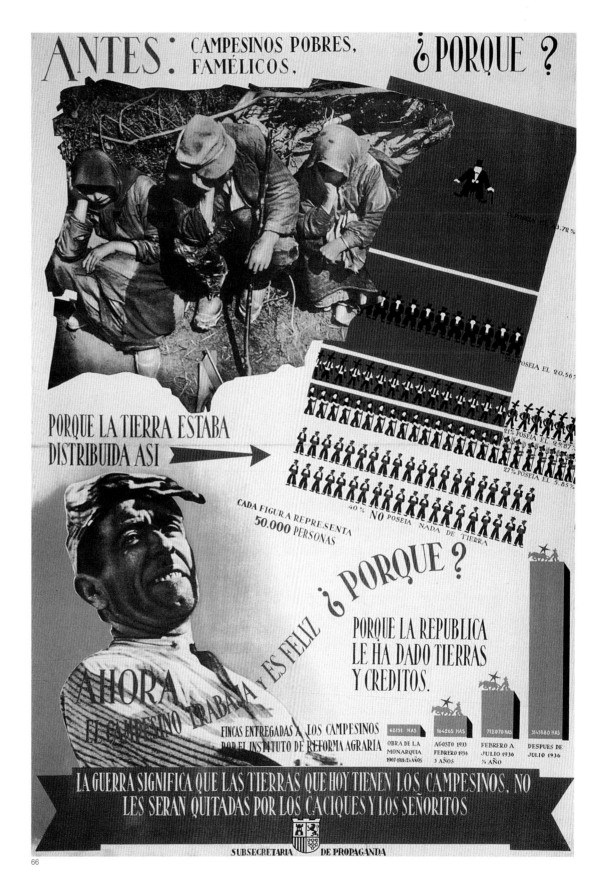

DAS VOLK WÄHLT LISTE 1

NATIONALSOZIALISTEN

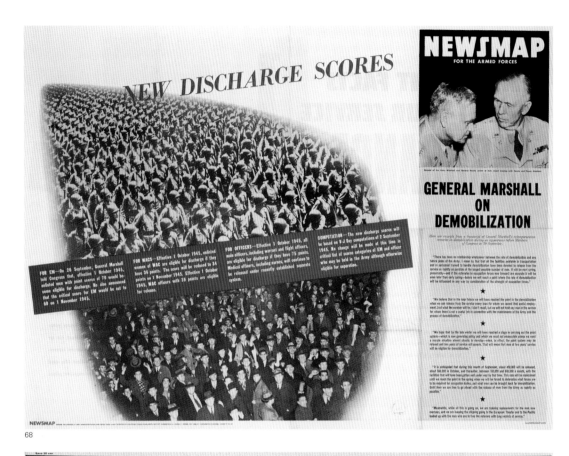

68

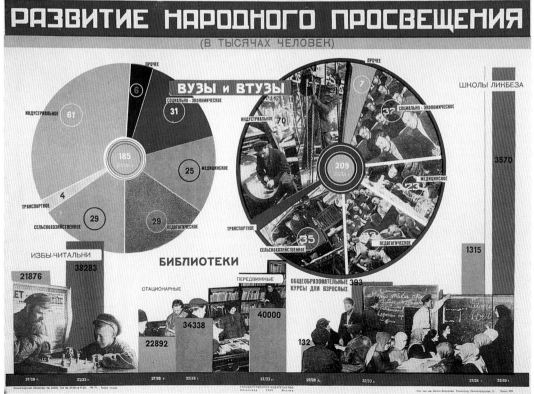

69

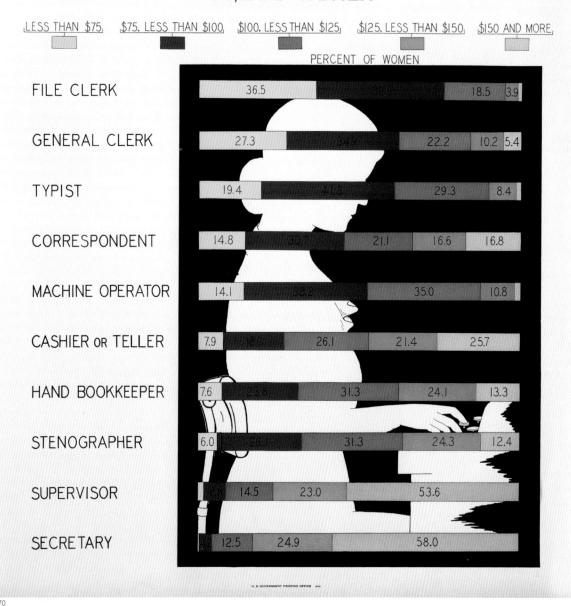

WOMEN'S BUREAU · DEPARTMENT OF LABOR · UNITED STATES OF AMERICA

WOMEN OFFICE WORKERS

MONTHLY SALARY RATE BY OCCUPATION
40,209 WOMEN

	LESS THAN $75	$75, LESS THAN $100	$100, LESS THAN $125	$125, LESS THAN $150	$150 AND MORE

PERCENT OF WOMEN

Occupation	LESS THAN $75	$75, LESS THAN $100	$100, LESS THAN $125	$125, LESS THAN $150	$150 AND MORE
FILE CLERK	36.5			18.5	3.9
GENERAL CLERK	27.3	34.9	22.2	10.2	5.4
TYPIST	19.4	41.3	29.3	8.4	
CORRESPONDENT	14.8	30.7	21.1	16.6	16.8
MACHINE OPERATOR	14.1	38.2	35.0	10.8	
CASHIER OR TELLER	7.9	18.9	26.1	21.4	25.7
HAND BOOKKEEPER	7.6	23.6	31.3	24.1	13.3
STENOGRAPHER	6.0	26.1	31.3	24.3	12.4
SUPERVISOR	8.8	14.5	23.0	53.6	
SECRETARY		12.5	24.9	58.0	

U. S. GOVERNMENT PRINTING OFFICE

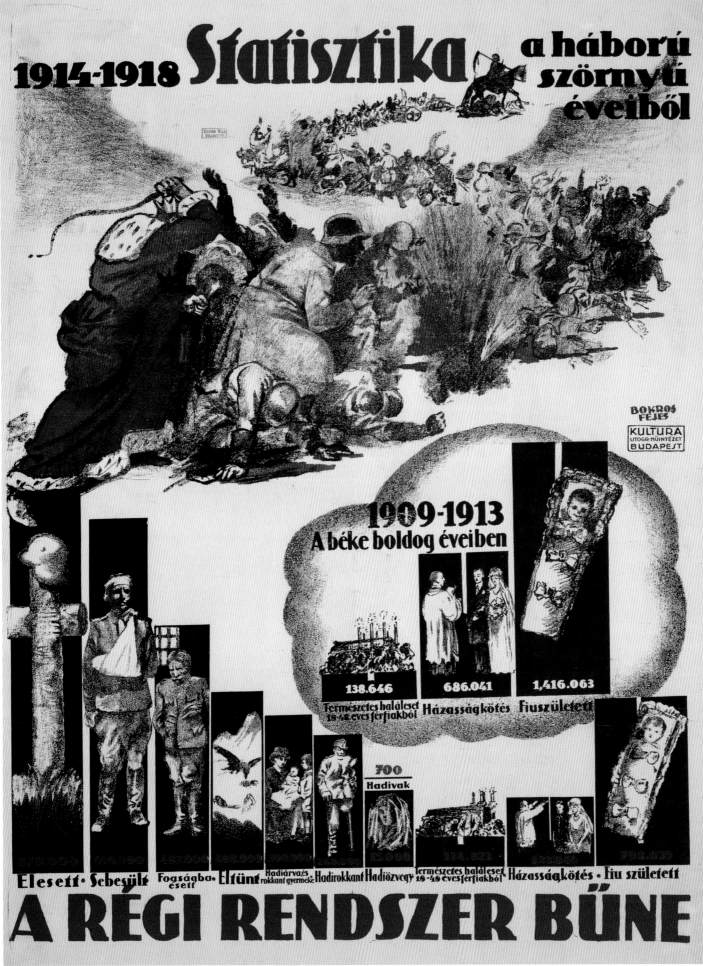

"While all our ancient beliefs are tottering and disappearing, while the old pillars of society are giving way one by one, the power of the crowd is the only force that nothing menaces, and of which the prestige is continually on the increase. The age we are about to enter will in truth be the *era of crowds.*" So wrote the French sociologist Gustave Le Bon just before the turn of the twentieth century and the era in question was one that interwove new forms of mass-based politics with industrialization and mass communications. Industrialization played the decisive role in covering the globe with networks of cities inhabited by millions of statistical individuals. Mass-communications media, from broadsides to newspapers and magazines to film, radio, and television, provided a virtual place of assembly and exchange in a world where traditional forms of human connection had been sundered by topographic and social mobility, the pace of change, and the money economy. Political posters are among the protagonists of the industrial metropolis and of the new world of mass communications. They are artifacts of the age of industry, multiples that speak to the multitudes in the image of the multitudes. Printed commercially on industrial paper with cheap industrial inks, posted simultaneously all over cities and, often, all over entire nations, political posters communicate under pressure from the million other distractions provided by modern life. They are designed to make a quick impact and then to move on; not to last, but to serve as weapons on the wall.

72
Artist unknown
English Christmas Greeting to the Serbian People, 1943–44 (?)
37¹/₄ x 24¹/₂ in.

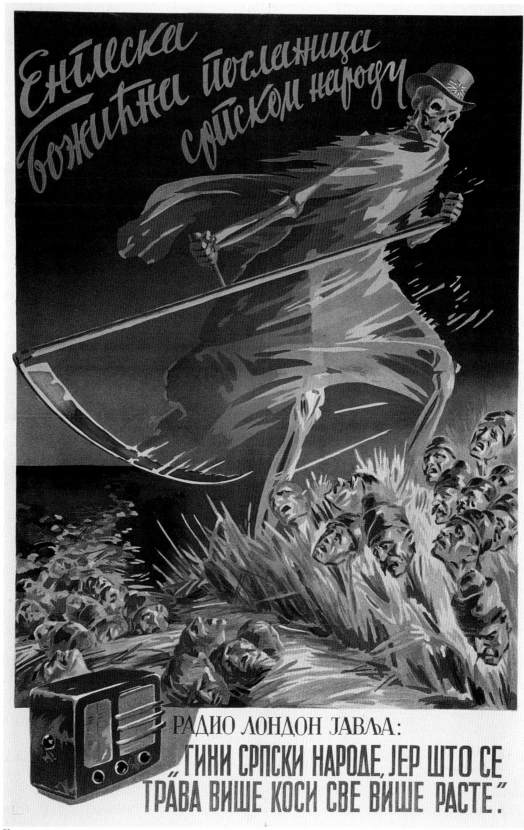

72

73

Philippe Henri Noyer
National Radio, 1941
64^{1}/$_{4}$ x 47^{3}/$_{8}$ in.

74

Ans van Zeyst
Radio Television, 1951
Gouache, ink, and graphite on paper,
5 x 3 in.

73

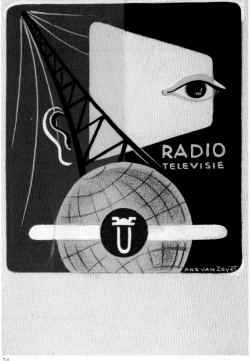

74

75
Leonid
*All of Germany Hears the Führer with the
People's Receiver*, 1936
47 x 33¹/₄ in.

76
Max Spielmanns
Traitor, 1944
26 x 19 in.

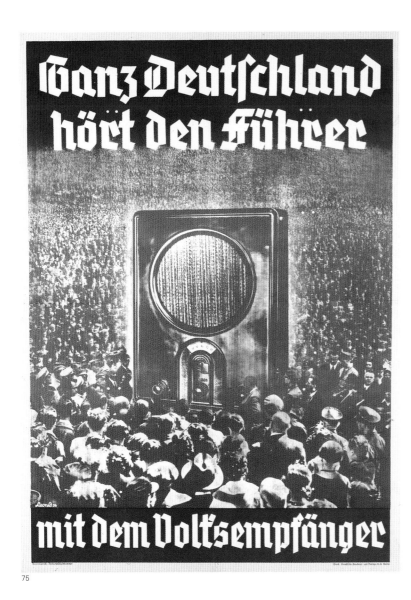

75

76

Oreste Gasperini
How One Becomes a Teacher of Physical Education, 1938
Photomechanical print, 27⁵/₈ x 39¹/₂ in.

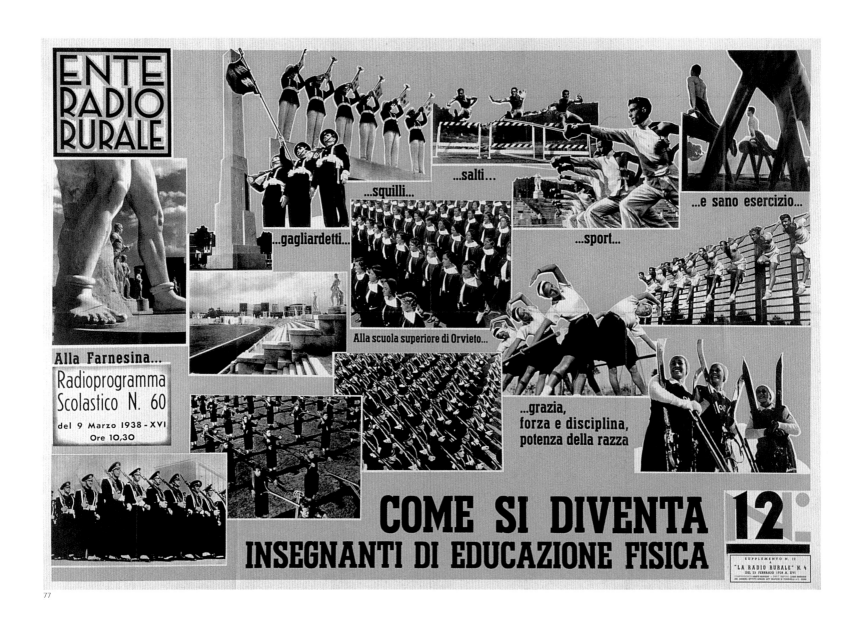

77

78

Artist unknown
The SA Calls on You Too to Join Its Forces,
early 1940s
33 x 21 in.

79

Pokras
For Our Own—For Our Allies, 1942–45
17$^1/_8$ x 11$^1/_4$ in.

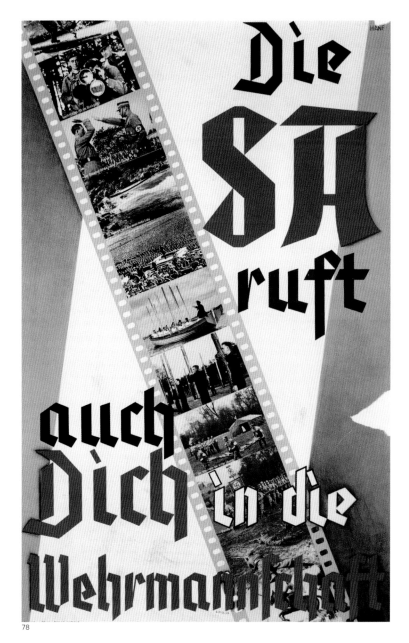

78

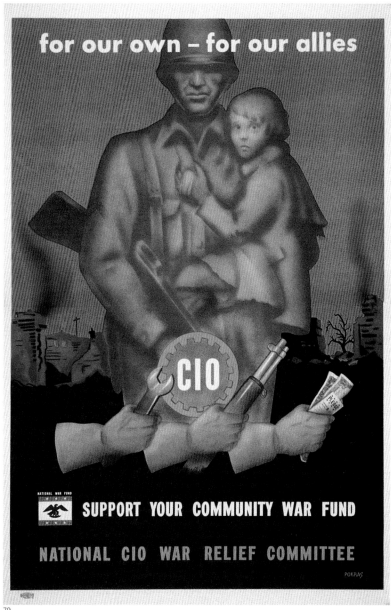

79

80
Jean Carlu
America's Answer! Production, 1941
30⅝ x 40⅜ in.

81
IZORAM Collective
Let's Crush the False Shock Workers, 1931
27½ x 41 in.

Opposite
82
Gustav Klucis
*1 May: To the Battle for the Five-Year Plan,
for Bolshevik Speed, for the Defense of the
USSR, for World October*, 1931
40¾ x 28¾ in.

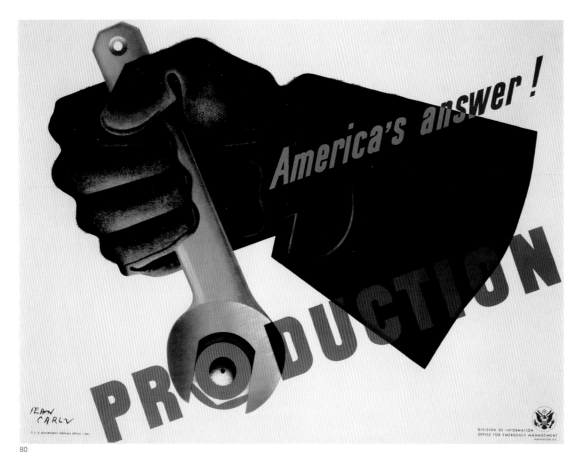

80

81

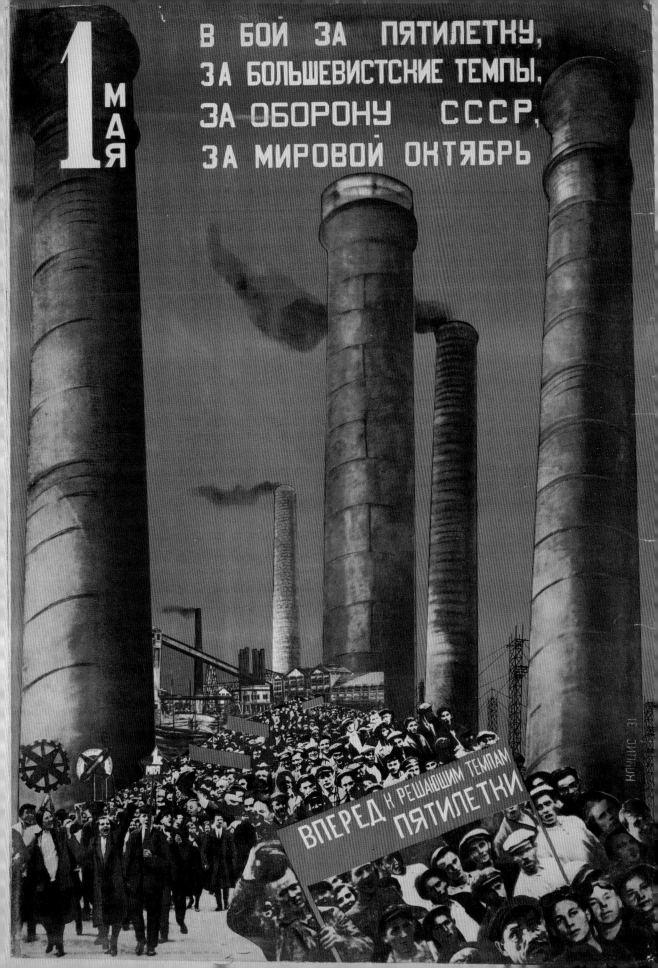

Kill Counts

The very sociopolitical, economic, technical, and environmental conditions presupposed by modern societies also create the preconditions for mass death. Whether due to natural disasters, political acts, or mechanized war, the dark flipside of the heroic image of marching crowds of citizens expressing their opinions or defending their rights in the public squares of the modern metropolis, is represented by the mass grave. Mass death is a constant in the era of crowds. From the heads heaped under guillotines in 1792 to the vast tangles of bodies
in the trenches of Auschwitz to the disfigured hordes of Rwanda's killing fields, the gravity of the event, its importance and newsworthiness, are measured on the basis of kill counts.

Artist unknown
Bolshevik Freedom, 1920s
$42^{7}/_{8}$ x $31^{1}/_{8}$ in.

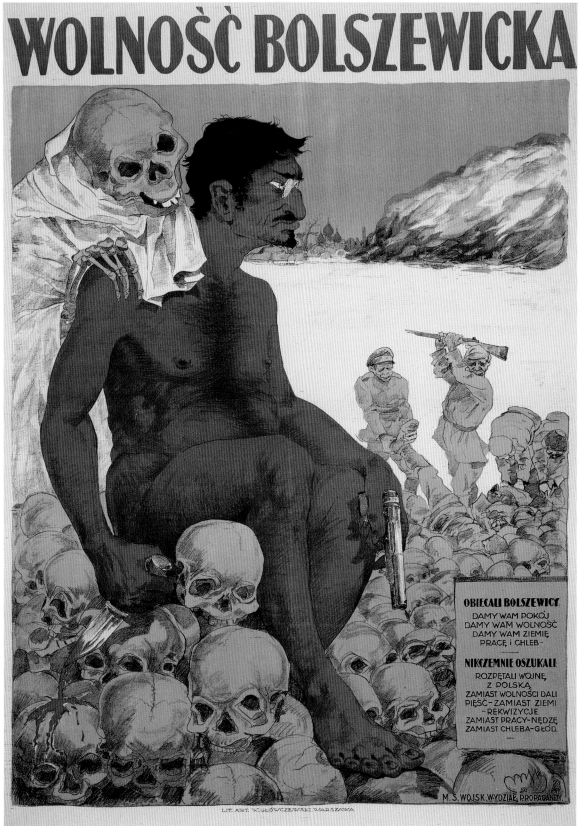

83

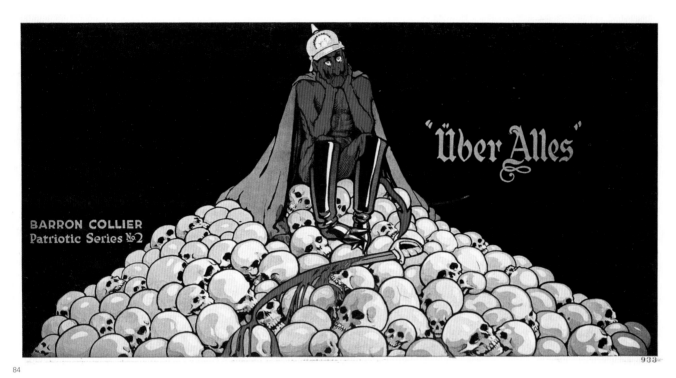

84

85

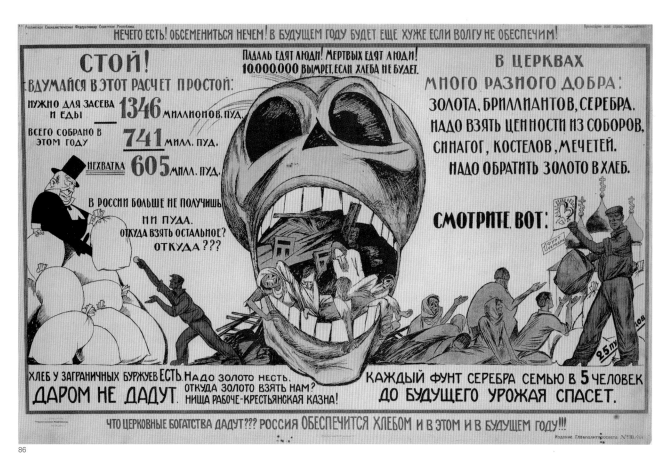

86

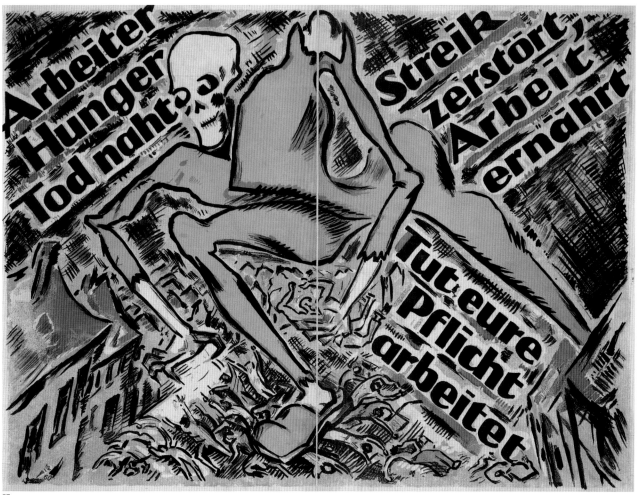

87

THE POWER OF AN AWAKEND NATION IS VICTORIOUS OVER ALL THE ARMS OF THE SUPERPOWERS .

〈IMAM KHOMEINI〉

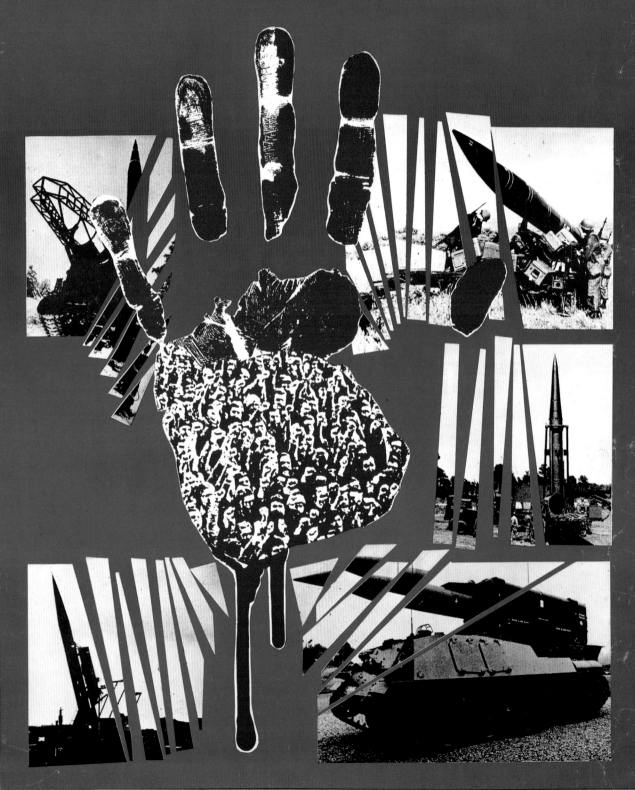

ISLAMIC REPUBLIC OF IRAN
MINISTRY OF ISLAMIC GUIDANCE

89
Artist unknown
This Is Our Only Vietnam Deadline,
early 1970s
22 x 17 in.

Opposite
88
Artist unknown
*The Power of an Awakened Nation Is
Victorious over All the Arms of the
Superpowers—Imam Khomeini,* early 1980s
28 x 20 in.

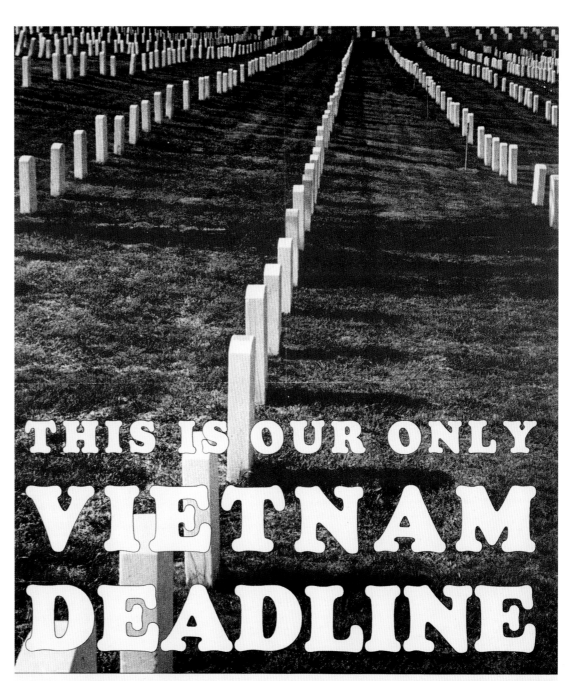

89

Totems

In the course of the nineteenth and twentieth centuries new symbols, myths, and invented traditions accompany the emergence of multitudes as the protagonists of modern public life and overwhelm local habits or centuries-old practices. Among such innovations are the cult of flags, party symbols or acronyms, national personification allegories (Uncle Sam, Lady Liberty, Britannia, and Marianne), anthems, holy books (Mao's red book), national fabrics (Scottish plaids, Ghanaian kente cloth), and sacred oaths (the Pledge of Allegiance), all of which confer identity on communities within the framework of a secularized sacred. Not unlike their preliterate counterparts, modern totems presume that an ineradicable relation exists between the collectivity and a class of objects, artifacts and symbolic representations. The fate of the one hinges on the fate of the other. Their importance grows in times of war and social upheaval as a means to rally public opinion, quell dissent and division, and provide comfort. Images from the past, they represent promises regarding the future of the collectivity.

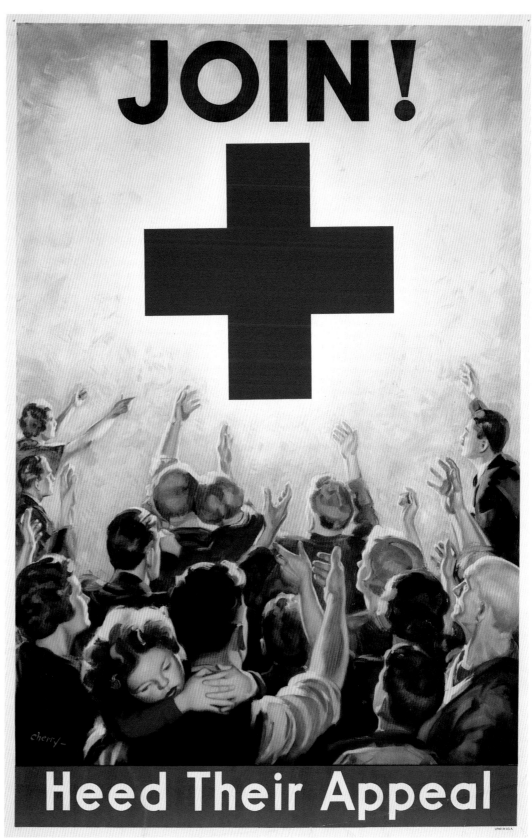

90

Artist unknown
*Loyal Compatriots of Hong Kong
and Kowloon, Arise and Resolutely Fight
Back the Provocations of British
Imperialism!* 1967
21³/₈ x 27¹/₈ in.

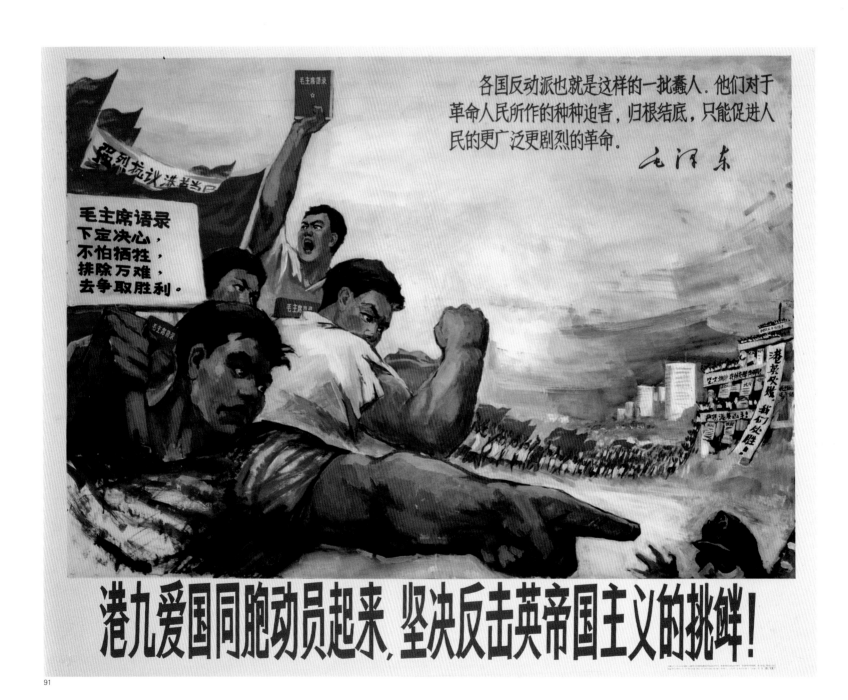

91

92
Artist unknown
The Free Association of German Unions.
Over One Million Individuals Have Freely
Joined for the FDGB, 1946
34 x 24 in.

93
Artist unknown
KPD SPD Unity Guarantees Reconstruction!
1946 (?)
23 x 16 in.

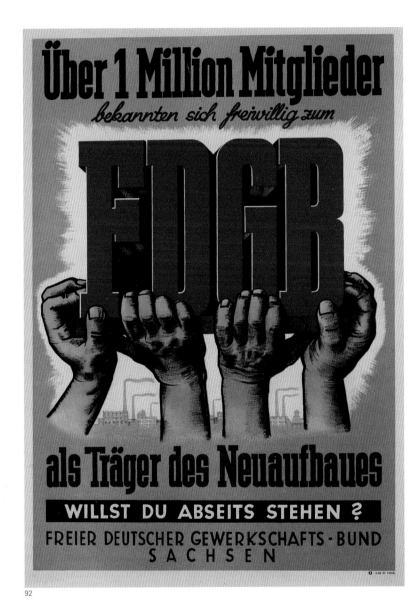

92

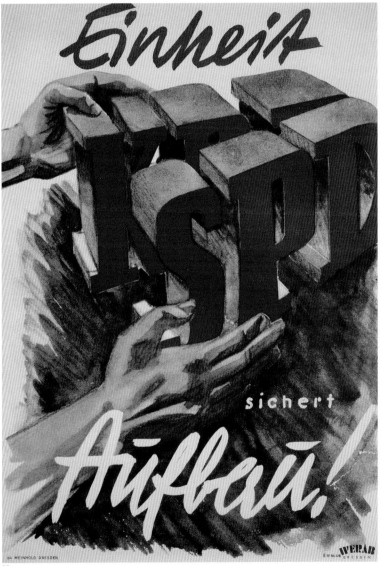

93

94
Francisco Rivero Gil
Orders from the P.O.U.M. until the End!
1937
$39^3/_8$ x $27^3/_8$ in.

95
Bohumil Štěpán
*United We Will Fulfill the Governmental
Program*, 1945
$36^1/_2$ x $24^3/_8$ in.

Opposite
96
Septimus Edwin Scott
*National Service. Defend Your Island
from the Grimmest Menace that Ever
Threatened It*, 1917
40 x 30 in.

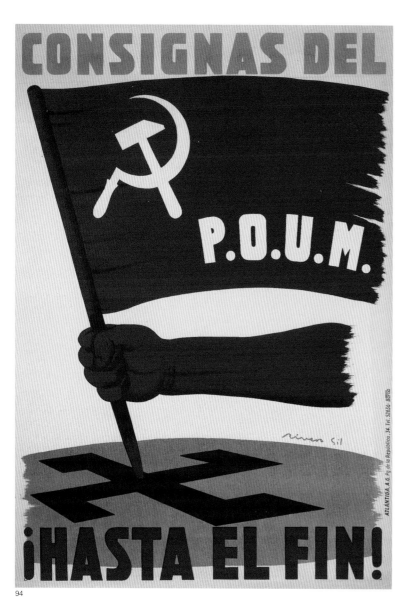

94

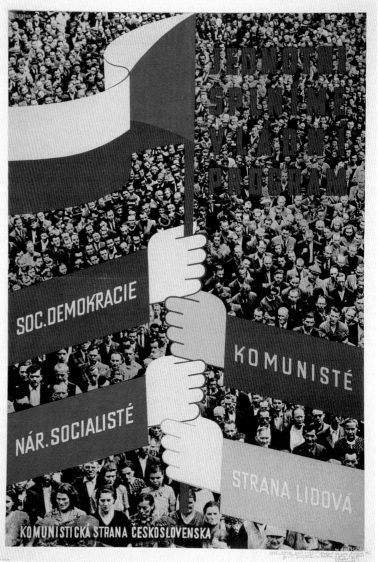

95

NATIONAL SERVICE

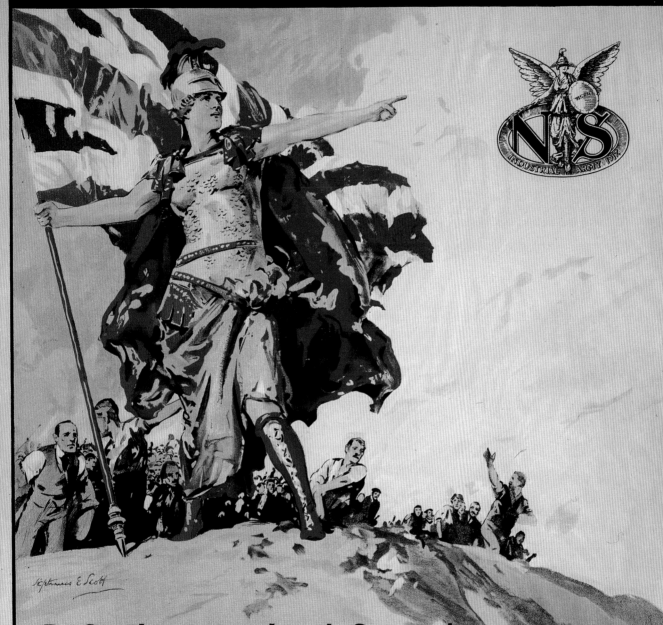

Defend your island from the grimmest menace that ever threatened it.

— DAVID LLOYD GEORGE.

Every man from 18 to 61 should ENROL TO-DAY

Forms for offer of Services may be had at all Post Offices, National Service Offices and Employment Exchanges.

SERIES B 8

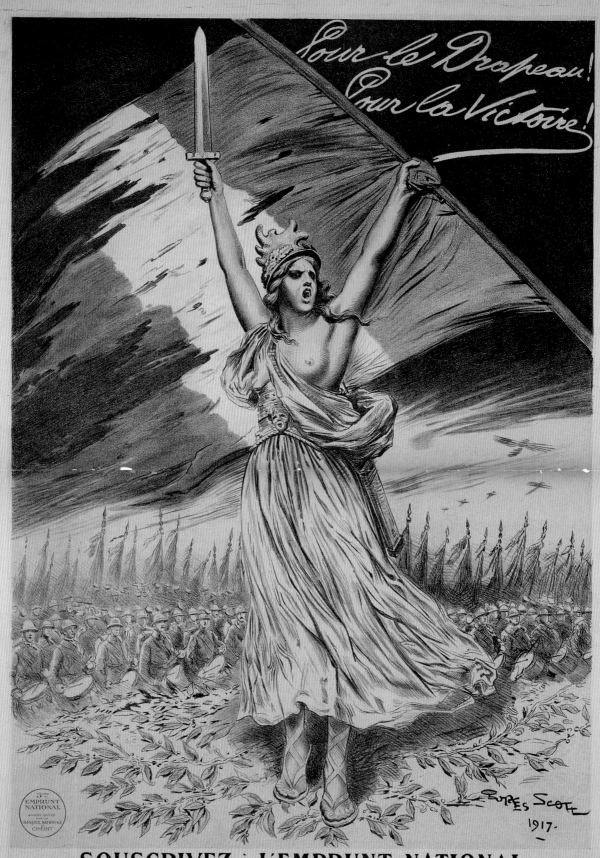

Pour le Drapeau!
Pour la Victoire!

EURES SCOTE
1917.

SOUSCRIVEZ à L'EMPRUNT NATIONAL
LES SOUSCRIPTIONS SONT REÇUES A PARIS ET EN PROVINCE
À LA
BANQUE NATIONALE DE CRÉDIT

VISA_ N° 9.498

98

99

Mass Leaders and Mass Deceivers

Divine descent, aristocratic blood, the mere possession of superior brute force are no longer sufficient to grant legitimacy to leaders in the era of popular sovereignty. Rather, the leader's legitimacy depends on his ability to portray himself as emanating from and belonging to the multitudes. The result is a paradox. On the one hand, the leader must be one of the crowd—the person in the street, a face in the crowd; on the other, this individual must become the glue that binds the body politic together, the face of the revolution, the nation's head, a transcendental being endowed with superior vision and communication skills that permit the leader to shape the multitude into his own image. The paradox of the mass-produced superior individual yields a variety of solutions in twentieth-century political art. Sometimes the leader is pictured hovering above the masses he represents; sometimes he figures as their literal head; sometimes his visage emanates from out of a multitude that has mysteriously assumed his shape. The graphic sleight of hand leaves unresolved the deeper question of whether the equation of the leader with the multitude is genuine or the product of fakery that does violence to the popular will.

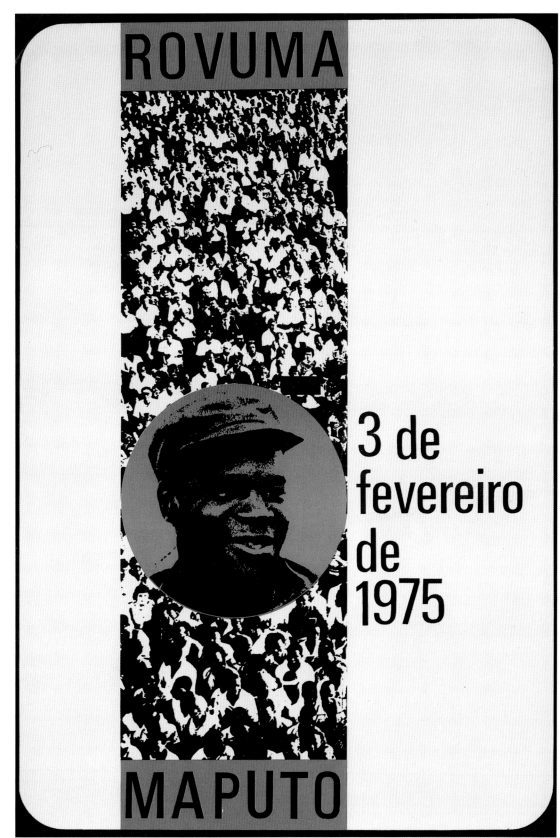

100

1934·XII

SÌ

ROMA 301.403 • AGRIGENTO 103.162 • ALESSANDRIA 218.289 •
ANCONA 78.107 • AOSTA 70.550 • AQUILA 88.695 • AREZZO 77.231 •
ASCOLI PICENO 65.566 • AVELLINO 112.656 • BARI 170.078 •
BELLUNO 58.719 • BENEVENTO 58.668 • BERGAMO 143.164 •
BOLOGNA 190.976 • BOLZANO 47.985 • BRESCIA 175.996 •
BRINDISI 59.692 • CAGLIARI 90.903 • CALTANISSETTA 56.495 •
CAMPOBASSO 99.205 • CATANIA 138.057 • CATANZARO
132.969 • CHIETI 81.603 • COMO 108.685 • COSENZA 136.098 •
CREMONA 99.461 • CUNEO 170.292 • ENNA 58.464 • FROSINONE
78.509 • FERRARA 87.465 • FIRENZE 243.226 •
FIUME 24.856 • FOGGIA 97.924 • FORLÌ
105.578 • GENOVA 221.321 • GORIZIA
54.464 • GROSSETO 50.025 • IMPERIA
43.423 • LECCE 113.923 • LIVORNO 57.805 •
LITTORIA 13.319 • LUCCA 84.281 •
MACERATA 61.396 • MANTOVA 111.289 •
MASSA CARRARA 46.140 • MATERA 32.410 •
MESSINA 126.394 • MILANO 543.598 •
MODENA 120.629 • NAPOLI 471.201 •
NOVARA 114.201 • NUORO 48.530 • PADOVA
126.766 • PALERMO 166.091 • PAVIA 137.803 •
PERUGIA 115.881 • PESCARA 47.949 •
PESARO 78.102 • PIACENZA 79.263 • PISA
93.333 • PISTOIA 58.683 • POLA 75.919 •
POTENZA 66.310 • RAGUSA 50.884 •
RAVENNA 80.611 • REGGIO CALABRIA
109.327 • REGGIO EMILIA 86.900 • RIETI
34.543 • ROVIGO 72.730• SALERNO 127.304 •
SASSARI 73.583 • SAVONA 84.396 • SIENA
71.858 • SIRACUSA 65.487 • SONDRIO
35.559 • SPEZIA 52.516 • TARANTO 62.749 •
TERAMO 60.978 • TERNI 512.490 •
TORINO 320.676 • TRAPANI 14.560 •
TRENTO 108.212 • TREVISO 140.277 •
TRIESTE 75.563 •UDINE 210.426 •VARESE
108.005 •VENEZIA 131.475 • VERCELLI
136.232 • VITERBO 57.801 • ZARA 3526

Elettori iscritti 10.526.504
Votanti (96.25%) 10.061.978
Favorevoli (99.84%) 10.045.477
Contrari (0.15%) 15.201

102
Arthur S. Mole
Living Portrait of Woodrow Wilson, 1918
Photograph, 19⅜ x 17 in.

Opposite
101
Xanti Schawinsky
1934-XII, 1934
Letterpress, 42⅞ x 30¾ in.

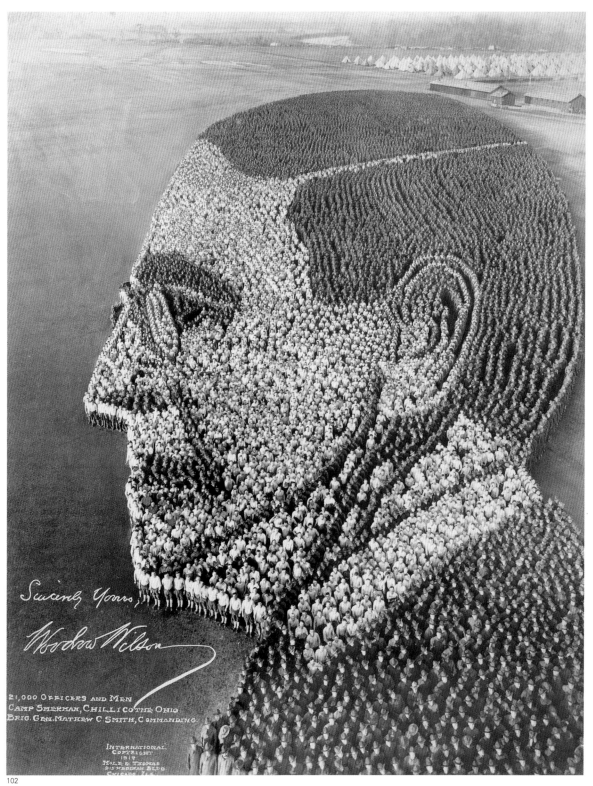

102

103
Andrzej Dudzinski
Lech Wałęsa, 1982
Etching, 16$^{1}/_{2}$ x 13 in.

104
Artist unknown
*1A in Our Draft. CIO Political Action
Committee*, 1944
11 x 9 in.

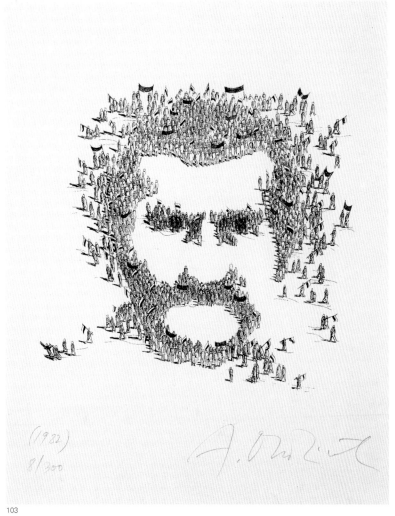

103

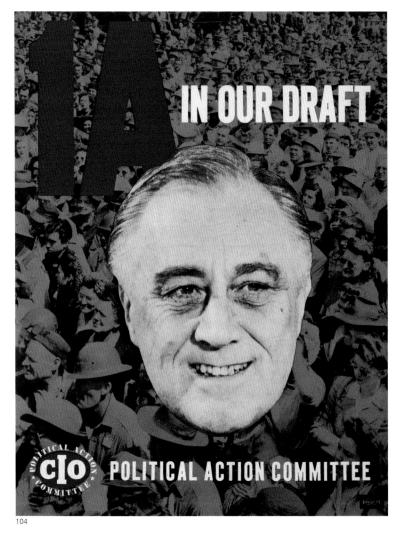

104

105

Otto Kummert
*His Name Will Live on through the
Centuries and So Will His Work*, 1982
22$\frac{1}{2}$ x 33 in.

106

Renato Bertelli
Continuous Profile of Mussolini, 1933
Bronzed terra-cotta, 11$\frac{3}{4}$ x 9 x 9 in.

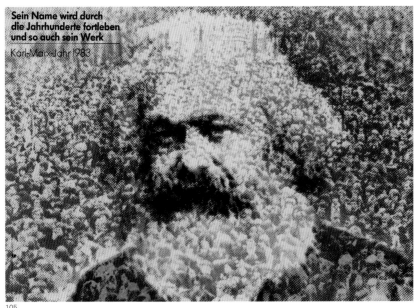

Artist unknown
Yes! Führer, We Will Follow You! 1934
34 x 24 in.

Opposite
108
Artist unknown
Lenin and Gandhi, 1927
33³/₈ x 21³/₈ in.

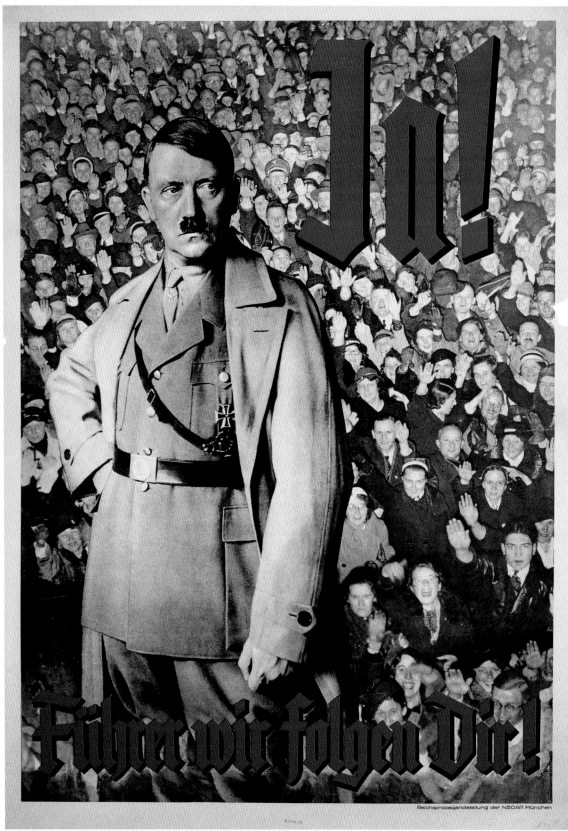

107

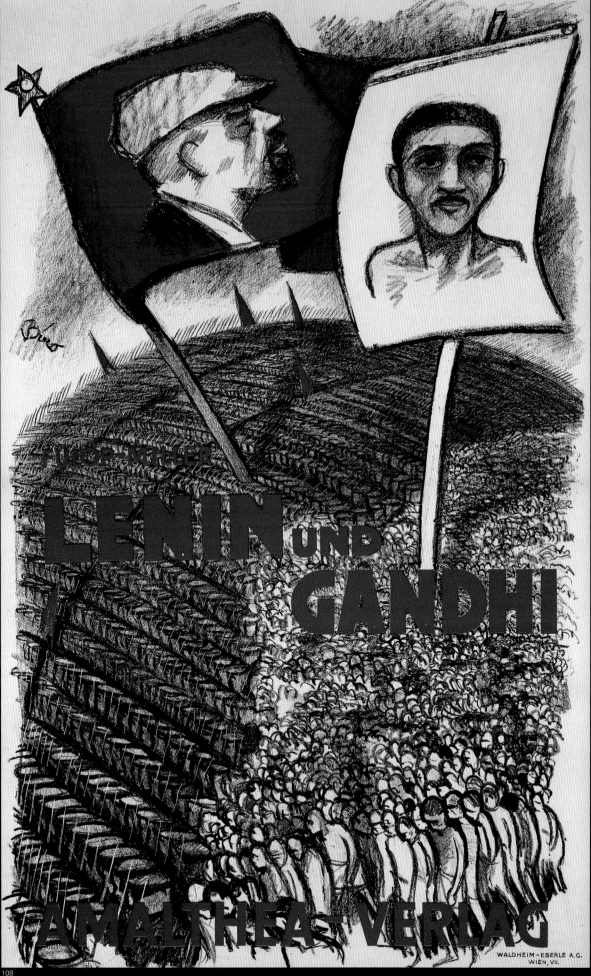

FÜLÖP-MILLER

LENIN UND GANDHI

AMALTHEA-VERLAG

WALDHEIM-EBERLE A.G.
WIEN, VII.

The Man of the Crowd

Standing opposite the modern mass leader, as if in the mirror, are the men and women who compose the crowd. A shift in focal length reveals these once antlike, anonymous beings as idealized human individuals who exemplify and embody the values of a revolution in progress. Like the leader who is their no-less idealized transcendental double, they are creatures of paradox. On the one hand, they appear as if standardized, stamped out of the same industrial mold, in harmony with the mass-produced tools, machines, and appliances that have transformed their everyday environment. Sometimes they literally don uniforms. On the other hand, they retain their individuality in the form of bodily particularities, marks of social class, signs of regional or national identity. Political-poster artists propose a synthesis between uniformity and individuality that, whether relying on illustrational technique, airbrushing, or photomontage, elaborates a myth of the collectivity's vitality that corresponds to the heroic myth of the modern mass leader. In Edgar Allan Poe's short story, "The Man of the Crowd" (1840), the daylong pursuit of an urbanite amid the streets of a modern city yields only a mystery. The man of the crowd proves unknowable in the end. He is an empty shell that the graphic artist can fill at whim so that the uniform makes the new woman or man and vice versa.

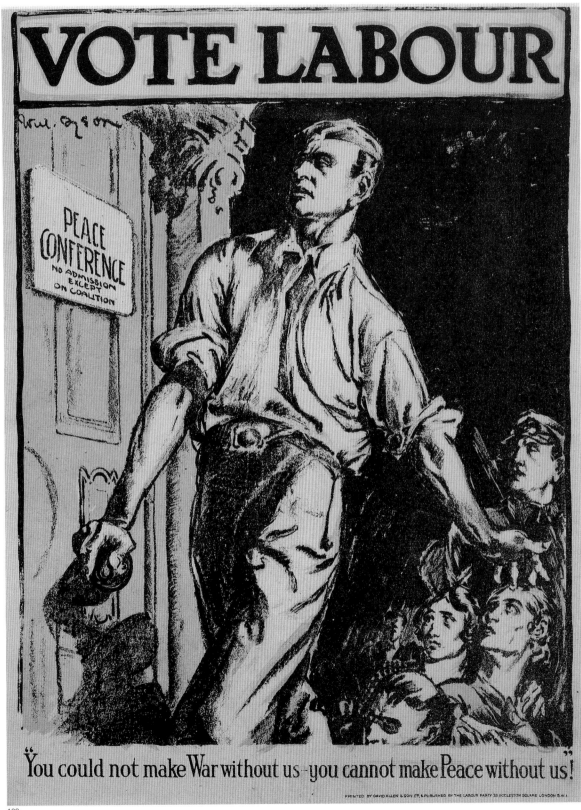

109

Opposite
111
Hans Schweizer [Mjölnir]
The Coordinated Will, 1930s
34 x 24 in.

110

Artist unknown
American Democracy / Private Enterprise—
And They Said Our System Was Crumbling!
1943
27¹/₈ x 20 in.

Opposite
113
Vasilii Elkin
Every Collective Farmworker, Every
Brigade, Every MTS Must Know the Plan
for Bolshevik Sowing, 1931
40³/₄ x 28⁷/₈ in.

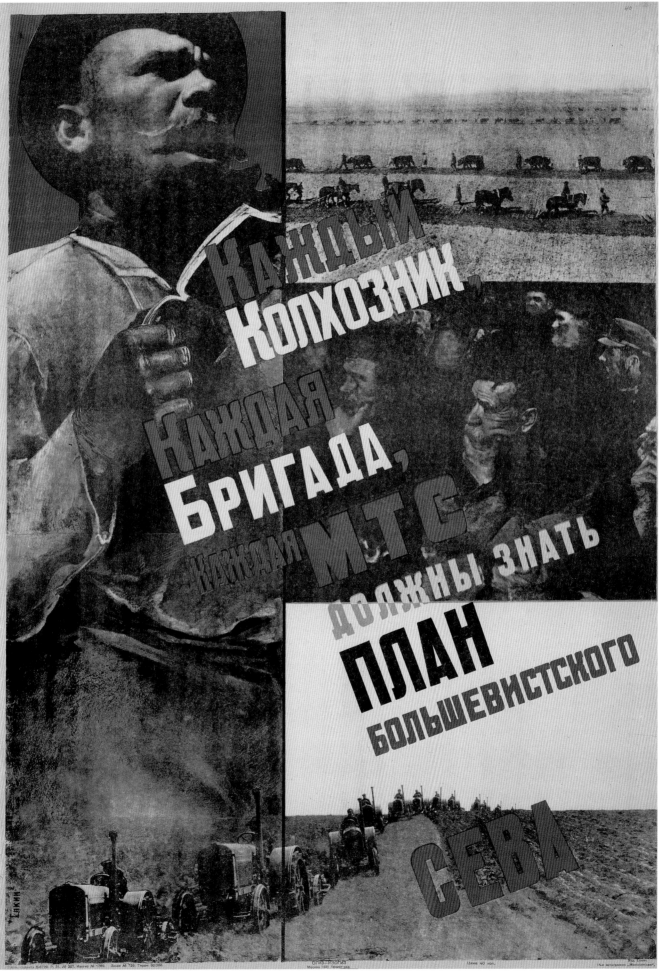

КАЖДЫЙ КОЛХОЗНИК, КАЖДАЯ БРИГАДА, КАЖДАЯ МТС ДОЛЖНЫ ЗНАТЬ ПЛАН БОЛЬШЕВИСТСКОГО СЕВА

Opposite
114
Viktor Klimashin
USSR Agricultural Exhibition 1939, 1939
40 x 26³/₈ in.

115
Lester Beall
A Better Home, 1941
Lithograph and screenprint, 40 x 29⁷/₈ in.

116
Attributed to Bohumil Štěpán
*West Czechoslovak Communists Will
Donate Half a Million Hours of Work to
the Republic*, 1945
36¹/₄ x 26¹/₈ in.

115

116

After the Crowd

If modernity is the era of crowds, as Gustave Le Bon famously declared, is this still true in today's information-based society with its proliferation of virtual forms of assembly? The rallying multitude and political posters have hardly vanished as features of contemporary political life, particularly in developing countries. To what degree do they serve as the pillars on which are constructed contemporary notions of political persuasion and action? Has the modern model of politics built on the literal physical massing of bodies in public places and the performance of symbolic marches in real time and space been superseded by a new model based instead on spectacular gestures shaped by and for electronic media: a model that relies on indirect and asynchronous forms of presence, organization, and participation?

Whatever the case, the first signs that political posters might no longer channel the ebbs and flows of future revolutionary tides began to surface in the early 1970s. The decade in question represents a golden age of political-poster art thanks to the abundance of contestatory movements spawned by it. Yet the period also inaugurates practices of ironization, parody, and pastiche that establish a firm equation between propaganda and kitsch.

117
Philippe Grach [Phili]
Freedom, 1944
45 x 30 in.

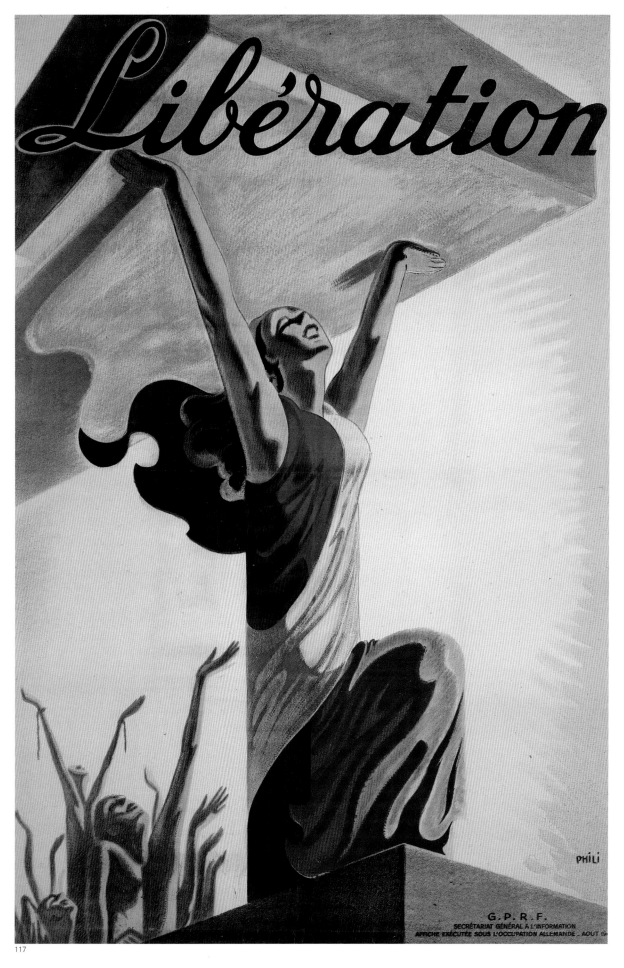

117

118
Andy Warhol
Mao Tse Tung, 1972
Screenprint, 36 x 36 in.

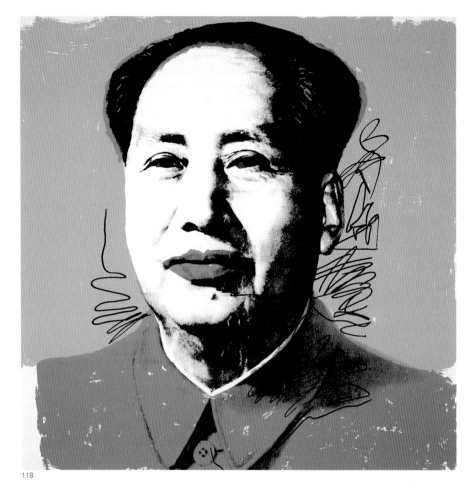

118

119
Andy Warhol
Mao Tse Tung, 1972
Screenprint, 36 x 36 in.

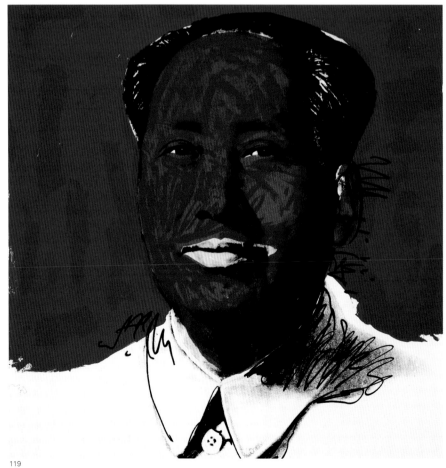

119

120

Critical Apparatus

Annotated Entries

The March

1

Bogdan Nowakowski (1887–1945)
Poland
Look Where the Socialists Are Leading the People! (*Patrzcie dokąd prowadzą naród socjalisci!*), mid-1920s
39⅝ x 28½ in.
Hoover Institution Archives

• This poster makes a striking visual appeal to ethnic Poles to reject political and social opposition to the nationalist regime established after the defeat in World War I of the three partitioning powers, Austria-Hungary, Germany, and Russia. The crowd at its center represents the Polish people—young and old, men, women, and children—dressed in national costumes (the red striped pants tucked into high black boots typical of the central Lowicz region worn by one of the falling men; the close-fitting velvet coat of the Polish nobility on the figure directly above him). The crowd depicted in the center is herded into an abyss by shadowy red-clad figures brandishing whips in one hand and red banners bearing the initials of opposition political parties in the other (PPS, Polish Socialist Party; SD, Democratic Party; BBWR, Nonparty Bloc for Cooperation with the Government).

The "socialists"—here a blanket term describing the opposition and connoting Bolshevik sympathies—are bankrolled by the three figures in the foreground. Reveling at the demise of the Polish nation, each embodies an ethnic stereotype. According to a 1931 census, ethnic Poles made up 68.9 percent of the total population of Poland. The sturdy figure on the right in a bloodied peasant shirt and felt boots represents Poland's Ukrainian (13.9 percent) and Belorussian minorities (3.1 percent). The two men on the left, one in a characteristic German military helmet and the other in a yarmulke and prayer shawl, stand for Poland's Germans (2.3 percent) and Jews (8.7 percent).

The entire scene is reminiscent of artistic renderings of the Last Judgment, and its message is clear: both the political opposition and Poland's ethnic minorities embody dark forces inimical to nationalism. Ethnic Poles are exhorted to support the regime before it is too late. At a time when both the city (evoked by factory smokestacks on the left) and the countryside (trees and silhouettes of village houses on the right) were suffering economic hardships, serious tensions divided the state authorities from the masses and the dominant Polish population from the national minorities. This poster appears as a government-endorsed attempt to unify the country while denigrating the ethnic minorities.
Margarita Nafpaktitis

2

Georgii Kibardin (1903–1963)
Union of Soviet Socialist Republics
Let's Build a Squadron of Dirigibles in Lenin's Name (*Postroim eskadru dirizhablei imeni Lenina*), 1931
40¾ x 28⅞ in.
Published by Central State Publishing House and State Publishing House for Art (OGIZ-IZOGIZ), Moscow and Leningrad, authorized by Glavlit, the state censorship authority
Hoover Institution Archives (RUSU1424)

• The successful launch of the Graf Zeppelin in Germany in 1928 intensified the worldwide craze for airships. Not to be left behind, the Soviet Union proposed the immediate construction of 425 rigid dirigibles, inviting the famous Italian builder and Artic explorer Umberto Nobile to Moscow to direct its vast undertaking. While the engineers set to work or at least tried to—the requisite materials and skilled labor were both in devastatingly short supply—an equally vast media campaign was begun to solicit funds to pay for the project. Artists played a central role in this media campaign, especially those working in the rapidly expanding domain of graphic design. Posters featuring Soviet dirigibles were issued in massive editions of twenty thousand or more, while postcards circulated in the millions, often bearing special-issue stamps.

In most of these mass-circulation images a single airship is represented in elevation, its vast length aligned horizontally to the ground. *Let's Build a Squadron of Dirigibles in Lenin's Name* is distinctive in that it conjoins two contrasting points of view. On the one hand, a dazzling spectacle is presented in worm's-eye view: seven gigantic dirigibles—the Stalin, the Lenin, the Old Bolshevik, the Pravda, the Collective Farmer, the Klim[ent] Voroshilov (the head of the Red Army), and the Osoaviakhim (the acronym for the All-Union Association for the Promotion of Aviational and Chemical Defense—loom overhead in a golden-red dawn sky. None has yet been built. Before the fleet stands an airship mooring tower, another marvel of modern engineering. The Soviet leader Vladimir Lenin, who had died seven years earlier, gestures with outstretched arm as if summoning forth the dirigibles. By skewing the conventionally perpendicular axis of the pictorial field, the designer conjures for the viewer a swirling sensation. But we are interrupted by a crowd presented in elevation at the bottom of the poster. Marching directly toward us, its members are waving, laughing, smiling. A few gaze skyward, but most look forward to share with us their collective enthusiasm. "Let's build a squadron of dirigibles in Lenin's name," their banner shouts.

The designer also plays provocatively with the poster's text. While its upper band is held aloft by marchers at left and right, its top corners spill over into the margins of the sheet itself, thereby disrupting the conventional delimitation of diegetic space (the marching crowd) from the graphic medium of its representation (photolithography). This disruption is accentuated in the middle and lower bands of text, which are not anchored in the fictional world of the poster. The poster thereby involves its viewer through two different modes of agitational speech—that of the depicted rally and that of the mechanical reproduction—with the ultimate objective of securing a financial contribution to this massive construction effort in Lenin's memory. (To this end, the state bank account number of the Lenin Squadron Fund is provided in the upper-left corner.) In an appeal to the non-Russian segments of the Soviet population the Central State Publishing House and State Publishing House for Art (OGIZ-IZOGIZ) issued the same poster in Georgian, Ukrainian, and Belorussian.
Maria Gough

3

Artist unknown
United States
Buy War Bonds, 1942
40 x 30 in.
Printed by U.S. Government Printing Office, Washington, D.C.
Hoover Institution Archives (US1679)

• This unsigned poster was one in a series commissioned by the U.S. Department of the Treasury to increase citizen involvement in the war effort through the purchase of bonds. Modeled after its predecessors in World War I, the war-bond initiative was launched in 1941 by Treasury Secretary Henry Morgenthau, Jr. When it came to an end in 1946, eighty-five million Americans had invested a total of 185.7 billion dollars. Specific bonds were issued to support the army, the navy, and special forces.

The present example demonstrates the power of the U.S. armed forces on both the ground and in the air. In the foreground Uncle Sam, a figure closely identified with the early history of American political-poster art, leads his citizen army. The nineteenth-century icon of Yankee patriotism bears a staff in his hand; the American flag billows behind him against the sky. As in James Montgomery Flagg's 1917 *I Want You* army

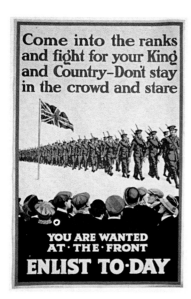

Fig. 5a
Artist unknown, United Kingdom
Come into the Ranks, 1915
26 x 45⅝ in.
Printed by Roberts & Leete, Ltd., London
Hoover Institution Archives (UK525)

Fig. 6a
Giuseppe Pellizza da Volpedo (1868–1907),
Italy
The Path of the Workers (*Il cammino
dei lavoratori*), 1898
Oil on canvas, 25⅞ x 45⅝ in.
Preparatory sketch for *The Fourth Estate*

recruiting poster, Uncle Sam points a finger. But here there is some ambiguity as to whom the gesture addresses. Is it at the enemy to be overcome? Or is it at the American public, summoned to join the war effort? Or is it at both?

Although it balances ground and air forces, the poster alludes to the key role assumed by bombers during World War II. Here the bombers are the legendary "Flying Fortresses," or B-17s. The most popular aircraft used in Army Air Service missions before the arrival of the B-24 Liberators, the B-17 was an aircraft familiar to many Americans and, therefore, likely to elicit patriotic feelings and inspire investment in bonds. *Wei-en Tan*

4

Artist unknown
People's Republic of China
Strengthen Yourself by Confronting High Waves and Mighty Winds! (*Dao dafeng dalang zhong qu duanlian*), 1966–69
30¼ x 42 in.
Hoover Institution Archives

• Chairman Mao Zedong was an enthusiastic swimmer. His 1956 poem *Swimming* (*Shui diao getou: You yong*) praised the building of the first bridge over the Yangtze River at Wuhan in Hubei Province and engaged China to accomplish the Three Gorges Dam project. More to the point of this poster, in a speech of 1963 Mao had urged the youth of the country to "strengthen themselves by confronting high waves and mighty winds." In 1966, to show he was strong enough to pursue the Cultural Revolution, which would throw legions of his young supporters against the "capitalist-roaders," high-ranking party officials who had questioned his fitness to lead after the great famines of the early 1960s, he swam the Yangtze again, a feat endlessly commemorated in photographs and the press.

One effect of the "high waves and mighty winds" slogan was to stimulate the building of swimming pools and the formation of swimming teams all over China. But the eager Red Guards of this poster are not taking the chairman's words in such a pedestrian way. Although armed and dressed for war, they stride with confidence into the waves of an allegorical sea. Those in the foreground launch themselves at the water at an impetuous forty-five degree angle. Some comrades in the background are in it up to their chins, at least one has begun the freestroke, but none seem to be wet. The red flags wave in profusion, as they did over farms and buildings across China, where revolutionary spirit proved a low-cost source of labor for

public works. It is the meeting of two great collective nouns, the People and the Sea. From the look on their faces, the People appear to be winning.
Haun Saussy

5

Artist unknown
United Kingdom
Step into Your Place, 1915
20 x 30 in.
Printed by David Allen & Sons, Harrow
Hoover Institution Archives (UK192)

• During the early years of World War I the Parliamentary Recruiting Office in London launched a relentless recruitment campaign for the British Armed Forces, taking full advantage of the possibilities inherent in the poster as a medium of mass communication. Several advertising strategies stand out, foremost among these the propagation of an ideal directly linking heroism with national defense. In itself this was not a new concept; as early as the seventh century B.C.E. the Spartan poet Tyrtaeus wrote, "it is a fine thing for a brave man to die … while fighting for his homeland." What we find in British recruitment posters, however, is this ideal translated to a graphic image designed for a mass audience and rendered in terms intelligible to a specifically British public.

Printed in an edition of ten thousand, *Step into Your Place* deploys Tyrtaeus's heroic ideal with elegance. The deceptively simple text conveys a command wrought with authority. It declares every British man's place to be foremost among the troops marching toward the front. The motion of men toward the horizon (or an established communal goal) features a slow transformation of individual civilians of differing classes and occupations into a unified column of marching soldiers. This pictorial strategy speaks of the underlying unity promulgated by the Parliamentary Recruiting Office: namely, regardless of one's station in civilian life, British nationality, or "the homeland," served to unify all in its defense.

Although the artist of this poster is unknown, we can see traces of his hand in such works as *Come into the Ranks* (1915), a contemporary color lithograph, printed by a different printer, that employs the same basic design (fig. 5a).
Sebastian de Vivo

6

Attributed to Iosif Ganf (1899–1973)
Union of Soviet Socialist Republics
Social Democracy and Fascism Are Two Links in One and the Same Chain of Capitalist Exploitation (*Sotsial-demokratiia i Fashizm—Dva zvena odnoi i toi zhe*

tsepi kapitalisticheskoi eksploatatsii), 1932
29 x 19½ in.
Published by Central State Publishing House and State Publishing House for Art (OGIZ-IZOGIZ), Moscow and Leningrad, authorized by Glavlit, the state censorship authority
Hoover Institution Archives (RUSU824)

• A united "red front" of hundreds of workers—male and female, young and old, black and white—march fearlessly toward a single capitalist (the top hat identifies his class position). In his gloved right hand he brandishes a pair of shackles, on the cuffs of which appear demonic caricatures of two of the main parties competing for power in Germany in the early 1930s: the Social Democrats and the National Socialists.

The chief ideological purpose of this poster is to drive a wedge between the interests, aspirations, and beliefs of the revolutionary proletariat and those of the various European parties of Social Democracy with which it might otherwise mistakenly align itself. Despite their common roots in Marxism, the Bolsheviks increasingly denounced the Social Democrats as reformist and not truly revolutionary, especially after the Bolshevik victory in Russia in 1917. At issue from the Bolshevik point of view were the Social Democrats' continuing efforts to secure electoral representation within existing parliamentary systems (rather than the overthrow of those systems), their emphasis on reforms within capitalism (and not its eradication), and their restriction of violent proletarian actions to defensive measures only. The denunciation of Social Democracy reached a peak under Joseph Stalin, who described it as but "the moderate wing of fascism."

During the 1920s and early 1930s Iosif Ganf became a well-published political caricaturist and satirist, contributing regularly to the journal *Krokodil* and daily newspaper *Pravda* in addition to designing posters for the state publishing houses. By placing the viewer behind the figure of the capitalist exploiter (and thus directly in the path of the approaching crowd), Ganf invokes a major historical precedent (fig. 6a) for his cartoonlike representation of the marching proletariat, Giuseppe Pellizza da Volpedo's panoramic *The Fourth Estate* (*Il quarto stato*, 1898–1901). *Maria Gough*

7

Lewis Rubenstein (1908–2003)
United States
Washington Hunger March (December 1932), c. 1933
Gouache, conté crayon, and graphite on paper, 19 x 10¾ in.
The Wolfsonian–Florida International

Fig. 7a
Lewis Rubenstein
Washington Hunger March (grisaille detail)

Fig. 7b
Lewis Rubenstein with Rico Lebrun
(1900–1964), United States
Washington Hunger March (detail), 1934
Fogg Art Museum fresco (no longer extant)

University, The Mitchell Wolfson Jr. Collection (TD1988.52.6)

• Posters are but one form of public art typical of "the era of crowds," as French sociologist Gustave Le Bon famously characterized the modern period. More traditional forms such as fresco painting also underwent a worldwide revival during the 1920s and 1930s, as exemplified by this study for a large-scale mural depicting the Washington Hunger March.

After Lewis Rubenstein returned to the United States from a year of studying fresco painting in Italy, where he examined such masterpieces as Luca Signorelli's Cappella Nova fresco cycle in Orvieto, he threw himself into social activism. The Great Depression had reduced many Americans to poverty, particularly workers and World War I veterans, giving rise to waves of marches on Washington—the "bonus" and "hunger" marches—many of which were met with police violence. The December 1932 march had begun in New York, but the demonstrators' trucks and buses soon reached racially polarized Wilmington, Delaware, where the police had revoked their permit to assemble. After a demonstration in which they marched down the streets chanting, "Negro and white unite and fight against starvation," they assembled at a Polish church, holding a meeting on its steps. As a woman activist addressed the crowd, the police stormed the church and launched the assault depicted in Rubenstein's eyewitness sketch. By the time the marchers reached the nation's capital, one week later, they found themselves outnumbered by the forces of order.

As suggested by the panel's classical framing and pair of grisaille panels (fig. 7a) depicting other moments in the Wilmington riot, Rubenstein sought to ennoble the struggles of ordinary workers by adapting formulae employed by Renaissance artists in presenting the lives of princes or saints. The sketch was incorporated into frescos realized in 1934 by Rubenstein and his collaborator Rico Lebrun for the Fogg Art Museum at Harvard (fig. 7b).
Jeffrey T. Schnapp

8
Nikolai Kochergin (1897–1974)
Union of Soviet Socialist Republics
*Ever Higher the Banner of Leninism—
The Banner of the International
Proletarian Revolution* (*Eshshe vyshe
znamia Leninizma—Znamia
mezhdunarodnoi proletarskoi revoliutsii*),
1932
42 x 29¼ in.
Published by Central State Publishing
House and State Publishing House

for Art (OGIZ-IZOGIZ), Moscow and Leningrad
Hoover Institution Archives (RUSU2309)

• With photomontage the favored medium for poster production in the early 1930s, the traditional lithography of this image is somewhat anachronistic, perhaps deliberately so. Designed by Nikolai Kochergin, an artist renowned for his many Russian civil war posters, *Ever Higher the Banner of Leninism* presents the bright red world of Leninism in stark contrast to the black underworld of capitalism, imperialism, and fascism. Above, row on orderly row of Soviet foundry workers, miners, mechanics, surveyors, accountants, electricians, textile workers, engineers, and architects—not only from Russia but also from the union's Central Asian republics—march into the ranks of the party. (The banner held aloft by the Promethean blacksmith leading the march reads: "Into the ranks of the VKP[b] [All-Union Communist Party (Bolsheviks)].") Guided by Lenin's outstretched arm and apparently infinite in number, this proletarian army is undaunted by the steep incline ahead. In the background are an orderly array of industrial work places: factories, mines, grain elevators, turbines, and machine-tractor stations. A cluster of silos, increasing in height from right to left and inscribed with the years 1930, 1931, and 1932, announce the rapid increase in Soviet productivity.

Below, Leninism's antithesis is fragmented into vignettes of economic chaos and colonial exploitation. In the metropolis the capitalistic economy is in crisis: the classical columns of the stock exchange (*birzha*), symbolizing the lawlessness of marketplace economics, appear to topple. Factories are closed. Workers go on strike, while an angry crowd bearing red flags and the tools of proletarian labor clash with mounted police and machine gunners outside a prison. Soldiers, accompanied by missile-mounted tanks, goose step behind a Nazi flag; an ecclesiastical figure gives the order for the execution of blindfolded prisoners. In the Far Eastern colonies of the imperialist nations natives are beheaded while a black-suited capitalist and colonial administrator calmly look on; in the tropical colonies locals are lynched or forced into slave labor.

The key motif in these vignettes is a little man in a yellow suit and bowler hat. In one instance he attempts to placate the crowd of demonstrators, in another he appears to aim a machine gun at a strike leader. Elsewhere he goose steps in unison with soldiers, mimics the clergyman's gesture, and joins those witnessing the beheading. On his suit jacket and flag appear the letters "SD," identifying him as a fig-

ure of Social Democracy. Kochergin thus puts his limited three-color palette to efficacious symbolic use: if red is the color of good and black of evil, yellow is that of cowardice. The poster asserts that the economics of Leninism and not those of the Social Democrats will secure the international proletarian revolution.
Maria Gough

9
Artist unknown
People's Republic of China
A Truly Great Wall (*Weida de
changcheng*), 1967
21⅜ x 30½ in.
Hoover Institution Archives

• One difficulty in the painting of crowds is that, apart from a few foreground figures, the more people a crowd contains, the more likely they are to become blurs and squiggles of color. Making a virtue of this shortcoming, the designer of this poster has turned the blur into a block. Rising high on the left, deep red, and seen as if from ground level, a phalanx of defenders in greatcoats has congealed into a single solid mass. Their expressions are identically stalwart. Headgear and equipment alone distinguish them: the soldier with helmet and bayoneted rifle; the cadre with starred cap, gun, and Little Red Book; the airman with earflaps and goggles; and more soldiers and cadres lined up toward the horizon. Red banners ripple behind them, and from celebratory balloons rising to the skies dangle banners with the messages: "Long live Chairman Mao!" "Long life to the victory of Chairman Mao's revolutionary line!" "Long live the victory of the Great Proletarian Cultural Revolution!" At lower than knee level, and dashed as if by an irresistible force toward the right-hand margin of the image, cower assorted cartoon-figure counterrevolutionaries: Uncle Sam waving his nuclear bomb, a ragged Chiang Kai-shek, Nikita Khrushchev with a pennant reading "Revisionism," and Mao's erstwhile colleague Liu Shaoqi, guilty of bourgeois deviationism and yet clutching a globe in fond dreams of world domination. The founder of the first Chinese Republic in 1911, Sun Yatsen, often complained that his compatriots were "a tray of sand," split apart by regional and family loyalties. The revolutionary army, here molten and recast as a many-headed rampart, demonstrates its might and invincibility by refusing even to lower its collective gaze to take in a clutch of pawky class enemies.

"The Great Wall" was a byname for the Chinese military, derived from speeches in which Mao warned troublemakers "not to damage our Great Wall" (challenge or divide

the army). In black typography the Red-Tasseled Spear Combat Unit, a group within the State Science and Technology Commission, is identified as the sponsor of this message. The original Red-Tasseled Spear was a guerilla group loyal to Mao in the Jiangxi Provincial Soviet of 1927; the reuse of the name affirms the Cultural Revolution's status as a "revolution within the revolution."

Haun Saussy

10

Georges Goursat [Sem] (1863–1934)
France
To Triumph, Subscribe to the National Loan (*Pour le triomphe souscrivez à l'emprunt national*), 1917
45 x 31 in.
Printed by Devambez, Paris
Hoover Institution Archives (FR428)

• In one of the iconic posters of World War I, the French army, spurred on by a vengeful angel, sweeps down on a cloud through the Arc de Triomphe on its way to the front. The arch, commissioned by Napoleon after his 1805 victory at Austerlitz, symbolizes French military dominance, reverberating with the triumph evoked in the poster's slogan.

The modern poster is in many ways a French invention, its political use dating to 1789. It was well established as a medium for propaganda by the end of the nineteenth century and enlisted in the war effort after the outbreak of hostilities in 1914. Since France had a conscription system in place, French posters had no need to enjoin their audience to enlist as soldiers. They instead entreated the public to subscribe to the national war loan. The first war poster in France was designed by Jules Abel Faivre in 1915 to sell subscriptions to the fund. Many others followed with considerable success (although the French, like the other European belligerents, nevertheless ended the war heavily in debt).

Known before 1914 as a talented caricaturist of the Parisian demimonde, Georges Goursat (who signed his work "Sem") parlayed his skill at exaggeration into war posters that plucked vigorously at the heartstrings of French patriots. The evocation of the triumphant Napoleonic army, descending tattered from the heavens, seeks to resurrect—quite literally—the glories of France's military past in the nation's present. Goursat's poster is remarkable for its play with the fluidity of the crowd—the soldiers streaming from the sky fall seamlessly into formation with the marchers below, all forming a flowing whole. The Napoleonic soldiers merge imperceptibly into the twentieth-century infantry moving

toward battle. At the same time the viewer's eye moves from the detailed individuals in the lower left to the undifferentiated mass at the far right. The individual seems to be produced only as a by-product of this endless stream, whose source—outside the frame and behind the arch—is apparently inexhaustible. The singularity of the individual soldier in the foreground, with his starkly outlined shadow, serves as a counterweight emphasizing the blurred edges and indistinct features of the collectivity.

Matthew Tiews

11

Ernest Hamlin Baker (1889–1975)
United States
For Every Fighter, a Woman Worker, 1918
42 x 28 in.
Printed by U.S. Printing and Lithography Company, New York
Hoover Institution Archives (US486)

• This poster is one in a series created for the Young Women's Christian Association as part of its involvement in the United War Work Campaign, an ecumenical fundraising cooperative initiated in the summer of 1918 at the request of President Woodrow Wilson and Secretary of War Newton D. Baker. The campaign not only promoted monetary contributions to relief organizations but also encouraged women to replace men in industrial jobs and to provide the goods necessary for war.

In *For Every Fighter* masses of women march together, forming not only the "second line of defense" but also the third, fourth, fifth, and on. In the foreground four women dressed as workers carry the tools of industry (a wrench and a hammer). Beyond the second row the figures become increasingly abstract so that they gradually merge into a streaming crowd. In the back rows, even the black of their hats fades into an infinite field of yellows and oranges, suggesting that the fusion yields a noble and beautiful collective cause.

Ernest Hamlin Baker designed at least two of the many posters created for the United War Work effort. After the war he went on to a distinguished career as a magazine illustrator and his covers for *Time* and *Fortune* magazines are especially well known.

Alda Balthrop-Lewis

12

Valentina Kulagina (1902–1987)
Union of Soviet Socialist Republics
1905—The Road to October (*1905 God— Put' k oktiabriu*), 1929
41 x 28½ in.
Published by Central State Publishing

House (OGIZ), Moscow and Leningrad, authorized by Glavlit, the state censorship authority
Hoover Institution Archives (RUSU1794)

• This poster proselytizes the Bolsheviks' view that the Revolution of 1905, the first mass uprising against the czarist regime, set the stage for 1917. "Without the 'dress rehearsal' of 1905," Vladimir Lenin wrote in 1920, "the victory of the October Revolution would not have been possible." At left, a sequence of images details the course of the 1905 revolution, which was sparked by Nicholas II's massacre of hundreds of workers demonstrating outside the Winter Palace in January 1905 (Bloody Sunday). As if stepping out of that important historical moment, five giant revolutionaries, the first carrying a banner with "1905" in its upper-left corner, lead the charge into the future, where three riflemen stationed behind a crenellated wall fire on a montage of photographic fragments signifying the detested Nicholas II. (An outline of the imperial crown is drawn over a photograph of the czar's head, which has been "beheaded" from a statue that a worker is in the process of dismantling.) The dynamism of revolutionary history is suggested by the spiraling of the poster's elements around the point of convergence, just below the front striding figure's left heel.

Characteristic of Valentina Kulagina's most accomplished posters of the late 1920s and early 1930s is the signature conjunction of drawn and photographic elements. Typically her drawn elements are monumental figures rendered in a postcubist, mechanomorphic style. Initially trained as a painter at the Higher State Art and Technical Institute (VKhUTEMAS), Kulagina turned to photomontage in 1925. Like several other Russian artists, Kulagina joined the October group in 1928 and executed many posters for the state publishing houses through the 1930s.

Maria Gough

13

János Tábor (1890–1956)
Hungary
Red Soldiers Forward (*Vörös katonák elöre*), 1919
50 x 37 in.
Printed by Kunossy Lithography Studios, Budapest
Hoover Institution Archives (HU4133)

• Produced in the turbulent revolutionary year of 1919, *Red Soldiers Forward* illustrates a common theme of the era, the forward march and inevitable triumph of the Red armies. With its powerful, stylized graphics, the poster embodies the armed

struggles of the Hungarian Soviet. Two preternaturally muscular figures, one carrying a rifle and the other a large red banner, lead a crowd, cursorily represented by bayonets and banners, forward and to the left, a direction emphasized by the cut-off forward tip of the flag.

While both image and message are relatively simple, Tábor creates a powerful sense of urgency and flow through color and form. Red prevails, the color not only of the banner dominating the page but also of the rifles and factory windows in the rear. Symbol of Soviet power, red seems to flow from the banner through the staff and the rifle into the factories, a metaphor perhaps for the Soviet vision of the future.

The repetition of shapes and angles also invests the simple image with a subtle but powerful dynamism. The exaggerated musculature of the two lead figures is repeated in the shape of the red banner, which is tilted at the same angle as the figures. The rifle, banners, and bayonets held by the crowd all repeat that tilt and strengthen the sense of power and motion toward the left. Even the exaggerated accent of the artist's name, by presenting a small line in the opposite direction, further emphasizes the leftward tilt of the image.
Sam Albert

14

Artist unknown
Western Sahara, former Spanish Sahara
The Martyr El-Basheer El-Ahlawi, Shot Down on 8 March 1974. Martyr for a Free and Independent Sahara. Day of the Martyrs, 8 March 1977 (*Al-Shaheed al-Bashir al-Ahlawi, saqta shaheed biyoum 8-3-1974. Shaheed min ajla al-Sahrâ Huran mustaqiln. Yaoum al-shuhadâ 8-3-1977*), 1977
23 x 16 in.
Printed by Hans Hoogenbos, Amsterdam
Hoover Insitution Archives (SS1)

• On a schematic outline of a political territory, colored gray, lies a body covered with a flag. In the near background a triangular phalanx of men approaches, each waving a similar flag. "Martyr for a free and independent Sahara," says the caption, signed with a repetition of the territorial motif inset in the outline of Africa flanked by the words *Frente Polisario* (Polisario Front) in Spanish. The use of a deliberately restricted palette in which only the colors of the flag and the soil are seen proclaims consubstantiality between martyr and marching troops.

The land claimed by the Polisario since 1976 in the name of the Saharan Arab Democratic Republic is under dispute, its flag not universally recognized, and the title of

"martyr" remains contingent on an act of nation building that remains incomplete. The image exists to make these doubtful conditions certain. It anticipates a day when it will be possible to say "He did not die in vain." A martyr is someone whose death is valuable to someone else. Here the poster gives dramatic visual form to the actions whereby that value is created and stocked: in sum, the wrapping of the body in the flag. The fact that the flag here postdates the body makes the process of appropriation unusually transparent.

For some years before March 1973, the Spanish Sahara had been stumbling toward decolonization. When Spain began handing its Saharan possessions over to Morocco, local resistance groups began to form, and the Polisario Front emerged in May 1973. Supported at first by Libya and then by Algeria, the Polisario carried out attacks on Spanish, Moroccan, and French targets. The present poster dates from the height of the war in the late 1970s, when Polisario forces shelled Nouakchott, capital of Mauritania, and endured bombing raids by the French air force. By the time a United Nations disarmament mission entered in 1991, approximately ten thousand people had died and forty thousand had become refugees. The territory today remains under Moroccan control. The promised referendum on statehood, originally scheduled for January 1992, has never taken place.
Haun Saussy

15

Artist unknown
Iran
The Organization of the Dispossessed of the Islamic Revolution (*Sazman-i mustaz'afin-i inqilab-i Islami*),
1979–82 (?)
27 x 18 in.
Hoover Institution Archives (IR52)

• Many key concepts of Shi'a Islam are considered to be remnants of pre-Islamic Zoroastrian and Mithraic ideas. The doctrine of a messiah and his return is one such concept. Contrary to the belief of Sunni Muslims, the Shiites hold that the Prophet Mohammad chose his successor and that his name was Ali. They further believe that Ali and his eleven male progeny are ordained by God to lead Islamic society. The Shiites consider that the twelfth imam, Mohammad al Mahdi (the messiah), has gone into hiding and will someday reappear to bring about the promised earthly paradise.

This poster, redolent with the color red signifying the blood of martyrs, portrays the Iranian Revolution as the harbinger of the global rise of Islam. At the top is the

Qur'anic verse, "There is no god other than Allah." In bold letters in the middle of poster is written "Glory to the flag of the global government of Imam Mahdi." The Iranian Revolution, in short, will pave the way for the return of the messiah and the establishment of worldwide Islamic rule.

The group sponsoring the poster, The Organization of the Dispossessed of the Islamic Revolution, was one of hundreds that emerged during the early days of the revolution, nearly all of which were deracinated during the ensuing theocratic regime. The organization mixed vague notions of revolution and the proletariat, borrowed from Marxism, with their own radical reading of Shiism. The aesthetics of the poster, with red as its dominant color, with global revolution as its central message, and with the faceless proletariat-cum-dispossessed as the messiah, reflects the ideological eclecticism of both the group and of the era.
Abbas Milani

The Mass Ornament

16

Sergei Sen'kin (1894–1963)
Union of Soviet Socialist Republics
Long Live the First of May
(*Da zdravstvuet pervoe maia*), 1929
42 x 28 in.
Published by State Publishing House, Moscow, authorized by Glavlit, the state censorship authority
Hoover Institution Archives (RUSU1959)

• This poster commemorates May Day, the annual socialist holiday (*prazdnik truda,* "holiday of labor") in honor of working men and women. Imported into Russia from western Europe in the late nineteenth century, May Day was reinvigorated on a massive scale in the wake of the October Revolution of 1917.

Sergei Sen'kin organized his design around a large red banner, such as would be waved by the crowd at any large-scale May Day celebration. Unfurling down the length of the sheet, the banner forms a back-to-front S shape (not a letter in the Cyrillic alphabet). Along its edge runs the exhortation "Workers of the world unite for peace, for the defense of the USSR, against imperialist wars." Its unfurling creates two main spaces in and around which Sen'kin pasted an assortment of photographs, alternating images of Soviet labor with May Day meetings and parades from around the world. Scenes of mechanized agriculture are stamped with the instruction: "With collective labor [and] the tractor, increase the harvest." A blacksmith—the common symbol of proletarian labor—paus-

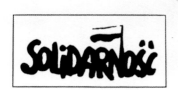

Fig. 19a
Jerzy Janiszewski (active), Poland
Solidarity logo, 1980
Hoover Institution Archives

ing at his forge in the upper-left corner is balanced at lower right by his military counterpart, a Red Army man. A huge rally fills the lower reaches of the sheet. The innovation of this design lies in Sen'kin's transgression of the conventional delimitation of the two elements of the composition, the banner, which belongs exclusively to the poster's typographic space, and the worker who holds the banner aloft and who exists only, by contrast, within the poster's photographic space. Interesting also is the way in which the worker's face—the traditional locus of human psychology—is almost completely obscured by his "working" hands.

A graduate of the the Higher State Art and Technical Institute (VKhUTEMAS) in Moscow, Sen'kin was well grounded in both suprematist and constructivist principles. When *Long Live the First of May* was made, he was a member of the newly established artists group October (*Oktiabr*). The photomontage section of October dismissed both the abstraction of modern photography and the heroics of socialist realism in favor of a documentary record of the process of socialist reconstruction.
Maria Gough

17

Jules Grandjouan (1875–1968)
France
White-collar Misery (*La misère en faux-col*), 1919
16 x 47 in.
Hoover Institution Archives (FR741)

• Four well-fed capitalists, brandishing signs indicating raised rents, taxes, consumer goods, and transportation costs, hold clerical workers tethered by their detachable collars—the symbol of office work. The poster exhorts these white-collar workers to join the Communist Worker-Farmer Bloc.

Jules Grandjouan was the principal graphic artist for the French Communist Party for nearly half a century, beginning around 1900. His work appeared on numerous posters and in the political journal *L'assiette au beurre. White-collar Misery* represents a remarkable variation on the familiar theme of capital as an octopus, reaching its tentacles into every aspect of existence. The tethers of capital are attached to the detachable collars worn by office workers, strangling them as they attempt to move forward by tying them to the deadweight of the rising cost of living. The figures in the foreground represent types of workers, as indicated on their caps—retirees, postal workers, employees of Parisian Regional Public Transport (TCRP). While the figures suffer individually from the separate ropes attached to each, they are

united in the misery of their common instrument of torture. More importantly, however, by depicting these representative workers as an overlapping, physically proximate mass, Grandjouan makes them appear as an entity capable of collective organization—as, indeed, a "bloc" operating under the same conditions as the workers' bloc they are urged to join.
Matthew Tiews

18

Artist unknown
Iran
War, War until Victory! (*Jang, jang ta pirouzi!*), 1983–85 (?)
9 x 24 in.
Hoover Institution Archives (IR143.48)

• A grainy photograph presents a mass of people, arms raised to signal their allegiance to the slogan appearing across the top of the poster: "War, war until victory!" The faceless throngs are foot soldiers roused and ready for combat. The poster is part of the propaganda campaign waged by the Islamic Republic to encourage its people to fight in the war with Iraq. The war began in 1980 when Iraq invaded Iran. After 1982, when Iran had pushed the Iraqi army back to the prewar borders, there was pressure, internally as well as internationally, for peace. Ayatollah Khomeini refused to end the war. "We will fight," he said, "until victory and the fall of Saddam Hussein." By 1988 neither had happened, and, after the loss of an estimated 1.5 million lives, Iran was forced to agree to a cease-fire.

Iranian culture is so enamored of poetry that everything, from a curse to a war cry, must display rhythmic and metric features. Hence, Ayatollah Khomeini's fighting words were turned into a slogan that is lyrical in the original Persian. The verso of the poster shows a column of volunteers marching along a road under a sign that reads, "We are going to Karbala."
Abbas Milani

19

Artist unknown
Poland
1 May: Holiday of Worker Solidarity (*1 Maja: Święto solidarności robotniczej*), 1980s
19³/₈ x 26⁵/₈ in.
Hoover Institution Archives

• The Solidarity (Solidarność) movement was born out of Gdańsk's Lenin Shipyard strike in August 1980. It was during this era that the logo for Solidarity (fig. 19a)—depicted here in a red box in the upper right —was created by Jerzy Janiszewski, a young designer from Gdańsk. Janiszewski recalled: "I

saw how solidarity appeared among the people, how a social movement was being born out of that and how institutions joined in. This all had a great effect on my spirit and I decided I wanted to join the strike."

He chose the word *solidarity* because he thought it best described what was taking place among the striking workers and their supporters. The style of lettering came from Janiszewski's desire to evoke the crowds in front of the shipyard gates, crowds that were not shoving but leaning on one other. Thus, the letters in his "Solidarity" logo, of which the i, ś, and ć resemble human figures, cannot stand on their own without the support of their neighbors. By adding a fluttering Polish flag to the top of the letter n and invoking its colors, Janiszewski emphasized Solidarity's role in representing a national, not just a local, struggle. The logo soon spread worldwide and helped sustain international sympathy until the movement successfully negotiated free elections in 1989 and put Lech Wałęsa, the leader of the shipyard strikes, in the presidential office (see no. 103).

Given the Solidarity uprising, Poland's Communist regime significantly scaled back its 1981 May Day celebrations and made participation voluntary. May Day posed a dilemma for Solidarity as well, given that the holiday was tainted by its appropriation by the state. This poster commemorating "1 May: Holiday of Worker Solidarity" deliberately appropriates and subverts official May Day iconography. The word *solidarity* is inserted into the middle of the workers' holiday, literally representing a Solidarity presence that cannot be suppressed. The lower half of the poster represents the working masses; the male heads and torsos of some foreground figures are distinguishable, each wearing a hat and a Solidarity armband.

The workers' chiseled features, predominantly red clothing, and massed, marching formation all evoke typical Communist May Day symbolism. The hats are not, however, the hats of military authority but the everyday hats of the Polish working class, and the armbands are emblems of opposition. The workers are not marching in profile past the viewer—as they would past the viewing stand of a conventional May Day parade—but directly toward the viewer, challenging authority, reclaiming the holiday for workers, and asserting that now the authorities must face their scrutiny. The red mass of workers stretched along the bottom half of the poster and the white band of sky above them create a living Polish flag, vividly reinforcing Solidarity's message that this worker's movement represents the real Poland.
Margarita Nafpaktitis

20

Artist unknown
(possibly Krol and Marczewski)
Poland
Vote with Us (*Głosuj z nami*), 1989
20 x 26⁵/₈ in.
Hoover Institution Archives

• In December 1981, a year after Solidarity was allowed to register as a trade union, martial law was declared in Poland and the union was outlawed and forced underground. In August 1988 Lech Wałęsa and General Czeslaw Kisczak, Poland's interior minister, began negotiations that would lead to the relegalization of Solidarity and to its triumph in the June 1989 elections.

This poster was one of many pro-Solidarity posters produced in the months leading to the elections. The image represented is that of a crowd photographed from above and from a distance so great that individual faces cannot be distinguished. The bodies of the crowd fill the lower two-thirds of the poster and recede into the horizon so that the crowd appears to be boundless. Superimposed over the horizon line on the right is a message in the familiar red script of Solidarity's logo (replete with the Polish flag flying from the letter n): "Vote with us." The placement of the invitation to join the crowd recalls the origins of the Solidarity logo as an evocation of striking workers. The call to vote rises directly from the multitude of Solidarity supporters, riding the wave of mass support.

The red V victory sign in the upper-left corner, visually connected to the Solidarity logo by sporting its own Polish flag, calls to mind the victory sign flashed by movement leaders to signal to their supporters that progress was being made, whether for the successful resolution of a strike or for the successful negotiation of a peaceful transition from Communism to democracy. Solidarity's familiar logo on election posters also signaled the beginning of unrest in Central and Eastern Europe. By 1989 a wave of popular revolutions and uprisings was surging over the continent, accompanied by hastily created street graphics, posters, flags, fliers, and handheld signs.
Margarita Nafpaktitis

21

Hattingberg (lifedates unknown)
Germany
We'll Do It with the Manual (*Wir schaffen es mit dem Fachbuch*), 1937
33 x 24 in.
Hoover Institution Archives (GE974)

• Published for the German National Socialist Workers' Party (NSDAP, National-sozialistische Deutsche Arbeiter-Partei), this poster incorporates a photograph cropped and situated so that it appears that masses of blue-collar workers, reduced to the backs of their heads, are advancing into a technician's manual. Viewers, too, are directed into the book, their gaze and footsteps following the workers.

The gigantic open book presumably outlines certain technical skills mastered by the workers. The result, emblematized by the smokestacks, is the emergence of a modern, industrial society by means of rigorous, rule-bound training. Although the mechanization and standardization of individual life had been part of a persistent critique of technology during the Weimar period, under Nazi ideology, industry and technology (*Technik*) were now rendered compatible with the values of German *Kultur*. Far from simply backward-facing, this brand of "reactionary modernism" sought to reclaim German cultural values while simultaneously embracing the progress of technology.
Todd Presner

22

Artist unknown
Lithuania
Red Army Go Home, 1992
17⁷/₈ x 10¹/₄ in.
Printed in Vilnius
Hoover Institution Archives

• The poster was produced for the 14 June 1992 national referendum on the presence of troops from the former Soviet Union on Lithuanian soil. Despite the demise of the USSR in December 1991 and the fact that Lithuania had declared and achieved independence in, respectively, March 1990 and August 1991, the Red Army remained in place. The battle against its presence, like the independence struggle itself, was led by Sajudis (the Movement). Initially made up of nationalists within the Communist Party and nonparty members, this organization was dedicated to the cause of Lithuanian "national reconstruction" during Mikhail Gorbachev's *glasnost* (openness) and *perestroika* (restructuring) campaigns in the USSR. The referendum sought both the removal of the occupying army and compensation for the losses that Lithuania had incurred because of the Red Army's presence. Held on 14 June, the Day of Mourning and Hope, a national holiday commemorating the first mass deportation of Lithuanians to Siberia carried out by Joseph Stalin in 1941, the referendum received favorable votes from 68.95 percent of the electorate.

In this poster of simple, straightforward graphics, a white typographic band bi-sects a color image of the sorts of mass rallies that had become commonplace in the Lithuanian capital Vilnius during the 1988–92 period. Like many such other rally banners, the band is inscribed with the title not in Lithuanian but in English, pointing to the increasing importance assumed by the global mass media in local political struggles. It is no longer sufficient for the multitudes to physically gather in the public spaces of the capital to achieve political results. Rather, a far vaster, virtual assembly must be mobilized by reaching out across the globe to readers of newspapers, viewers of television, and navigators of the World Wide Web. It is to this virtual assembly that the poster speaks in the lingua franca of universal communications, English.
Jeffrey T. Schnapp

23

KGK Brigade:
Viktor Koretsky (1909–1998)
Vera Gitsevich (1897–1976)
Boris Knoblok (lifedates unknown)
Union of Soviet Socialist Republics
Free Working Hands of the Collective Farms into Industry (*Svobodnye rabochie ruki kolkhozov v promyshlennost'*), 1931
28 x 39¹/₂ in.
Published by Central State Publishing House and State Publishing House for Art (OGIZ-IZOGIZ), Moscow and Leningrad, authorized by Glavlit, the state censorship authority
Hoover Institution Archives (RUSU1717)

• The KGK Brigade (Brigada KGK) comprised three designers who collaborated in the early 1930s: Viktor Koretsky, Vera Gitsevich, and Boris Knoblok. As with many designers working for the state publishing houses during this period, the brigade's chief subject was the Soviet Union's drive toward rapid industrialization, known as the First Five-Year Plan (1928–32). This poster represents the plan's policy of recruiting into industrial production unemployed farm workers, perhaps those displaced by the forced collectivization and mechanization of agriculture (note the tractors plowing at upper left). In a June 1931 speech excerpted in the lower right of the poster, Joseph Stalin had argued that to reap the greatest economic benefits from the policy recruiting should be conducted in an organized fashion, with contracts drawn up between all parties concerned. Accordingly, the Russian word for contract, *dogovor*, is written out by a large hand on the blank sheet of paper that fills the composition's lower-left corner.

The graphic strength of *Free Working Hands of the Collective Farms into Industry* lies in the careful organization of its pho-

tographic, planar, and drawn images into an off-center, starlike configuration of orthogonals radiating out from the point of their convergence just above the large hand. Cramped between the two orange planes is a bird's-eye view of a vertical mass of farm workers, some still carrying hoes and rakes, others raising their hands, all soberly lining up to sign the papers that will release them from the collective farm into the pleasures—if the expressions on the faces of those who have made it to the other side are any indication—of industrial labor. With the implements of industry slung over their shoulders, the latter, ever larger-than-life, march into a productive future. Accompanying them on their way is a rapidly foreshortened megacomplex of modern factory buildings with large expanses of glass windows, resplendent with electrically illuminated interiors.

Other posters by the KGK Brigade similarly combine abstract color planes with photomontage into dynamic graphic ensembles. In doing so, the brigade brings compositional techniques developed in the early 1920s by artists such as El Lissitzky and Gustav Klucis into the service of the First Five-Year Plan. Even by electing to call themselves a brigade, Koretsky, Gitsevich, and Knoblok emphasize this realignment, for the term "shock brigade" (*udarnaia brigada*) was a staple of the accelerated industrialization campaign. In this use of the word brigade they were not alone; the journal *Brigade of Artists* (*Brigada khudozhnikov*) appeared in 1931. Interestingly, a message in fine print along the bottom of this poster invites viewers to send their comments about the *Free Working Hands* poster to the Agitational Section of the State Publishing House for Art in Moscow.
Maria Gough

24
Artist unknown
United States
Victory. Fighting in France for Freedom! Are You Helping at Home? 1917
16 x 19 in.
Hoover Institution Archives (US4365)

• Immediately after its entry into World War I, the United States became steeped in a climate of xenophobia, as foreign-born residents were considered national security risks. In the name of patriotism local "public safety committees" sought to quell widespread uncertainty over the nation's participation in the war. Federal laws provided a legal basis for such hysteria. The 1917 Espionage Act criminalized antiwar activities and targeted labor activists and foreign workers. The 1918 Sedition Act punished with fines and imprisonment "disloyal … language about the form of government of the United States."

In this climate the Maine Committee on Public Safety published a monthly News Photo Poster series as part of its mission to muster support for war. These posters were filled with photographs of civilian and soldiers, including mourners attending military funerals, Fourth of July parades, and the arrests of draft resistors. The posters consistently represented the nation in the form of a mobilized citizenry and military masses, in effect emphasizing cooperation and unity as national virtues.

Victory stands out in the poster series as the lone "formation photograph." The genre, popularized by photographers like Arthur S. Mole (see no. 102) and Eugene Goldbeck during the war, captured the images of thousands of people assembled in the shape of a word, face, or national symbol. In this case, two thousand sailors at Pelham Bay, New York, are assembled in solidarity with soldiers dispatched to France and Belgium. The caption simultaneously emphasizes the gravity of the war and implies the strength of U.S. forces by likening the ease of their efforts to a decisive boxing match. By anticipating a U.S. victory, the poster inspires confidence in the war effort and encourages readers to "stand firmly behind" the American army.
Jason Glick

25
Wolfgang Janisch (born 1960)
(East) Germany
What Is Man? (*Was ist der Mensch?*), 1988
Black-and-white lithograph, 23 x 16 in.
Hoover Institution Archives

• As Cold War anxiety spread in the 1980s "Peace!" became a rallying cry for East Germans. The protestors objected to West Germany's 1983 acceptance of U.S. Pershing II nuclear missiles and the retaliatory positioning of Soviet SS-20 medium-range missiles in East Germany. They also called on the government to turn "swords into plowshares," a push for change that threatened the totalitarian grip of the Socialist Unity Party (SED, Sozialistische Einheitspartei Deutschlands) on the German Democratic Republic (DDR, Deutsche demokratische Republik). Dissidents were often the subject of surveillance by the secret police (Stasi); in extreme cases they faced expulsion from the country. In this repressive environment prominent intellectuals did not openly support the protestors, so the movement was largely a grassroots effort based on an alliance between the Protestant church, Greens, Social Democrats, and the Moscow-oriented German Communist Party.

By means of this close-up image of a young girl superimposed over the masses, underground graphic artist Wolfgang Janisch in this poster printed for the 1988 Kirchentag celebrations highlights the tension between the individual and the crowd. The girl could merge into the activity of the surrounding crowd, but she is set apart by the contemplative expression on her face and by the outline of the cross. The artist thus celebrates participation in mass protests but not the mindless conformism that sometimes characterizes group behavior.

The text is an adaptation of Psalms 8:4: "What are human beings that you are mindful of them, mortals that you care for them?" These words invite viewers to weigh their own existence in communal, spiritual terms within the setting of the Protestant Church's increasing prominence in the peace movement. In addition to providing safe meeting places, the church mediated between activists and government leaders and helped organize mass protests, including the demonstrations that brought an end to the GDR regime in 1989.
Heather Farkas

26
Wolfgang Janisch (born 1960)
(East) Germany
We Are the People! (*Wir sind das Volk!*), 1989
Black-and-white lithograph, 23 x 16 in.
Hoover Institution Archives

• By the fall of 1989 the East German people were fed up with their lack of basic freedoms and protests reached a fever pitch. The popular revolt was striking given that demonstrations were illegal and citizens had to swear loyalty oaths to the state's Marxist-Leninist ideology. The most forceful displays of dissatisfaction were the "Monday demonstrations," weekly gatherings that began at the Church of Saint Nicholas in Leipzig and eventually spread throughout the German Democratic Republic. On 4 November 1989 the movement exploded: five hundred thousand people gathered in Berlin's Alexanderplatz. "We are the people!" was their rallying cry and the inspiration for this poster by an artist who had long sympathized with the opposition.

Typical of Wolfgang Janisch's technique, the photograph of the crowd is recycled from another poster, *What Is Man?* no. 25. But the specific meaning here is unmistakable. The image strives to empower the people in their fight to unseat the totalitarian Socialist Unity Party and to

Fig. 29a
Frédéric Auguste Bartholdi (1834–1904),
France
Study for "Statue of Liberty," early 1870s
Plaster
Musée Bartholdi, Colmar, France

bring down the Berlin wall. These sentiments were distorted in the months that followed. After the border was opened, Germans who advocated reunification altered the phrase to "We are *one* people! ("*Wir sind ein Volk!*"). Many, including Janisch, were wary of the effects of unification, and this linguistic alteration articulated a view that was far from unanimous. With the benefit of historical hindsight, then, this poster encapsulates the contingent nature of visual and verbal meaning, especially in the context of rapidly evolving political events.
Heather Farkas

Anatomies of the Multitude

The Fist

27
Artist unknown
Iran or United States
In the Name of God the Merciful
(*Bism Allah al-rahman al-rahim*), 1980
31 x 24 in.
Hoover Institution Archives (IR94)

• The Islamic Revolution was fought with the hope of bringing democracy and freedom to Iran. It was victorious thanks to the participation of both men and women and the unification of secular, religious, liberal, and leftist groups. Once in power, however, Islamic forces almost immediately set out to disenfranchise women and impose an Arabic-infused religious ideology on Iranian society. These efforts were not entirely successful: women continued to fight for their rights and nonreligious forces continued to defend secularism.

This poster, published soon after the victory of the revolution, serves as a harbinger of the curtailment of women's rights and imposition of a harsh religious orthodoxy. The fist-shaped image chosen to represent the revolutionary masses includes no women. The public display of a woman without her head scarf was fast becoming not only a sin but also a crime. The poster celebrates the shah's departure from Iran and Ayatollah Khomeini's return after fourteen years of exile by means of a Qur'anic verse in English and Arabic—"Truth has come and falsehood has vanished" (surah 17: 81)—followed by, in Persian only, "congratulations to all Muslims and oppressed peoples of the world, and all Iranian brothers and sisters on the first anniversary of the Islamic Revolution of Iran; 11 Feb. 1980." The implication is that the shah represents falsehood and the Ayatollah and his revolution the truth. By now it was becoming mandatory to open all discourse

with the name of Allah. The first words in Arabic that appear on the right side of the poster are "in the Name of Allah, the beneficent, and the merciful."
Abbas Milani

28
Artist unknown
United States
Forward (*Et en avant*), 1943–44 (?)
29 x 20 in.
Hoover Institution Archives (US8324)

• Propaganda posters—"weapons on the wall"—reached the apotheosis of their power in the pitched battle for public opinion during World War II. Nowhere was this truer than in France, occupied by the Germans from 1940 to 1944, the unoccupied southern part of the country governed by the collaborationist regime of Philippe Pétain. In an effort to woo the French populace, the Third Reich flooded Paris with posters advertising the wealth of jobs to be had in Germany, blaming the war on the English, and depicting American President Franklin Roosevelt as an assassin. Toward the end of the war the English, and especially the Americans, began a counterattack, producing images in support of French resistance efforts. This poster was probably produced in the United States for a French audience.

Masculine strength, as represented in a muscled arm, was a frequent image in American war posters, illustrating the American military might thrown into the war effort. The arm embodies the collective strength of the nation; the people's combined will coalesces in its gesture of defiance. The fist, too, whether punching through a swastika to signal victory over Germany or simply clenched to show determination, often serves in American posters to symbolize a unified will against the enemy. French resistance posters meanwhile abound in images of shackles being broken. In fact, the chain and fetter in this poster bear a striking resemblance to the severed chains dangling from the liberated arms in *France Forever* (1944), a famous poster produced by Jean Carlu for the Free French Movement in America. But while French posters feature chains broken and shackles cast off, what is striking about this work is that the fist appears to have grabbed its own chain and broken itself free. The implication is clear. The people must gather their strength and liberate themselves with a show of force.
Matthew Tiews

29
Artist unknown
United States
Model for a Monument, 1930s

Painted plaster on wood,
21$\frac{1}{8}$ x 18$\frac{1}{4}$ x 18$\frac{1}{4}$ in.
The Wolfsonian–Florida International University, The Mitchell Wolfson Jr. Collection (87.744.6.1)

• Although the author and purpose of this model are unknown, it was likely inspired by Frédéric Auguste Bartholdi's Statue of Liberty (*Liberty Enlightening the World*, 1884), at whose feet lie broken chains, representing the people's emancipation from tyranny. Traditional iconographies of Liberty sought their origins in ancient Roman religion within which Libertas was depicted as a female figure with a pileus (the felt cap worn by freed slaves), a spear, and a laurel wreath. Initially the goddess of personal freedom, she later became the goddess of the commonwealth, worshiped in temples in the Forum and on the Aventine Hill. In Cesare Ripa's seventeenth-century *Iconology*, little was changed. Liberty was represented as "a woman dressed in white whose right hand holds a scepter [signifying authority] and whose left holds a cap [signifying manumission]."

In the present model a massive left hand thrusts upward to form a clenched fist, a traditional gesture of defiance and salute, often associated with leftist worker's movements. It is encircled at its base with men, women, and children—the "huddled masses yearning to breathe free" of Emma Lazarus's famous poem "The New Colossus" (1903)—all of whom gaze up expectantly at the spectacle of their emancipation. Some pray, some plead; others hoist their infants skyward. Grasped in the fist is the fragment of a chain that has been sundered, as in Bartholdi's earliest models in which Liberty held a broken chain in her left hand (fig. 29a).
Jeffrey T. Schnapp

30
Bahman Sehhat-Lou (lifedates unknown)
Iran
Untitled, 1970s
14$\frac{1}{2}$ x 10$\frac{1}{2}$ in.
Printed by Art Bureau of the Islamic Propagation Organization, Tehran
Hoover Institution Archives (IR217)

• The defining event in Shiism's hagiography is the battle of Karbala on 10 October 680, when the third imam, Hussein, and a band of seventy-two followers were slaughtered by the army of the ruling caliph, Yazid. Since then Shiites take to the streets and self-flagellate in mourning to commemorate the anniversary of Hussein's death.

Printed in Tehran, the poster combines some of the most venerable sacred icons

of Shiism with images borrowed from the pantheon of the Islamic regime. The symmetrical repetition of the same image in its overall design conjures the aura of special tapestries, filled with repetitious Qur'anic verses and sacred images, employed in religious rituals. The bloody severed arm, symbolizing the cut-off hands of martyrs in the battle of Karbala, is transformed into a clenched fist, the iconic modern image of mass rage and revolutionary action. Lest the clenched fist become too secular in its connotations, it is rendered sacred by the kneeling saint holding a sword. Shiism forbids the representation of a human face so the figure is portrayed as a haloed faceless man, who, in this context, clearly stands for Hussein.

The two flags with the five-pronged symbol at the tip are often used in traditional Shiite processions. The five-pronged symbol not only recalls the severed hands of martyrs but also the Shiite belief in *panj tan*, the five saints of Shiism: the Prophet Mohammad, his son-in-law Ali, his two grandsons Hassan and Hussein, and his daughter Fatima. The image of Ayatollah Khomeini appears in one of the five-pronged symbols, clearly insinuating that his status is on a par with that of the saints, rendering the image sacrilegious to traditionalists.
Abbas Milani

31
Artist unknown
Iran or United States
The Deposed Shah Must be Tried in Iran, 1980
27 x 19 in.
Hoover Institution Archives (US8099)

• After the deposed shah of Iran, Mohammad Reza Pahlavi, was allowed into the United States for medical treatment, a group of students who called themselves Followers of Imam's Line occupied the American embassy in Tehran on 4 November 1979. Their name referenced what the Red Guards had called themselves during the Chinese Cultural Revolution, Followers of Mao's Line. The students occupying the embassy demanded the shah's extradition. For them, only revolutionary justice, represented in the poster by an arm bearing the image of masses holding the scales of justice, can sit in judgment of the shah.

In earlier phases of the revolution, commensurate with the political diversity of Iranian society itself, an aesthetic pluralism characterized political posters. Some emulated the socialist realism prevalent in the Soviet Union and Communist China; others took their inspiration from futurism

and surrealism. As totalitarianism replaced the vibrant pluralism of the revolution's early days, posters too tended to turn dour, as in this example, losing their vivid character, graphic verve, and inventive color.
Abbas Milani

32
Artist unknown
United States
Prevent This, 1942
30 x 22 in.
Hoover Institution Archives (US8415)

• The Nazi symbol of the swastika was featured in many American posters during World War II. Meant to inspire fear about a possible German invasion, these posters contained poignant and powerful messages to promote patriotism, caution security, urge energetic production in factories, and emphasize the malevolent nature of the enemy. Produced by the General Electric Company in 1942, this color lithograph features an arm, symbolizing the hostile will of the German people, that is about to sear a swastika brand on the naked back of a sailor. The slogan, "Prevent This," is emblazoned across the flames surrounding the hot iron.

General Electric was among the numerous companies and organizations (including the Stetson Hat Company, the Red Cross, and the U.S. War Department) that produced posters illustrating Nazi hostility toward Americans. Posters with such alarming messages and symbols energized the nation, particularly those left behind on the domestic front. In the move toward national solidarity, posters served as silent weapons to convey the idea that everyone—from the soldier to the factory worker to the school child—was responsible for the outcome of the war.
Rhonda C. Goodman

33
Artist unknown
United Kingdom
Lend Your Strong Right Arm to Your Country. Enlist Now, 1914–15
8¹/₂ x 25 in.
Printed by H. & C. Graham, London
Hoover Institution Archives (UK222)

• On 4 August 1914 the so-called "picnic war, over by Christmas," kicked off its horrific five-year's carnage by means of an unprecedented advertising barrage. Unlike that of the continental powers, England's army relied on volunteer enlistment. At the beginning of the war it consisted of fewer than a quarter million soldiers, nowhere near large enough to endure a war of attrition. In a climate of fierce national resis-

tance to conscription (not overcome until January 1916), the War Office turned to posters to encourage enlistment by the millions needed for Lord Kitchener's armies. By the end of March 1915 more than two million copies papered the urban and rural landscapes, becoming what Peter Stanley has labeled "the weapon on the wall."

Lend Your Strong Right Arm survives as one of these weapons. A man's clenched fist, larger than life and deeply accentuated with shadows, promises to deliver a death blow to the Hun. Mounted laterally and issued in various sizes, the die-cut lithograph unites form and content to offer a vision of virulent masculinity and moral obligation, powerful enough to knock the Englishman off the fence and into the trenches. The poster embodies the war rhetoric that saw England as the defender of the rule of Right against Might. It glorifies the strength of the British volunteer while promoting the myth of hand-to-hand combat, consciously sidestepping any representation of modern warfare—an obvious deterrent to enlistment.

Produced for the Parliamentary Recruiting Committee (PRC), a party alliance formed on 31 August 1914 to coordinate local recruitment efforts, poster number 26 (of roughly two hundred PRC designs) remains unsigned, evidence of the often chaotic manufacture of propaganda. Printers, such as H. & C. Graham, usually generated the layout and design of PRC posters, many of which appeared in runs of more than twenty-five thousand copies. The shape of poster number 26, however, displays an unusual level of visual sophistication: this severed limb, simultaneously powerful and impotent, testifies to the millions of soldiers who sacrificed their bodies for their country.
Marie Louise Kragh

34
Mihály Biró (1886–1948)
Hungary
Scoundrels! Is This What You Wanted? (*Bitangok! Ezt akartátok?*), 1919
37 x 50 in.
Printed by Rado; Országos Propaganda Bizottság, Budapest
Hoover Institution Archives (HU382)

• With its giant crimson hand crashing into Versailles's Hall of Mirrors to smash the table around which conferees of the Paris Peace Conference meet, this poster is a clear reference to Mihály Biró's more famous and much-reproduced *Giant Red Man with Hammer* (1912). Here, the fist of the Giant Red Man wreaks havoc on the peace conference. The caption—"Scoundrels! Is this what you wanted?"—

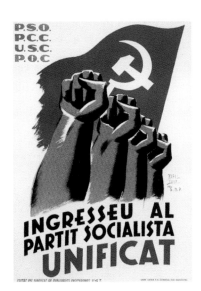

Fig. 36a
Rafael Tona, *Join the Unified Socialist Party* (*Ingresseu al Partit socialista unificat*), c. 1936
Reprinted by permission from Carulla and Carulla 1997, 1: 183, no. 545
Courtesy University of Illinois Urbana Library

references not the eventual Treaty of Versailles but the disarray caused in Hungary by Allied inaction.

The giant fist, cleanly and clearly delineated in black and brightly colored, contrasts with the pale room and pallid figures, whose loose portrayal and awkward stances border on caricature. Biró's use of the same color for the text with its critical message underscores the power of the fist and allies fist and word. The highly evocative phrasing of the text with its causative verb reinforces the idea that the conferees have brought this havoc on themselves.
Sam Albert

35

Karol Sliwka (active twentieth century)
Poland
Independent Self-Governing Trade Union of Individual Farmers "Solidarity" (*Niezależny samorządny związek zawodowy rolnicy indywidualni RI Solidarność*), 1981
$26^5/_8$ x $19^1/_4$ in.
Hoover Institution Archives

• Solidarity's rural arm (NSZZ RI Solidarność) waited even longer for official recognition from Poland's Communist government than did its urban counterpart. On the day of the final hearing in 1981 that led to its recognition, thousands of people, mostly peasants, marched through the streets of Warsaw to the district court. Although a political demonstration, it assumed the form of a religious procession with participants dressed in their Sunday best, carrying crucifixes and images of Mary, praying and singing religious hymns.

This poster commemorates the existence of Rural Solidarity, replicating the familiar Solidarity logo in green (in contrast to the urban union's red). A muscled hand and forearm enters the frame at a diagonal from the upper-right corner, coming into contact with the Solidarity logo. The arm—representative of a peasant hand worn by work not the artificially rosy, brawny forearms featured in Communist propaganda—is depicted with a scrupulous naturalism removed from ideological mystifications. The muscled hand scatters a fistful of grain seed in a sweeping motion toward the earth. The white-and-red grains fall into a pattern that evokes the Polish flag, and the Z formed by the Solidarity logo, the arm, and the seeds reinforces the presence of the union (*związek*) and of agricultural workers as practitioners of a trade (*zawodowy*) in its echoing of Solidarity's official designation, NSZZ.

Among the defining features of the Solidarity movement included its grounding in Christian ethics and the constant

symbolic presence of flowers. Both are indirectly captured in this image of the age-old agricultural practice of sowing the seed, calling to mind two related parables of Jesus: "The kingdom of heaven is like a mustard seed that someone took and sowed in his field; it is the smallest of all seeds, but when it has grown it is the greatest of shrubs and becomes a tree" (Matthew 13: 31–32), and also his admonition, "For truly I tell you, if you have faith the size of a mustard seed, you will say to this mountain, 'Move from here to there,' and it will move; and nothing will be impossible for you" (Matthew 17: 20).
Margarita Nafpaktitis

36

Rafael Tona (lifedates unknown)
Spain
P.S.U. To Smash Fascism Enroll in the Air Force (*P.S.U.: Per a aixafar el feixisme ingresseu a l'aviacio*), 1936
$43^3/_8$ x $31^5/_8$ in.
Printed by Grafica Ultra, Barcelona
The Wolfsonian–Florida International University, The Mitchell Wolfson Jr. Collection (TD1990.18.1)

• Rafael Tona's relationship to politics preceded the outbreak of the Spanish civil war in 1936. He was imprisoned in 1925 during the dictatorship of Miguel Primo de Rivera for interrupting a performance with a pro-Catalan nationalist cry of "¡Visca Catalunya!" (Long live Catalonia!). With the dictatorship's repression of Catalan separatist activity and its imposition of centrist policies that favored Castilian, Tona's gesture represented his recognition of the political force of language.

Like many other Catalan artists during the civil war, Tona constructed the message of this poster for the Unified Socialist Party of Catalonia (PSUC, Partit socialista unificat de Catalunya) in Catalan to convey the connection between defending the republic, fighting fascism, and protecting Catalan autonomy. Tona used the upraised clenched fist, a symbol of loyalty to the republica and of resistance to the military uprising led by General Francisco Franco, to express the political force behind a coordinated military offense (see fig. 36a). There is another message here as well. A disciplined organization will insure success for the Communist-backed goals of the PSUC.

Tona designed this poster when he was a member of the Trade Union of Professional Artists (SDP, Sindicat de dibuixants professionals), an organization affiliated with the Socialist General Workers Union (UGT, Unión general de trabajadores). Tona had a leading role in establishing the SDP, along

with younger artist Carles Fontseré. The SDP was initially supportive of the politics of the PSUC. Tona was the SDP's spokesperson at PSUC meetings and designed the masthead for the party's newspaper *Treball*.
Jordana Mendelson

The Salute

37

Artist unknown
Germany
Your Yes for the Führer on 4 December (*Dein Ja dem Führer am 4. Dezember*), 1938
34 x 23 in.
Hoover Institution Archives

• In 1918, when the Republic of Czechoslovakia was established, it included an area known as Sudetenland (the provinces of Bohemia and Moravia) that was home to a large minority population of German-speaking inhabitants. For Adolf Hitler this minority was an integral element in the building of One people, One Rule (*Ein Volk, ein Reich*). With the cooperation of the German Sudeten Party (Sudetendeutsche Partei), he secretly created a local army (Sudetendeutsche Freikorps), raising tensions within the region.

On 20 May 1938, the Czech government mobilized its armed forces but did not march. One month later the German Sudeten Party fared well in the Czech national elections. Talks with President Edvard Beneš ensued, yet by September a resolution seemed impossible. The Sudeten Germans demanded union with Germany, and Hitler threatened to provide them with military support. Interventions by British Prime Minister Neville Chamberlain proved futile. At a large Nazi rally in Nuremberg on 12 September 1938, Hitler gave his infamous Sudetenland speech in which he promised the unification of the territory with the German fatherland.

Printed for the German National Socialist Workers' Party (NSDAP, Nationalsozialistische Deutsche Arbeiter-Partei), *Your Yes for the Führer* was created for the elections that would decide Sudetenland's future. A single right arm reaches skyward, palm flat, fingers extended. The gesture is unmistakable: chains are broken, and the force of the upward-moving arm sends the shackles flying. It is the "Ja," with the letter J seeming to loop around and support the arm, which lifts the hand up and sets the individual free. We look on it from below, and we see a motion rising over us, commanding us, moving us. The diagonally placed arm positioned against the vertical typeface sets the image in motion. One

hand, one leader, one nation. Thus Hitler begins his march into "the great German future.
Kiersten Cray Jakobsen

38

Artist unknown
Iran
The Islamic Revolution Party:
Congratulations on the Victory (*Hizb-i jumhuri-i Islami mubarak ba pirouzi*), early 1980s
28 x 19 in.
Hoover Institution Archives (IR56)

• The early phases of a revolution are invariably utopian in their goals. In this poster the power of the faceless masses not only has brought victory and light to Iran but also promises to take the revolution worldwide. This would-be success is symbolized by the sun, represented by the artist as a series of concentric rings.

The poster is a simple, decidedly secular celebration of the victory of the Islamic Revolution. In the early days of the revolution secular sensibilities represented a formidable presence. This work poignantly bereft of any religious reference points to this power. The Persian text, rendered in beautiful calligraphy, reads, "Congratulations on the victory." The collective hand of the Iranian people is raised in the universal sign of victory.

The poster was printed for the Islamic Revolution Party, fast becoming in those early days of the revolution the chief vehicle for clerical supremacy over all facets of Iranian life, politics, commerce, and culture.
Abbas Milani

39

Artist unknown
Nicaragua
We Will Triumph! (*¡Venceremos!*), 1979
26 x 19 in.
Hoover Institution Archives (NQ87)

• In *We Will Triumph!* successive rows of rifles flank a muscular, unarmed hand, whose victory sign is echoed by the arrangement of rows of weapons. The poster was printed for the Sandinista Front of National Liberation (FSLN, Frente sandinista de liberación nacional) and was likely published just after their July 1979 triumph.

The iconography of the poster reflects the military strategy pursued by the FSLN to overthrow the government of Anastasio Somoza Debayle. From 1973 to 1979 the FSLN pursued the Insurrectionalist, "Third Way," Tendency (Tendencia insurreccional tercerista). This strategy fused two competing schools of thought within the FSLN: the Prolonged People's War (Guerra popular prolongada), which advocated guerrilla warfare in rural areas, and the Proletarian Tendency (Tendencia proletaria), which pushed for worker strikes and popular resistance in cities. In classical Marxist terms the Sandinistas sought to overcome the rural-urban divide. In *We Will Triumph!* the tools of the combined strategies herald the potential of the new Sandinista government.

The revolutionary cry "*¡Venceremos!*" signals the arduous project of social transformation that awaited the FSLN following its military success. Continued questions over its legitimacy, however, coupled with the U.S.-funded Contra insurgency, left the FSLN bogged down in military campaigns throughout the 1980s. Weapons never disappeared from Sandinista posters. A 1986 electoral poster depicts a woman nursing her infant, with a rifle strapped on her back. The caption highlights the intertwining of issues of military security and socialist goals: "Never has a heart been so filled with the homeland. The struggle continues" ("Jamás hubo tanta patria en un corazón. La lucha continua").
Jason Glick

40

Sergei Sen'kin (1894–1963)
Union of Soviet Socialist Republics
For the Many-millioned Leninist Komsomol (*Za mnogomillionnyi leninskii komsomol*), 1931
39³/₄ x 28 in.
Published by Central State Publishing House and State Publishing House for Art (OGIZ-IZOGIZ), authorized by Glavlit, the state censorship authority
Hoover Institution Archives (RUSU1729)

• In this poster Sergei Sen'kin organized his photographic and other graphic materials around the larger-than-life salute of a *komsomolka*, a female member of the Komsomol, or Communist Youth League (*Kommunisticheskii soiuz*). Catering to young people between the ages of fourteen and twenty-eight, the Komsomol was the third and final step in one's preparation for party membership (the other steps were the Little Octoberists, for children aged seven to nine; and the Pioneers, for those nine to fourteen). In 1931 the Komsomol had more than two million members (somewhat short of the "many millions" honored in the poster's title). As a mass organization, it served as a vehicle by which political enlightenment and fun— as formulated by the Communist Party— could be disseminated among ordinary citizens. Equally important, the Komsomol functioned as a recruitment agency for the party, as a proving ground in which young people could develop leadership potential and agitational skills.

New tasks could be demanded of Komsomol members at any time. In the long narrow panel flanking the *komsomolka*'s salute is an excerpt from a speech by Lazar Kaganovich, Moscow party chief and member of the Politburo from 1930 to 1957, in which the *komsomoly* are directed to take an active role in improving Soviet productivity (hence, the tractors and gleaming factory machines lining the bottom of the sheet). Judging by her forthright gesture, this *komsomolka* is ready to do her part. The large banner carried by a sailor at the head of the mass rally shown at middle right reads "KIM," an acronym for the Moscow-based Communist International Youth League (*Kommunisticheskii internatsional molodezhi*), the function of which was to organize youth organizations around the world and control them from Moscow. The smaller banners feature other Komsomol slogans ("For the victory of socialism," "We will provide … new cadres of warriors for socialism," and "We will strengthen the defense of the USSR").
Maria Gough

Pointing the Finger

41

Artist unknown
Germany
Yes! (*Ja!*), 1938
34 x 23 in.
Printed in Leipzig
Hoover Institution Archives (GE998)

• Following the resignation of Chancellor Kurt von Schuschnigg German troops marched into Austria, and Adolf Hitler announced the annexation of the country on 13 March 1938. On that day, the chancellor had planned to hold a nation-wide plebiscite to determine whether Austrians wanted a "free, independent, social, Christian and united Austria." Hitler threatened to invade Austria with two hundred thousand soldiers if the plebiscite was not canceled and the chancellor removed. Under this threat, von Schuschnigg resigned.

Printed for the German National Socialist Workers' Party (NSDAP, Nationalsozialistische Deutsche Arbeiter-Partei), the poster was created after the annexation (Anschluss) of Austria and depicts a voting card in which the Austrian people were asked to decide if they agreed with the "reunification" of Austria with the German Reich under the command of Hitler. Prior to this new plebiscite, held on 10 April, the German propaganda machine covered the streets in

posters, many of which were dropped by air, proclaiming agreement with the annexation. Support for the annexation had already been widespread in Austria, with popular slogans announcing, "People of the same blood belong to the same Reich."

The single finger voting retroactively for the "reunification" is meant to allegorize the consistent will of the masses. With Jews, gypsies, and other "undesirables" forbidden to vote, the results of the plebiscite were manipulated, with the result that more than 99 percent of Austrians voted to approve the annexation.
Todd Presner

42

Artist unknown
Italy
For Trieste's Future (*Per l'avvenire di Trieste*), 1954
39 x 27 in.
Printed by Tipografia Villaggio del Fanciullo, Trieste
Hoover Institution Archives (IT275)

• This poster was employed in Trieste's 1954 provincial elections, when the city reverted to Italian rule after nine years of Anglo-American occupation. Printed by a firm still active in the region, it was designed by the SPES (Sezione propaganda e stampa), the central propaganda organization for the Christian Democratic Party (DC, Democristiani), founded in 1948.

Technically simple, the poster required only the standard equipment available to local typesetters. It is graphically elementary, highlighting in red the lower and upper bars to emphasize, in turn, the photographic images of hands pointing to the three main issues of the 1954 campaign, each also highlighted in red: the Common Market (*mercato comune*), industrial growth (*potenziamento industriale*), and international trade (*traffici internazionali*). Although the artist is unknown, it was common for poster designs to be devised by party volunteers who preferred to remain anonymous.

Local posting of works like *For Trieste's Future* was highly effective not only because it offered the possibility of rapid response to attacks by rival parties, but also because it was very affordable. Party volunteers could post new images before workers started their morning shifts. Volunteers and designers privileged poster content over graphic design in keeping with their limited time and the simple presses available to them. They frequently employed a "downward perspective" in their work since posters were placed at the very top of a building to make them difficult to remove by opponents.

In addition to the Christian Democratic Party, other Catholic organizations, such as the Civic Comittees (Comitati civici), also participated in anti-Communist campaigns. By 1947 propaganda was becoming more sophisticated and posters had become key tools for leveling attacks against the rival party. The SPES headquarters in Rome issued periodic bulletins to volunteers and directed every aspect of the campaigns, from coordination of poster graphics and production to their timing and placement.
Giorgio Alberti

43

Henry Koerner (1915–1991)
United States
Someone Talked! 1943
34 x 24 in.
Printed in New York
Hoover Institution Archives (US5991)

• Formed in 1942 out of the merger of the National Art Council for Defense and the Artists for Defense, the New York-based Artists for Victory worked to ally government and business with artists to create visual materials for the war effort. With the collaboration of the Museum of Modern Art, the Council for Democracy, and the Office of Civilian Defense, the group held a national poster competition during the first year of its existence. The prizes were sponsored by R. Hoe & Co., a printing-press manufacturing company that produced weapon parts during the war. Artists from forty-three states submitted more than two thousand designs.

This poster addressing the dangers of loose talk during wartime was one of the competition winners. The image directs the viewer's attention to a particular danger but leaves the context open-ended. The fragmented newspaper story on the oversized hand points to a specific threat, "the Talker," who strides along at the lower left in his unassuming suit and hat. His indiscretion has enabled Axis torpedoes to sink an American ship and kill American citizens, but the omission of specifics (neither the vessel nor any victim is identified) makes the poster more versatile and powerful. The blank face of the man leaves his identity a mystery, adding suspense and putting the viewer on alert.

Henry Koerner, a Viennese graphic designer and painter who fled to the United States in 1938 following the Anschluss, made this winning poster. Soon thereafter, he began designing book jackets for the Maxwell Bauer Studios in New York and by 1942 he was working for the Office of War Information, a clearinghouse for wartime poster distribution. Drafted by the

army in 1943, the young artist was assigned to the Office of Strategic Services in Washington and later served as a court artist during the war-crime trials in Nuremberg.
Kevin Smith and *Heather Farkas*

44

Art Studio No. 62
Union of Soviet Socialist Republics
To Assist the Industrial and Financial Plan, Let's Organize a Production Comrades' Court (*V pomoshch' promfinplanu organizuem proizvodstvenno-tovarishcheskii sud*), 1931
40$^7/_8$ x 27$^1/_2$ in.
Published by State Publishing House for Art (IZOGIZ), Moscow and Leningrad, authorized by Glavlit, the state censorship authority
Hoover Institution Archives (RUSU1722)

• A sober crowd of industrial workers have just sentenced a trio of delinquent coworkers, the large red pointing finger expressing the collective judgment against the accused. The crowd appears here in its capacity as the factory's Production Comrades' Court (*Proizvodstvenno-tovarishcheskii sud*)—a tribunal of workers empowered to censure misconduct. The excerpt at the bottom of the sheet explains the court's findings. The conduct of comrade Sklochnikovaia (an invented name, from *sklochnik*, "troublemaker") is deemed unsatisfactory for a politically conscientious worker and she is issued an official "reprimand." Her companions are in even deeper trouble. The court has ruled that its reprimand of comrades Khuligankin (from *khuligan*, "hooligan") and Progulov (from *progul*, "absenteeism"), as disrupters of the factory's industrial and financial plan (*promfinplan*), be published in the factory newspaper. Further, if these comrades fail to mend their ways, the court will propose to management that they be fired and will recommend to the factory trade-union committee (*zavkom*) that they be excluded from union membership.

Presumably posted in factory canteens and workers' clubs, such posters encouraged industrial workers to help their factories fulfill their annual *promfinplan* by organizing Production Comrades' Courts to punish breaches of labor discipline. Composed of volunteers from the shop floor, such courts constituted both a radical experiment in lay justice and an invasive mechanism of peer policing. Later, comrades' courts were established in all industrial enterprises, educational institutions, residential buildings, and collective and state farms.
Maria Gough

The Open Hand

45–46
John Heartfield (1891–1968)
Germany
*The Hand Has Five Fingers. With Five,
You Will Strike Down the Enemy!
Choose List Five, the Communist Party
(5 Finger hat die Hand. Mit 5 packst du
den Feind! Wählt Liste 5.
Kommunistische Partei!)*, 1928
35 x 24 in.
45 Printed by Rudolf Renner, Berlin
Hoover Institution Archives (GE2216)
46 Printed by Hugo Everlein, Berlin
Hoover Institution Archives (GE813)

• John Heartfield is best known for his involvement in the Berlin dada movement shortly after the end of World War I. With his fellow dadaists, George Grosz and Raoul Hausmann, Heartfield claimed to have invented photomontage. In 1920 they organized the First International Dada Fair in Berlin. Shortly after its opening the German authorities shut down the fair because of its strongly satirical, antinationalist critique. Throughout the 1920s and early 1930s Heartfield worked closely with the German Communist Party (KPD, Kommunistische Partei Deutschlands), creating scores of anti-Nazi photomontages, many published in Communist newspapers such as *The Red Flag* (*Die rote Fahne*) and the *Workers' Illustrated Newspaper* (*AIZ, Der Arbeiter illustrierte Zeitung*).

This image, first published in *The Red Flag* on 13 May 1928, was created by Heartfield to galvanize electoral support for the Communist Party. In both versions of the poster, printed in 1928, the same photograph of a worker's right hand emerges from the picture plane, encouraging viewers to identify with the Communist Party by raising their left hand to the poster and joining the two together in reciprocal solidarity. This gesture could be endlessly repeated and thus underscores the production of the masses through their participation in the medium.

In the late 1920s a series of international exhibitions were staged throughout Europe on new uses of photography and photomontage. Of these, among the most significant was the exhibition *Film und Foto* organized by the German Werkbund and held in Stuttgart in 1929. Heartfield curated one of the exhibition galleries, in which he displayed multiple copies of this poster. Not only did he want to display the posters as they might be seen on the street, but he also wanted to indicate how the medium allowed for a serialized, mass reproduction of the image. Heartfield and his colleagues connected this mass reproduction to their belief in the photomontage as

a weapon of class struggle, one which could reveal and transform social reality.
Todd Presner

47
Artist unknown
Iran
The Islamic Republic Party (*Hizb-i jumhuri-i Islami*), 1980s
28 x 19 in.
Printed in Meshed
Hoover Institution Archives (IR72)

• The day 3 June 1963 is often seen as a dress rehearsal for the Islamic Revolution of 1979. On that day Ayatollah Khomeini made one of his fieriest anti-American, anti-shah speeches at the Faziye Seminary in the city of Qom. The speech seemed timed to coincide with the most important day in the Shiite calendar, when the third imam, Hussein, and his band of seventy-two disciples, were brutally murdered by the army of the ruling caliph, Yazid. Since that battle in 680, Hussein's death is mourned by Shiites with great emotional intensity. As the result of this battle, Shiism has become a religion that cherishes martyrdom as well as the idea that the righteous, like Hussein, are members of a persecuted minority who seek justice.

What catapulted Ayatollah Khomeini to the center of Iranian politics in 1963 was his fierce opposition to a recent law affording U.S. servicemen immunity from prosecution in Iranian courts. He was arrested two days after his speech and his supporters immediately took to the streets. The Iranian army brutally suppressed the massive uprising. There is no consensus on how many people died. Religious circles talked of thousands, while the government put the figure at around one hundred. Khomeini, repeatedly conjuring the image of Hussein to identify his movement, kept alive the memory of the June uprising well into 1979, when he was swept to power.

The Islamic Republic Party, for many years the dominant institution representing clerical power in Iran, sponsored this poster. Ali Khamenei, the current spiritual leader of Iran, and former president Akbar Hashemi Rafsanjani were among the party's founders. In the poster, a bloodied hand, alone but resolute, writes the date 3 June 1963 on a wall in blood. The subtexts of martyrdom as the elixir of politics and the righteous as a persecuted minority are clearly expressed in this poster. The blood of martyrs, the poster implies, is the cherished surviving memory of June 1963.
Abbas Milani

48
Chlad (lifedates unknown)
Germany

CSU: The Choice that Means Security
(*CSU: Wählen heisst Sicherheit*), c. 1953
24 x 16 in.
Printed by Carl Gerber, Munich
Hoover Institution Archives (GE2387)

• From the time of his election as chancellor of the Federal Republic of Germany in 1949, Konrad Adenauer pushed for the realization of his political vision: a sovereign, democratic West German state. One factor in that equation was the remilitarization of the republic, a move he believed would restore West Germany's status as a major player on the world stage. With the escalation of the Cold War and the outbreak of the Korean War, many Western nations grew increasingly afraid of the spread of Communism and viewed West Germany as a potential military ally in the fight against the Red Stain. Some resistance on an international level was to be expected—the most vocal objections came from France—but there was also much skepticism by Germans, who were still reeling from the war's devastating blows. The sweeping victory of Adenauer's Christian Democratic Union Party (CDU, Christlich demokratische Union) and its sister conservative party the Christian Social Union (CSU, Christlich-soziale Union) in the second Bundestag elections of 1953, for which this poster was designed, demonstrates that such apprehension was short-lived.

The poster's graphics and text assert that a vote for the CSU and its promilitarization platform would be a vote for security, but the image does not pin down exactly what kind of security the CSU would bring. This ambiguity enables the poster to tap into desires for strength and fears of weakness, thereby reaching a wider audience. The tanks represent Adenauer's vision for a stronger West Germany, but they also may call to mind unpleasant memories of occupation or associations with the recent workers' uprising in East Berlin, which was violently suppressed by the Soviet army. Any of these connections might inspire a passerby to support the CSU. The image of the outstretched hand, here the symbol of individual participation in government, emboldens the voter to seek the restoration of German might and keep foreign armies at bay.
Heather Farkas

49
Artist unknown
Italy
Defend the Fruits of Your Labor (*Difendi il frutto dei tuoi sudori*), 1948
39 x 27³/₄ in.
Hoover Institution Archives

• This Christian Democratic (DC, Democristiani) Party campaign poster for the 18 April

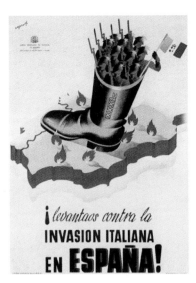

Fig. 50a
José Espert (lifedates unknown), Spain
Rise up against the Italian Invasion of Spain! (¡Levantaos contra la invasión Italiana en España!), c. 1937

1948 elections denounces Communist intentions to limit citizens' right to private property. Its representation of Communist clawed hands ready to steal good citizens' possessions was a hackneyed stereotype. Voting is the suggested tactic to defend every Catholic family from the flames of a Soviet hell. Because of the formulaic character of its iconography and rudimentary text, this poster was likely produced by the Civic Committees (Comitati civici), an independent Catholic organization that vigorously pursued the anti-Communist campaign on the local level.

Italy became a republic via a referendum held on 2 June 1946, but the political parties were unprepared for democratic elections and were poorly organized. The rivalry between the two major parties, the Christian Democrats and the social-communists (the Fronte democratico popolare formed by the Partito socialista and the Partito comunista italiano), yielded an extraordinarily high level of political participation. Eventually the Christian Democrats prevailed among political moderates and initiated Italy's enduring pro-American tilt in foreign policy. The battle between the two parties was fought on walls; no laws yet regulated the placement of the posters. At first, posters were elementary, displaying little more than party logos or explanations of how to vote.
Giorgio Alberti

50

Amado Oliver (born 1896; death date unknown)
Spain
The Italian Invader's Clutch Tries to Enslave Us (La garra del invasor Italiano pretende esclavizarnos), 1937
39³/₈ x 27⁵/₈ in.
Printed by Sindicato profesionales bellas artes, Madrid
The Wolfsonian–Florida International University, The Mitchell Wolfson Jr. Collection (XX1990.2880)

• Just months after the outbreak of the Spanish civil war, the Popular Front relocated their capital from Madrid to Valencia. In November 1936 the Representative Junta for the Defense of Madrid (Junta delegada de defensa de Madrid) was created to coordinate all aspects of the capital's affairs, which included the production of propaganda to inform the inhabitants of changing politics and pending dangers. Hundreds of posters commissioned by the junta were plastered on city walls, transforming the architecture of the street into a vibrant cacophony of political slogans. The junta's posters were also collected and sent abroad. Today they are among the most widely represented in collections of Spanish civil war posters.

The high quality of the junta's posters was due in large measure to the Artists' Workshop (Taller artístico) of the Fine Arts Trade Union (Sindicato profesional de bellas artes). Members of the workshop were professional graphic designers and commercial artists who had worked in advertising before the war. In this poster by Amado Oliver, an oversized hand, painted in the colors of the Italian flag, reaches across the Iberian Peninsula in a menacing gesture. Marching across the hand are rows of identical soldiers, each outlined with stencillike precision. Oliver's poster is immediately understandable even without the text, which curves around the bottom and right-side borders to form a typographic frame. Another poster designed by SPBA member José Espert uses a similar strategy to communicate the Italian menace. For his poster *Rise up against the Italian Invasion of Spain* Espert positions a massive boot filled with generic soldiers carrying an Italian flag squarely in the middle of an outline of Spain (fig. 50a). Just as Oliver indicated, by having a hand cast shadows across Iberia, the destruction to be wrecked on the country by a foreign-led invasion, Espert has the country burst into flames as a visual indication of the destruction that will follow in the wake of fascism.

Oliver was born in Barcelona but moved to Madrid when he was about fourteen years old. He worked at the advertising agency of Helios and Floralia and later became the artistic director of the agency Publicitas. Following the war, he was featured in such postwar design magazines as *Arte commercial*.
Jordana Mendelson

The Handshake

51

Antonio Arias Bernal (1914–1960)
United States
Unity Is Strength (La unión es la fuerza),
late 1930s
40¹/₂ x 29 in.
Hoover Institution Archives

• The founder of numerous Mexican humor magazines, Antonio Arias Bernal was internationally renowned for his antifascist caricatures. In *Unity Is Strength* Mussolini, Hitler, and Hirohito cower beneath the handshake of a worker and a soldier. The idealized bodies of the pair emerge from the smoke of an oil refinery to convey the idea that the productive forces of national industry give rise to a body politic whose cooperative energies will trump fascism, east and west. The worker-soldier pairing not only refers to the crucial contribution of Mexican oil to the Allied war effort but also to the alliance of workers and soldiers (as well as peasants and public employees) under the newly formed Party of the Mexican Revolution (Partido de la revolución mexicana). Both the soldier and the refinery worker are nationalist symbols, as the expropriation and nationalization of the Mexican oil industries in 1938 had signified a rejection of foreign capital.

The Office for Inter-American Affairs, a U.S. government organization that sought to counter fascist and Nazi inroads in Latin America, distributed *Unity Is Strength*. In 1952 Arias Bernal was awarded the Maria Moors Cabot Prize of Columbia Journalism School for his prolific work focusing on antifascism and inter-American cooperation.
Jason Glick

52

Artist unknown
Union of Soviet Socialist Republics
The Third Decisive Red Front (Tretii reshaiushchii rot front), 1931
39³/₄ x 27³/₄ in.
Published by Central State Publishing House and State Publishing House for Art (OGIZ-IZOGIZ), Moscow and Leningrad, authorized by Glavlit, the state censorship authority
Hoover Institution Archives

• The small print at the top of this poster exhorts "Workers of the world, unite!" Two arms, coded proletarian by their rolled-up shirtsleeves, obey without further ado. Their vigorous handshake—the declaration of their solidarity across national borders—quickly transforms itself into a weapon with which to pound their mutual enemy: the jagged-toothed, top-hatted, monocled capitalist. The vile creature wears a cravat composed of English, French, German, and American flags and a Nazi insignia. As capital is crushed, its allies stumble. On the right is the Roman Catholic Pope ("Papa"), who is so fat (read: greedy) that the blow knocks him to the ground, toppling his papal triregnum. The frock-coated figure at left loses his bowler and flaps his hands in consternation. The label on his back reads "2d International," which identifies him as a member of the international federation of socialist parties and trade unions that had existed between 1889 and 1914.

As this loose federation had been dominated by German Social Democrats and had given its support to its members' governments at the outbreak of World War I, it was detested by the Bolsheviks, who spearheaded the creation of the Third (or

Communist) International in Moscow in 1919. The Comintern entered its "third period" in 1928, when it denounced all Social Democrats as "social fascists." The Russian words *tretii reshaiushchii* ("third decisive"), stamped on the left side of the handshake and the German phrase *rot front* ("red front") on the right refer to this period of the Comintern.

The unknown designer of this lithograph deploys two different graphic styles. While the handshake is represented as a drawing and triggers associations with various socialist realisms, the caricature used for the rest of the image recalls the Russian civil war–satirical posters by artists such as Viktor Deni.
Maria Gough

53

John C. Atherton (1900–1952)
United States
Buy a Share in America, 1941
28³/₈ x 20³/₄ in.
Printed by U.S. Government Printing Office, Washington, D.C.
Hoover Institution Archives

• Another in the series of World War II bond posters, *Buy a Share in America* was designed as an entry in the National Defense Poster Competition. To channel the creative energies of American artists into the war effort, New York's Museum of Modern Art organized this competition in 1941 with the sponsorship of the Army Air Corps and the Department of the Treasury. John C. Atherton, a prominent commercial artist, won first prize in the defense-bond category with a design that shows the influence of Lester Beall's posters for the Rural Electrification Administration (see *A Better Home*, no. 115).

Atherton's red, white, and blue poster, featuring a factory as the backbone of America's defense effort, a symbolic handshake, and a catchy slogan, was a tribute to the spirit of private enterprise. The firm handshake at its center, with one hand representing the government and the other representing the worker-shareholder, seals what is simultaneously a business deal and a social pact. Published in a variety of sizes, the design was displayed as a forty-eight-foot billboard on the corner of Forty-second Street and Fifth Avenue in New York, one of America's busiest intersections.

The poster invited investment in savings bonds and stamps—stamps are omitted in one version—as a means to permit even children to participate in the war effort. In comparison with bonds, saving stamps were easy to buy and cost only ten cents apiece. Children placed them in

stamp books that, once completed, could be traded for bonds.
Wei-en Tan and *Jeffrey T. Schnapp*

54

Artist unknown
Mexico
National Workers' Council (*Consejo obrero nacional*), early 1940s
Screenprint, 36¹/₂ x 27¹/₂ in.
Hoover Institution Archives

• Two muscular hands join in agreement in front of a large hammer and the Mexican flag. The National Workers' Council (Consejo obrero nacional), a Mexican government organization established in 1942, was the state's solution to its conflicting need to support labor unions without alienating big industry. The flag emphasizes the state's legitimacy as arbitrator of disputes between business and labor, and the message is of national unity rather than class struggle. During the 1940s President Manuel Ávila Camacho slowly abandoned the socialist ideals of a workers' revolution in favor of a state apparatus that sought control over labor unions. In 1942, for instance, Mexican labor unions were made to sign an agreement not to strike for the duration of World War II on the argument that the health of the nation depended on maximizing production through the cooperation of labor and capital.

The two hands stand in for a much larger number of bodies and social forces: workers represented by major labor unions, corporations (rail and electric firms had been the target of frequent strikes throughout the 1930s), and the politicians who brought the two together. By capturing the precise moment at which this social pact is sealed by a handshake, the poster emphasizes cooperation as the defining mode of interaction between labor and business in socialist Mexico. But handshakes can prove fleeting. After some sharply antagonistic organizing efforts in February 1945, the Confederation of Mexican Workers (Confederación de trabajadores Mexicanos), the nation's largest and most powerful union, was promptly expelled from the National Workers' Council.
Jason Glick

55

Sabinsky & Vesely (lifedates unknown)
Czechoslovakia
Without the Russian October Revolution There Would Be No 5 May (*Bez Ruské říjnové revoluce: Nebylo by 5. Kvĕtna*), 1945
36¹/₂ x 24³/₈ in.
Printed by M. Schulz
The Wolfsonian–Florida International

University, The Mitchell Wolfson Jr. Collection (TD1991.55.36)

• Judging by its inscription, the poster was published for the Communist Party of Czechoslovak on the occasion of the 1945 anniversary of the Bolshevik Revolution (October 1917, according to the old-style calendar), here referred to as the Russian, rather than the Soviet, Revolution. The poster suggests that Czechoslovakia could not have been liberated from the Nazis in May 1945 had the Soviet Union not been ruled by the Communists. Stylized into symmetrically opposed wedges, the Czech and Soviet flags dominate the upper part of the image, while the Czech-Soviet handshake is a montaged photograph.

The handshake itself is distinctive. Bare forearms impress with their articulate veins rather than thanks to their sheer musculature. The significance of a handshake between workers, rather than between peasants or members of the intelligentsia, is unmistakable. Such an alliance follows Communist ideology that defined the working class as the leader in the revolutionary process. Sharply angled flags and the circle placed behind the hands underscore the idea graphically, echoing principles of information design dating to the 1930s.
Jindrich Toman

The Crowd's Voice and Ear

56

Heinrich Vogeler (1872–1942)
Germany
Support Red Aid! The Five-Year Anniversary of the International Revolutionary Fighters Aid (*Schafft rote Hilfe! Fünf Jahre I.R.H.*), 1928
29⁷/₈ x 21 in.
Printed by Peuvag, Berlin and Frankfurt
The Wolfsonian–Florida International University, The Mitchell Wolfson Jr. Collection (TD1990.34.11)

• This poster commemorates the fifth anniversary of the International Organization for Revolutionary Fighters Aid (MOPR, Mezhdunarodnaya organizatsiya pomoshchi bortsam revolyutsii). The catalyst for the group's formation was the conflict following the Red Army's withdrawal from Poland in 1921. The violence there spurred the founding members of the MOPR to organize worldwide worker relief efforts for victims of counterrevolutionary violence.

The activities of the MOPR were varied and wide-reaching, as documented in the multilingual placards depicted in this poster. The first major MOPR effort assisted Bulgarian victims of White Terror after a failed 1923 insurrection. In 1925 an

American counterpart, the International Labor Defense (ILD), took shape. Along with the efforts of the German organization Red Aid Germany (RHD, Rote Hilfe Deutschland), established in 1921 as an extension of the German Communist Party, these groups agitated for workers' causes. They pushed to free political prisoners in fascist countries while caring for imprisoned workers and their families. The MOPR, ILD, and RHD drummed up support for workers' rights around the world, rallying everywhere from Shanghai to San Francisco to Nicaragua. These organizations had helped tens of thousands of people by the time of the 1928 anniversary, as reflected by the masses marching on the lower right.

The artist of this poster, Heinrich Vogeler, had special ties to the RHD and MOPR. In 1895 Vogeler bought a farmhouse, the Barkenhoff, in the northwest German town of Worpsweder, which would soon become an artists' colony. At first the Barkenhoff, renovated in high art-nouveau style, served as a commune and trade school. In the wake of World War I, Vogeler grew increasingly concerned with the fate of the proletariat and abandoned his decorative mode. In the early 1920s he converted the Barkenhoff to a children's home, the first of two such homes run by the RHD. Finally, in 1931 Vogeler emigrated to Russia to work for the MOPR in Moscow, where he remained until his death in 1942.

Heather Farkas

57

Artist unknown
Union of Soviet Socialist Republics
1 October—All-Union Day of the Shock Worker (*1 Oktiabria—Vsesoiuznyi den' udarnika*), 1931
42 x 29 in.
Published by Central State Publishing House (OGIZ), authorized by Glavlit, the state censorship authority
Hoover Institution Archives (RUSU1670)

• Masses of red-drenched workers from across the Soviet republics, east and west, march toward the viewer, shouting in unison "We are reporting!!!" ("My raportuem!!!") as they point toward their palaces of labor represented by a montage of heavy-industrial plants. "We are completing the construction of the foundation of socialist economics!" they continue. "The task of building socialism in our country will be pursued to the very end!"

No ordinary workers, these are the dazzling shock troops of industry. A new type of Soviet worker born of the industrialization drive known as the First Five-Year Plan (1928–32), the shock worker (*udarnik*) is a

kind of superworker, who, "awash with adrenaline and productive frenzy," performs "spurts of heroic labor." Shock workers undertake longer shifts and exceed production norms. Because of their extraordinary efforts the First Five-Year Plan is fulfilled in only four years and three months. In their honor 1 October is decreed shock-workers' day.

By implicitly inviting the viewer to join the ranks of the superworkers, *1 October—All-Union Day of the Shock Worker* participates in one of the many recruitment drives that are a mainstay of the plan years. Significantly in this poster, it is the shock workers who attempt to mobilize the viewer. Even the conical configuration of their march toward us amplifies their voices as it recalls that staple of the mass rally, the megaphone.

Maria Gough

58

Norman Rockwell (1894–1978)
United States
Freedom of Speech, 1943
40 x 28 in.
Printed by U.S. Government Printing Office, Washington, D.C.
Hoover Institution Archives (US1663)

• In this popular lithograph the painter and illustrator Norman Rockwell places a central figure in the act of speaking at a town meeting, surrounded by his listening neighbors. The words "Save Freedom of Speech," and "Buy War Bonds" frame the picture. The figure stands in front of a blackboard—the artist's name is in the upper-right corner—which visually emphasizes the speaker's presence.

Originally a painting, Rockwell completed *Freedom of Speech* after hearing President Franklin Roosevelt's congressional address of 6 January 1941, his "Four Freedoms" speech. Three other works were painted for the series, *Freedom from Want*, *Freedom to Worship*, *and Freedom from Fear*. When the government initially rejected Rockwell's paintings, *The Saturday Evening Post* published the four paintings in four successive issues beginning on 20 February 1943, alongside a short story from a noted author. An essay by Pulitzer Prize-winning author Booth Tarkington accompanied *Freedom of Speech*.

The success of Rockwell's visual translations of abstract concepts was so compelling that four million posters were printed during the war. They illustrate the potential power of using accessible words and images to convey the messages of liberty and democracy to those at home and on the battlefield. The four scenes from

everyday life became centerpieces in the government's massive war bond drive and explicitly implied that buying war bonds was essential to the defeat of the Germans and Japanese and to the preservation of fundamental freedoms. The campaign raised a total of 132 million dollars.

Rhonda C. Goodman

59

Artist unknown
United States
Youth Accuse Imperialism
(*La juventud acusa al imperialismo*),
late 1960s
31 x 22 in.
Hoover Institution Archives (INT257)

• The poster was published by the World Federation of Democratic Youth (WYDF), a once Soviet-aligned youth organization that exists to this day as a consortium of socialist and communist youth groups. WYDF's mission is to organize international congresses and festivals, where students rally against colonialism "in all its manifestations," including foreign aggression, economic domination, and the stationing of troops on foreign soil. This poster was likely distributed at the 1968 festival in Sofia, Bulgaria, where WYDF delegates convened in the spirit of "Anti-Imperialist Solidarity, Peace, and Friendship."

Youth Accuse Imperialism makes visual the internationalist principle of solidarity. In several juxtaposed frames masses of youth rally against imperialist aggression. German signs demand freedom and neutrality for Vietnam while decrying the United States' use of napalm and other poisonous gases. One sign asks whether West Berlin, another U.S.-"occupied" territory, will be the next target of napalm bombing. Chinese posters condemn the U.S. occupation of Okinawa. The protestors are united not only by their shared ideology but also by their nations' proximity to U.S. military troops, who appear in the poster as repressive state agents, clashing with protestors. International organizing against imperialism solidifies in the form of a single iron-faced man, whose cry unifies the messages of the several crowds.

The poster stands out as an attempt to articulate the unity of international voices against imperialism. Yet *Youth Accuse Imperialism* also exemplifies the pretense of European Communist groups to speak for those most affected by colonialism. WYDF held its conferences "in the spirit of" the 1955 Bandung Conference in Indonesia, where Asian and African nations had met to oppose colonialism. Yet from

its founding in 1945, WYDF exclusively convened festivals in Soviet-bloc countries, with the nominal exception of Havana (1978).

The group ultimately failed to prioritize the voices of colonized peoples. In *Youth Accuse Imperialism,* for example, the only specter of Africa is a lone black fist in the lower-right corner logo.
Jason Glick

60

Artist unknown
United States
Are You a Megaphone Mouth? 1942
15^1/$_2$ x 11 in.
Printed by Barnes-Wiley
Hoover Institution Archives (US5930)

• Dressed in a white shirt, tie, and cap, the cartoon figure pictured here appears to be a member of the U.S. armed forces, as indicated by his prominent buzz cut. The rendering is an unconventional representation of military personnel, but this oddity is precisely how the poster makes its point. This weak-chinned fellow is a "megaphone mouth," a comical stereotype of the treasonous rumormonger. His scrawny physique and the yellow background underscore the cowardly nature of his gossiping and distance him from the military viewer.

This poster was published in 1942 by the Western Defense Command and Fourth Army, headquartered in the San Francisco Presidio. Led by Lieutenant General John L. DeWitt, this same corps oversaw the internment of about 120,000 individuals of Japanese ancestry in camps across the western United States. With fears of security breaches, such an image would have resonated deeply in the context of a military compound, where this poster probably hung.
Kevin Smith and *Heather Farkas*

61

Charles Howard (1899–1978)
United States
Serve in Silence, mid-1940s
Serigraph, 22 x 17 in.
The Wolfsonian–Florida International University, The Mitchell Wolfson Jr. Collection (1997.9.10)

• *Serve in Silence* is among a multitude of propaganda posters devised in the United States during World War II to emphasize the need for national discipline and resolve. Like *Enemy Ears Are Listening* (no. 65), Charles Howard's poster warns against networks of spies possibly operating throughout the United States, eavesdropping on information about troop and ship movements and war production. It was feared that any civilian worker or soldier might inadvertently endanger the nation by revealing details of the war effort. Between 1942 and 1944 dozens of posters on this theme were posted at factories, ports, and U.S. military bases throughout the world to promote a strict "tight lips" policy. One popular song counseled, "Shh! Don't talk too much. …. Boy, don't be too hip … 'Cause a slip of a lip might sink a ship." The combined message to the public was unequivocal: be cautious with information, the enemy is everywhere.

While artists produced posters with a variety of designs, this version of *Serve in Silence* is a rare example that actually depicts the enemy rather than American forces in harm's way. Here the threat is pictured as the Japanese emperor Hirohito, tangled in audio equipment and holding megaphones to his ears, determined to capture the slightest stray sound wave that might allow his imperial army to sabotage U.S. forces.
Jason Glick

62

Artist unknown
France
The Might—The Victory—The Alsace-Lorraine. Read on Fridays Les on dit. *Parisians, Politicians, Literati* (*La force— La victoire—L'Alsace-Lorraine. Lire le vendredi* Les on dit. *Parisiens— Politiques—Littéraires*), 1914–18
47 x 63 in.
Printed by Devambez, Paris
Hoover Institution Archives (FR126A)

• The publication advertised in this poster promises to deliver every Friday the latest rumors—"*Les on-dit*" (from the expression "On dit que," the equivalent of the English phrase, "They say that"). "They" in this case are politicians, military men, society types, an Alsatian woman (in traditional headgear, upper left), chatting conspiratorially about wartime activities. The giant ear serves as the recipient of their whispered confidences and seems to generate an irresistible force attracting rumors exchanged anywhere in its vicinity. The top-hatted gentleman in the lower right, for instance, may believe his secret will find only the ear of the young woman to whom he is confiding. But her hand is placed on the arm of the man behind her, who is funneling everything into the giant ear. The channel of communication is clear: nothing escapes the ear.

The ear serves as a figure for the publication itself—a vast and sensitive receptacle for murmured currents of information. It also by extension stands in for the readership the publication seeks. By reading the week's rumors published here, the public will become a giant collective ear, attuned to the whispered exchanges of the powerful and the influential.
Matthew Tiews

63

Artist unknown
Germany
Pst! 1939–43
33 x 23 in.
Hoover Institution Archives (UK3687A)

• As war broke out in September 1939, the Nazis wanted to maintain the more-or-less unified front they had constructed over the last decade, but the wartime demands of military security often got in the way. With a chaotic and competitive intelligence infrastructure of their own, the Germans could ill afford to lose any information to their foes. The Nazi's master of information manipulation, Reichsminister of Public Enlightenment and Propaganda Joseph Goebbels, launched a precautionary effort to keep the public from inadvertently revealing precious German secrets. The campaign was called "The Enemy Is Listening!" ("Feind hoert mit!"), and it alerted people to be wary of spies in their midst. Such a call to attention made every German a part of the war effort, uniting those on the home front with their husbands, sons, fathers, and brothers on the battlefields. The pervasive effort also had a downside. In addition to raising awareness about foreign intelligence operatives, the posters fostered a culture of paranoia, encouraging civilians to monitor one another and creating a society of oppressive surveillance.

The most recognizable emblem of the campaign was the Shadowman (Schattenmann), seen in this poster. The Shadowman sometimes appeared looming over an image of people talking, but in this case a more abstract scene confronts the viewer. Rather than depicting a single suspicious situation or type of person who might be more likely to spill secrets, the artist has chosen to render the Shadowman on a speckled yellow and black ground out of which the figure seems to emerge. This representation communicates its message in an especially powerful manner because it suggests that spies can materialize out of nowhere.
Heather Farkas

64

Artist unknown
United States
Warning! Walls Have Ears. Be Careful of What You Say! early 1940s
19 x 12 in.
Printed by National Process Company, New York
Hoover Institution Archives (US5933)

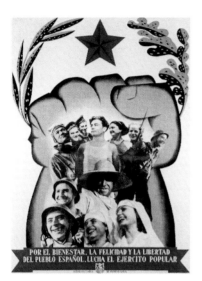

Fig. 66a
Josep Renau
The Popular Army Fights for the Well-Being, the Happiness, and the Freedom of the Spanish People (Por el bienestar, la felicidad, y la libertad del pueblo Español, lucha el ejercito popular), 1937

• As American propagandists refined their strategies to reach the greatest number of people, a split arose between those who believed that posters should be "war art," rich with symbolism and aesthetic merit, and those who felt that the images should read more like engaging advertisements. With the force of clarity on their side, the ad men eventually won out as research teams found that people were sometimes confused by more stylized imagery.

Warning! Walls Have Ears is a good example of a poster that embraces the advertising vernacular. It was likely produced for one of the many agencies (such as the War Advertising Council or the National Advisory Council on Government Posters) that campaigned for public self-censorship with slogans like "Loose lips sink ships!" The simple frontal composition makes the intended warning most straightforward. By employing an ear as a synecdoche for the "body" of the Axis powers, the poster presents its message without any distractions. No other body parts get in the way; the danger at issue lies in the potential for unseen spies to overhear useful information. The large ear seems to hang on a brick wall, as would a poster. The image thereby implies that the Axis spies, represented by a wall-mounted ear, can lurk in the very place where the viewer might find warnings of that threat. As such, the poster works to persuade Americans to mind the possible sensitivity of any information they may choose to communicate whether in private or in public.
Kevin Smith and *Heather Farkas*

65
Ralph Iligan (1894–1960)
United States
Enemy Ears Are Listening, 1942
14 x 26 in.
Printed by U.S. Government Printing Office, Washington, D.C.
Hoover Institution Archives (US5964)

• Ralph Iligan was a commercial artist who also designed posters during World War II, including this one for the U.S. Office of War Information (OWI). President Franklin Roosevelt created the OWI by executive order in 1942 to coordinate the content and imagery of war messages. Clarity was one of the OWI's top priorities. At the start of his tenure as the first director of this powerful organization, Elmer Davis pledged "an end to the conflicting statements which confuse the public." This poster demonstrates that commitment to straightforward communication by the clarity of its imagery.

Like many poster designers associated with advertising firms, Iligan chose a di-

dactic rather than symbolic approach. The heads of state, Mussolini, Hirohito, and Hitler, are as easily recognizable as is their gesture of listening. As the most overt symbol of the nations with whom the United States were at war, their likenesses play on the American fear of revealing vital secrets to the enemy. By demonstrating the threat so overtly, Iligan made the costs of careless talk abundantly clear.

Iligan's posters were highly patriotic, charged with symbols like the Statue of Liberty or the American flag. This example is more sinister in tone as he warns against spies eavesdropping on civilian conversations. The disembodied heads are especially effective in this regard because they give the viewer the sense that the enemy could be anywhere within earshot.
Kevin Smith and *Heather Farkas*

Statistical Persons

66
Artist unknown (possibly Josep Renau [1907–1982])
Spain
Before: Poor Hungry Farmers; Now the Farmer Works and Is Happy (Antes: Campesinos pobres famélicos; Ahora el campesino trabaja y es feliz), 1937
Photomechanical print, 41³/₈ x 28⁷/₈ in.
The Wolfsonian–Florida International University, The Mitchell Wolfson Jr. Collection (TD1988.48.6)

• This poster was one in a series published for the Undersecretary of Propaganda (Subsecretaría de propaganda) during the Spanish civil war. In nearly all examples a red ribbon at the bottom of the poster combined with the dynamic use of photography and vibrantly colored graphics identifying them as the products of a government agency. Didactic in their analysis of complex social, economic, and military issues and policies, the posters rely heavily on images to communicate statistical and comparative ideas (see fig. 66a).

Establishing a contrast between "before" and "after," this poster defends the redistribution of land by the republican government. Comparative statistics highlight the previous dominance of a small number of large estates (*latifundios*) over the larger number of landless peasant farmers. The poster balances the disclosure of its policies as a method to counter international anxiety over the spread of Communism with a reminder that the government was, in fact, dominated by Communists after 1937, when Juan Negrín became prime minister. In the poster this alliance with the Soviet Union is signaled by the individual stars ap-

pearing over three statistical columns describing the amount of land given to farmers by the Institute for Agrarian Reform.

Although this poster is unsigned, Valencian artist Josep Renau may have been responsible for its design. Throughout the 1930s Renau, who was a committed Communist familiar with Soviet agitprop, masterfully used the technique of photomontage (fig. 66a) as an editor of his own political magazine *New Culture (Nueva cultura)* and as coordinator of the photomurals at the Spanish Pavilion for the 1937 World's Fair in Paris.
Jordana Mendelson

67
W.E.M. (lifedates unknown)
Germany
The People Choose List One: National Socialists (Das Volk wählt Liste 1: Nationalsozialisten), 1932
48 x 33 in.
Printed by Adolf Wagner, Kunst im Druck, Munich
Hoover Institution Archives (GE786)

• The years leading to the November 1932 Reichstag elections were grim. Unemployment doubled from 650,000 in 1928 to 1,320,000 in 1929. When Germany looked west, its financial woes amplified. America's economy was in swift decline and the loans made to Germany under the Dawes Plan of 1924 and the Young Plan of 1929 were on the verge of recall. Germany was, in the words of Gustav Stresemann, "dancing on a volcano." Before the end of 1932 more than five million Germans found themselves unemployed. The economic meltdown gave rise to increased nationalism, and the German Nationalist Social Workers' Party (NS-DAP, Nationalsozialistische Deutsche Arbeiter-Partei) was quick to tap into this burgeoning patriotism. The party's program was general, appealing to the unemployed and the middle class, farmers and white-collar workers.

The People Choose List One reflects this moment and movement. The placard's goal is to persuade voters to mark their ballots for the NSDAP. Here, crowds gather in the distance, approaching the large red swastika from the country's four corners. Their bodies, mere dots in the distance, grow in size and definition as they approach the polling place. Yet they are not individual bodies but shapes partially defined by adjacent figures. They are outlined when standing together; they are formless when alone. In the absence of the individual, there is only the collective. This is *das Volk*, the people, collectively choosing a single party. Yet as these bodies become the ink that marks the ballot, they are bodies marked.

While the crowds form the party, they are also formed by it. The looming swastika is a brand from which the people ooze. The heavy red emblem seems to quash the people, and the unbroken form of the numeral one rises up as a beacon and presses down like a stamp. Although the Nazis lost approximately thirty-five seats in the November elections, their party remained the largest in the Reichstag. The momentum gained after the elections thrust Adolf Hitler into the position of chancellor.
Kiersten Cray Jakobsen

68

Artist unknown
United States
New Discharge Scores, 1945
35 x 47 in.
Printed by U.S. Government Printing Office, Washington, D.C.
Hoover Institution Archives (US7824)

• *New Discharge Scores* was produced after the unconditional surrender of Japan to the Allies on 12 September 1945. Victory, however, was not a straightforward proposition. The sheer scale of World War II and the necessities of occupation and reconstruction severely complicated the return home of the victorious armies.

The increasingly complex project of demobilization required Allied command centers to distribute informational posters, such as this example, designed for active servicemen. It was designed first of all to outline the points-based procedure by which servicemen qualified for demobilization. This system had been initially crafted after the European victory to redeploy one million troops to the Pacific, although by the Japanese surrender only 150,000 men had been actually transferred from Europe. Total victory, nonetheless, did not preclude the need to occupy and rebuild both the defeated and victorious nations and thus qualified only a portion of active servicemen to return home. This, along with a series of remarks by General George Marshall on plans for demobilization, is the message the poster seeks to convey to its audience. On its verso, important information is included outlining the transfer of life-insurance policies for servicemen entering civilian life.

Perhaps the most striking feature of this poster is the central photographic image of multitudes of men, bisected by a red typographic band in which is explained the qualifications for demobilization. The pictorial strategy, arresting because of its directness, communicates at a glance what the poster conveys in words, namely, that the move forward into the civilian world is simply a matter of points. Not only, it seems, does the explanation of these points preclude the transformation, but the point system itself stands as a barrier between the soldier and the civilian.
Sebastian de Vivo

69

Artist unknown
Union of Soviet Socialist Republics
The Evolution of Public Education (*Razvitie narodnogo prosveshcheniia*), 1931
26 x 32³/₄ in.
Published by Gosudarstvennoe izdatel'stvo, Leningrad
The Wolfsonian–Florida International University, The Mitchell Wolfson Jr. Collection (TD1989.290.41)

• Industry and agriculture are not the only areas of Soviet production to be subject to rapid acceleration during the First Five-Year Plan. The same is true also for public education, a particularly sensitive domain given the party's belief in the power of education to transform social and political allegiances and the fact that, at the time of the October Revolution, 80 percent of the Russian population was agrarian and illiterate.

Using key visual tools of the statistician—pie charts and graphs—the designer of this 1931 lithograph offers a panorama of the Soviet leadership's projections for across-the-board increases from 1927–28 to 1932–33 in both the number of educational institutions and also the number of students enrolled. In other words, educational evolution by number.

Two pie charts detail the statistics for tertiary institutions, which are called either institutions of higher learning, including both universities and specialized research institutes (VUZy, Vysshie uchebnye zavedeniia), or technical colleges (VTUZy, Vysshie tekhnicheskie zavedeniia). The left chart tells us that in 1927–28 there were 185,000 students enrolled in tertiary education. This figure is then broken down according to areas of study (61,000 in industrial VUZy, 4,000 in transportation, 29,000 in agriculture, 29,000 in teaching, 25,000 in medicine, 31,000 in social economics, and 6,000 in other domains). The pie chart on the right tells us that the plan projects a total enrollment of 209,000 in 1932–33.

While tertiary education gets the lion's share of space, the statistics at the other end of the education spectrum are much more dramatic, testimony to the massive scale of the Soviet literacy campaigns. At far right the number of students enrolled in "schools for the campaign against illiteracy" are projected to rise almost three-fold from 1,315,000 to 3,570,000. In the lower left the number of enrollees in "village reading rooms," where peasants could read or en-gage in faculty-sharpening activities such as chess (Lenin's favorite game), will rise from 21,876,000 to 38,283,000. The number of library readers (lower middle) will increase by about a third from 22,892,000 to 34,338,000, and an evidently new category—the mobile library—will have some 40,000,000 users. The number of students enrolled in "general education courses for adults" (lower right) will almost quadruple from 132,000 to 393,000.
Maria Gough

70

Artist unknown
United States
Women Office Workers, 1934
32 x 24 in.
Printed by U.S. Government Printing Office, Washington, D.C.
Hoover Institution Archives (US4977)

• The data for this poster comes from a study published by the Women's Bureau of the U.S. Department of Labor in 1934. The survey reveals a number of interesting facts about the female office worker. For instance, as of the 1930 census, she was one of 1,973,353 women employed as office workers. She was usually single (only 11.8 percent were married). She had very likely been with her firm for five years or more. She had probably attended high school, but she had a less than 50 percent chance of having graduated. Occupations in advertising, banking, and investment houses were well paid, while work in publishing and mail-order distribution was less lucrative. She most likely regarded herself as a cut above domestic workers and factory employees. Although this was partially class prejudice, it also accurately reflected differences in work conditions. The Woman Office Worker's work hours were shorter, between 38.5 and 42 hours a week, and her eventual salary expectations after ten years of experience as a secretary could be more than two hundred dollars a month.

The Women's Bureau was founded in 1920 with the mandate to investigate and represent the needs of employed women. Over the years the bureau has published reports on women's positions in various industries and fields, tracked the wage differential between men and women, and fought for legislation protecting women at work. This poster captures beautifully the process by which bureau statisticians collected and abstracted women's lives to produce the composite by which the status of the wage-earning woman has entered public debate. The working woman is quite literally seen through the data compiled about her.
Nora Niedzielski-Eichner

71

Gyula Fejes (1895; death date unknown)
and
Ferenc Bokros (1897–1974)
Hungary
1914–1918 Statistics of the Horrible War Years (*1914–1918 Statisztika a háború szörnyű éveiből*), 1919
47 x 37 in.
Printed by Kultura Litogr. Munitezet, Budapest
Hoover Institution Archives (HU114)

• One of the few collaborative works by the artists Ferenc Bokros and Gyula Fejes, this poster, with its blending of word, number, and image, presents a dry, didactic criticism of World War I and the havoc it wreaked on Hungarian society.

In the center of the poster is a serpentine parade of civilians, led by a horse-mounted Grim Reaper carrying a blood-drenched scythe and driven from the rear by a whip-bearing ermine-clad crowned figure. Several soldiers aid the two in carrying out their deadly duty. The legend across the top states: "1914–1918 statistics of the horrible war years," while the bottom reads: "crimes of the past regime." Arrayed above that caption are various statistics regarding the costs of the Great War: the number of dead, injured, captured, missing soldiers, orphaned or injured children, wounded in combat, war widows (above which, without representative figure or background, the number of war blind is listed, the lack of image perhaps being a subtle commentary on the fate of those 750), the natural deaths suffered by eighteen to forty-nine year olds, marriage statistics, and, finally, male births. The figures are each presented with an image set against a black background that seemingly does double duty as a bar graph.

These horrific figures of the war years are contrasted with statistics set on a cloud-like background captioned "1909–1913, in the happy years of peace." Only three relevant peacetime statistics are illustrated: natural deaths among eighteen to forty-nine year olds, marriages, and male births.
Sam Albert

Mass Production / Mass Reproduction

72

Artist unknown
Serbia
English Christmas Greeting to the Serbian People (*Engleska Božiæna poslanica srpskom narodu*), 1943–44 (?)
37¹/₄ x 24¹/₂ in.
The Wolfsonian–Florida International University, The Mitchell Wolfson Jr. Collection (TD1992.39.27)

• In this terrifying testament to the key role assumed by radio broadcasts during World War II, the Grim Reaper dons a stovepipe hat (with traces of a Union Jack on its front) and reaps a harvest of dead Serbian soldiers. A radio unit is superimposed over the illustration on the lower left, accompanied by the inscription, "Radio London announces to the Serb people: 'The more the grass is cut the higher it grows.'"

From the beginning of the war Radio London had been a powerful presence in the Balkan theater, where a native Nazi-supported government ruled over Yugoslavia from the time of the German invasion of April 1941 through the war's end. Although this government ferociously punished citizens for listening to "enemy" broadcasts, many defied the ban.

In the early years of World War II English government policy (and, accordingly, Radio London policy) had been to support the Chetnik resistance movement led by Colonel Draža Mihailović. Solidifying their ties with the British establishment, the Serbian royal family sought refuge in England after the German invasion and lobbied for their Chetnik supporters. The Chetniks' rivals and sometime allies in the anti-Nazi resistance, Josef Broz Tito's Partisans, eventually gained the upper hand in the course of several years of guerilla fighting. In 1943–44, when this poster was probably printed, English support shifted to Tito's Partisans.
Jeffrey T. Schnapp

73

Philippe Henri Noyer (1917–1985)
France
National Radio (*Radio national*), 1941
64¹/₄ x 47³/₈ in.
Printed by Jean Demachy & Cie.
The Wolfsonian–Florida International University, The Mitchell Wolfson Jr. Collection (TD1992.93.6)

• The French National Radio (RFN, Radiodiffusion française nationale) was created in 1939 as a propaganda arm of the wartime commissariat of information. After Philippe Pétain negotiated an armistice with Adolf Hitler in 1940, dividing France into occupied and unoccupied zones, the RFN came under the control of Pétain's collaborationist Vichy regime, which governed the southern portion of the country. This poster advertises a weekly print publication, *Radio national*, that served as the official RFN program guide.

The poster is remarkable in its portrayal of intersecting mass media. Radio waves emanate in concentric circles from the upper-right corner to intersect with the radio dial, out of which branch out the municipal radio stations under Vichy control. The elliptical dial echoes the oval representing the radio wave, indicating graphically the unity of the individual radio stations in a single national broadcast. The concentric radio waves collide directly with the magazine cover, which features a photograph of Marshall Pétain on a dais in front of a radio microphone. In a self-reinforcing feedback loop, the image presents its viewer with the impression of media saturation, the interpenetrating modes of communication requiring the female viewer at once to listen to the radio, buy the magazine, and revere Pétain. It is no accident that the radio program guide featured here is dated May 1941. On 15 May 1941 Pétain gave the decisive radio address in which he announced the principle of collaboration with Hitler.

Philippe Noyer attended art school in Lyon before moving to Paris in the 1930s, where he fell in with the surrealists, whose mild influence can be seen here in the disembodied female hands of the media consumer. He worked as a graphic artist through the early years of the war before achieving success as a painter beginning in 1943.
Matthew Tiews

74

Ans van Zeyst (lifedates unknown)
the Netherlands
Radio Television (*Radio televisie*), 1951
Gouache, ink, and graphite on paper,
5 x 3 in.
The Wolfsonian–Florida International University, The Mitchell Wolfson Jr. Collection (TD1990.340.117)

• Changes were swift in Dutch broadcasting in the immediate wake of World War II. Under Nazi occupation, radio broadcasts had been reduced to a lone state-controlled station and the free radio station known as Radio Orange had to be piped in from London with the help of the BBC. In the years following the war, broadcasters found a rapidly growing audience as receiver ownership quadrupled to more than 1.3 million by 1949. With the construction of Holland's first television transmitters, the country found itself on the threshold of a media revolution. Realizing television's great potential, radio broadcasting companies were quick to get involved in its development. In 1951 they set up the Netherlands Television Foundation (NTS, Nederlandse Televisie Stichting) to handle the complexities and high costs of television production and to coordinate programming. Later that year the government also granted NTS its first broadcasting license, which ushered in a two-year period of experimental transmissions. Although there were fewer than five hundred tele-

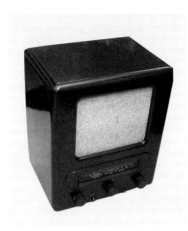

Fig. 75a
Walter Maria Kersting (active twentieth century), Germany
Volksempfänger radio model VE3015, c. 1938
Bakelite electric radio with woven-silk speaker cover, 12¹/₂ x 10³/₄ x 8¹/₈ in.
The Wolfsonian–Florida International University, The Mitchell Wolfson Jr. Collection (XX1990.1046)

Fig. 77a
Radio rurale, c. 1935
Courtesy Alfonso Mignoli

vision sets in the country at the time, the first broadcast featured an address by the prime minister, which attests to the new television industry's importance as a medium for connecting the entire nation.

In this drawing Ans van Zeyst, a Dutch book illustrator, captures the spirit of the moment with a dynamic composition built around the anatomy of the viewer's eye and ear. He references the lengthening reach of the radio and television industries with the sweeping diagonals of the tower and bright screen that swing toward the space of the viewer. The instruments' large scale in relation to the gray globe at the bottom and the division of the background into blue and black suggesting day and night skies indicate, respectively, the extraordinary power of broadcast media to create virtual forms of assembly on a worldwide scale and their ability to overleap time and space. The stylized eye and ear symbolize the two senses used to gather most information. By employing these distilled representations to communicate the acts of watching and listening, van Zeyst makes those activities seem like out-of-body experiences. It is as though radio and television waves had already become part of the ether and could enter the eye and ear without bodily interference. The modern visual vocabulary of bold, flat color and reduced forms seems fitting for an image trying to relay the exciting possibilities of a postwar media frontier in which mass communications would be free from the control of totalitarian regimes.
Heather Farkas

75

Leonid (lifedates unknown)
Germany
All of Germany Hears the Führer with the People's Receiver (*Ganz Deutschland hört den Führer mit dem Volksempfänger*), 1936
47 x 33¹/₄ in.
Published by Preussische Druckerei und Verlags
The Wolfsonian–Florida International University, The Mitchell Wolfson Jr. Collection (XX1990.3116)

• With the invention of a relatively cheap radio called the People's Receiver (*Volksempfänger*) in the early 1930s, Adolf Hitler's disembodied voice could now enter into the homes of virtually every German citizen (fig. 75a). The radio cost just seventy-six Reichsmark (compared to earlier models costing several hundred), and by 1938 a mini-People's Receiver was marketed for a mere thirty-five Reichsmark. Significantly neither radio was sensitive enough to receive signals from abroad.

Immediately following the Nazi Party's seizure of power, Hitler's propaganda minister, Joseph Goebbels, recognized the radical potential of the medium to disseminate the messages of the party and seized control of the German airwaves. In a speech given on 18 August 1933 Goebbels argued that if Napoleon was right to consider the "press as the seventh great power" then the radio "will be for the twentieth century what the press was for the nineteenth." Goebbels explained: "We live in the age of the masses; the masses rightly demand that they participate in the great events of the day. The radio is the most influential and important intermediary between a spiritual movement and the nation, between the idea and the people."

In this poster the radio is literally depicted as the eighth wonder of the world. The towering, transcendental object of attraction pulls the hypnotized masses toward it. The fact that all of Germany could now hear Hitler on their own radios was ultimately a testament to the totalitarian control of the masses. Not only did the radio disseminate the voice of the Führer into virtually everyone's private home, but it also created a new public sphere for the consolidation of the masses.
Todd Presner

76

Max Spielmanns (lifedates unknown)
Germany
Traitor (*Verräter*), 1944
26 x 19 in.
Printed by Deutsche Informationsstelle
Hoover Institution Archives (GE1177)

• Bathed in darkness and crouching in fear, a German listener places his ear against the radio speaker while tuning the dials to Radio London. In the space above him, the words of a German-speaking Briton circulate through the air: "soldiers," "radio London," "radio Moscow," "broadcast West," and "enemy." The concentric circles also mark the coverage area of the radio signals. The poster labels the German listener, who is filling his ears with English propaganda in the last years of the war, an unequivocal traitor to the Nazi cause.

From its inception in 1923, German radio was state-owned and operated. The intention was to prevent any one political party or private interest group from owning the airwaves. Radio technology quickly spread throughout Germany and by the time Adolf Hitler came to power in 1933, half of all households were already wired. Although Nazi control of the German airwaves began immediately after Hitler's seizure of power and continued up through 1945, the medium could never be com-

pletely harnessed by the Nazi propaganda machine. The dialectic of private reception and public dissemination could be disrupted by the very technology used by Joseph Goebbels and the Nazi Party to form individuals into masses of passive listeners.
Todd Presner

77

Oreste Gasperini (lifedates unknown)
Italy
How One Becomes a Teacher of Physical Education (*Come si diventa insegnanti di educazione fisica*), 1938
Photomechanical print, 27⁵/₈ x 39¹/₂ in.
Printed by Tumminelli and Co., Rome
The Wolfsonian–Florida International University, The Mitchell Wolfson Jr. Collection (XX1990.2989)

• Mass outdoor demonstrations of rhythmic gymnastics first established themselves at the end of the nineteenth century, thanks to the support they enjoyed among educational reformers bent on reconciling humanity with nature, culture with physical culture. They grew in importance in the 1920s and 1930s when they became integral to the efforts undertaken by totalitarian regimes to mold a new kind of mass individual and mass society. In fascist Italy such physical training was intended to differentiate youth from their parents, to transform them into "Mussolini's [new] Italian" (*l'italiano di Mussolini*), a hyperactive, disciplined, and muscle-bound member of the national work force, perpetually mobilized and just as eager to lead as to obey.

Oreste Gasperini's poster was the twelfth in a series of more than twenty such inserts designed for the monthly review *La radio rurale*, the program guide of the Rural Radio Agency (Ente rurale radio), designed to promote the diffusion of the national radio network in rural areas. Since the mid-1930s a program of government subventions had supported the production of low-cost "rural radios" (fig. 77a). By means of a scattering of text and halftone images, some silhouetted, mounted along a series of parallel diagonals, the poster illustrates the training of an elite group of youth, teachers of physical education. The viewers are reminded of a special radio program on the topic, scheduled for the morning of 9 March 1938. The text reads: "At the Farnesina . . . banners, trumpet calls, jumps, sport, healthy exercise; at the Orvieto Academy, grace, strength, and discipline, the power of the race." Many of the photographs were shot in Enrico del Debbio's twenty-thousand seat Stadium of Marble Statues (1928–32) in the Foro Italico sports center, in the heart of Rome's Olympic village.
Jeffrey T. Schnapp

78

Artist unknown
Germany
*The SA Calls on You Too to Join Its
Forces* (*Die SA ruft auch Dich in die
Wehrmannschaft*), early 1940s
33 x 21 in.
Printed by Stahle & Friedel, Leipzig
Hoover Institution Archives (GE1079)

• This is a recruitment poster for the SA
(Sturmabteilung), or storm troopers, and
calls for Germans to enlist in the home
guard. The poster was probably produced
in the early 1940s, a time in which the SA
had lost almost all its power and prestige
in Nazi Germany. Consisting of disen-
chanted German soldiers after World War
I, the SA first served as a private army for
Adolf Hitler in the early 1920s. It later
turned into a paramilitary organization dur-
ing the later years of the Weimar Repub-
lic (1919–33), disrupting political meetings
and terrorizing enemies of the Nazi Party.
Under the leadership of Ernst Röhm, the
SA grew to nearly 4.5 million members.
After the purge of SA leaders during the
Night of the Long Knives (Nacht der lan-
gen Messer) on 30 June–1 July 1934 its
importance greatly diminished. The Night
of the Broken Glass (Kristallnacht) pogrom
of 9–10 November 1938 was one of the
last occasions for which the SA was mo-
bilized.

In this poster, printed for the German
National Socialist Workers Party, a series of
photographs are arranged as a film se-
quence to depict various home-guard ac-
tivities undertaken by SA members: training
missions, ground fighting, sports and recre-
ation, and participation in mass rallies. The
poster uses film, certainly the dominant vi-
sual mass medium of the era, to solicit new
recruits.
Todd Presner

79

Pokras (lifedates unknown)
United States
For Our Own—For Our Allies, 1942–45
17¹/₈ x 11¹/₄ in.
The Wolfsonian–Florida International
University, The Mitchell Wolfson Jr.
Collection (TD1995.8.4)

• Formed in 1942, the National War Re-
lief Committee of the Congress of Indus-
trial Organizations collected more than
twenty million dollars in its first year of
existence. Dividing these funds among
members of the nascent United Nations
to provide services to war refugees, the
committee immediately became a politi-
cally and financially significant force among
charitable organizations in the United

States. It solicited donations through work-
er payroll-deduction plans—typically one
hour's wage per month—becoming the
first major philanthropic organization to
utilize unions and workers in its fundrais-
ing efforts. Later it would become part of
the United Way. Posters such as *For Our
Own—For Our Allies* would have been
used in local fundraising efforts through-
out the country.

Set against a backdrop of a smolder-
ing city, the poster portrays a young World
War II refugee clinging to a soldier. A trio
of gloved hands, each signifying an aspect
of the national will, illustrates three types
of contributions to the war effort: industri-
al production, military service, and mone-
tary donations. Several aspects of the
poster emphasize a spirit of unity and uni-
formity: the color and position of the gloved
hands (borrowed from Jean Carlu's prize-
winning 1941 poster *America's Answer!
Production* [no. 80]); the use of collective
pronouns in the text ("for *our* own—for *our*
allies"), and the altruism exhibited by the
formidable, anonymous soldier. Through
such visual rhetoric, self-sacrifice emerges
as the work's dominant motif.
Aaron David Shaw

80

Jean Carlu (1900–1997)
United States
America's Answer! Production, 1941
30⁵/₈ x 40³/₈ in.
Printed by U.S. Government Printing
Office, Washington, D.C.
Hoover Institution Archives

• Printed at the time of the U.S. entry in-
to World War II, *America's Answer! Pro-
duction* heralds the nation's ongoing
industrial expansion that, under the Lend
Lease Act of 11 March 1941, had supplied
British and Soviet armies and would soon
also supply the nation's own growing mil-
itary. The exuberance of Jean Carlu's
poster would prove fitting. American in-
dustrial production doubled between 1939
and 1945. The modern military-industrial
complex was born as the United States
awarded tens of billions of dollars in mili-
tary contracts annually to the nation's
largest corporations. Although the major
war powers all augmented their productive
capacities, the United States was partic-
ularly successful in converting existing
commercial plants and in building entire-
ly new factories. In this outstanding ex-
ample of midcentury graphics, the wartime
conversion of the economy is likened to
the mere tightening of a bolt. The graph-
ic gesture also suggests the temporary
quality of the economic adjustment.
Dozens of factories were opened that

would be abandoned as surplus a few
short months after the war's end.

As political propaganda, this poster,
produced for the Division of Information of
the Office for Emergency Management,
marks a thematic break in Carlu's oeuvre as
a commercial graphic artist (carried on in
France with the exception of the wartime
period). Yet the visual style follows his long-
standing philosophy of seeking "the graph-
ic expression of the idea" (*l'expression
graphique de l'idée*), by which a subject is
presented with bold images and minimal
text. The force of the poster stems from its
extreme graphic economy, which, perhaps
inevitably, obscures the narrative of the me-
chanics of production. The anonymity of
the worker's glove focuses the message on
national mobilization and prosperity rather
than on the composition of the nation and
its labor force. By collapsing the populace
into a single gloved hand, the poster con-
ceals the productive forces that facilitated
the economic triumph: the contribution of
millions of women newly employed in fac-
tories and Mexican braceros working on
railroads and in agricultural fields. *Ameri-
ca's Answer! Production* won Carlu a New
York Art Directors Club medal.
Jason Glick

81

IZORAM Collective
Union of Soviet Socialist Republics
Let's Crush the False Shock Workers
(*B'em po Izheudarnikam*), 1931
27¹/₂ x 41 in.
Published by State Publishing House for
Art (IZOGIZ), Moscow and Leningrad
Hoover Institution Archives (RUSU1748)

• Soviet graphic designers working in the
service of the Five-Year Plans (see nos. 23,
57, 69) made hundreds of posters ex-
horting workers to become shock work-
ers and join industrial shock brigades
(*udarnye brigady*). More particularly, this
poster addresses a problem that emerges
once this form of socialist competition is
underway: the "false shock workers"
(*Izheudarniki*), those who pretend to be
shock workers to secure the privileges
that come with the title (preferential allo-
cation of living quarters and scarce goods,
promotion into management, and even
fame and glory).

Designed by the Leningrad-based IZO-
RAM Collective (its insignia appears at
lower left), the poster employs two dif-
ferent graphic techniques: the silhouette
and the cartoon. The poster's hero is a
Promethean foundry worker who appears
in red silhouette not once but three times
to convey the exquisite mastery of his
hammer swing. Note the hyperextension

of both his body and the hammer's handle as he summons his strength, compared with their contraction as he brings his movement to completion. (To raise labor productivity an entire institute in Moscow had been devoted to teaching this skill, drawing on the time-motion studies of F. W. Taylor, Henry Ford, and Frank and Lillian Gilbreth.) So perfectly articulated is the hammer's passage through space, that the form it traces is none other than that of a sickle. This hammer cum sickle strike the head of a hungover pseudoshock worker, who is still asleep even though it is after nine. Cartoonlike vignettes retrace this slacker's movements over the past day. At left, he loudly announces that he, too, is a shock worker. In the middle vignette he sits eating fish and swilling beer. Before long, he is fast asleep. As a result, the two machines at far right are at a standstill, even though the workday has begun (one complains, "Will I be idle for long?" while the other shouts, "Down with false shock workers!").
Maria Gough

82

Gustav Klucis (1895–1938)
Union of Soviet Socialist Republics
1 May: To the Battle for the Five-Year Plan, for Bolshevik Speed, for the Defense of the USSR, for World October
(*1 maia: V boi za piatiletku, za bol'shevistskie tempy, za oboronu SSSR, za mirovoi oktiabr'*), 1931
$40^{3}/_{4}$ x $28^{3}/_{4}$ in.
Published by State Publishing House for Art (IZOGIZ), Moscow and Leningrad
Hoover Institution Archives (RUSU1746)

• May Day has arrived and the urban proletariat spends its day celebrating all things good and Soviet: the Five-Year Plan, Bolshevik speed, the defense of the USSR, and world October. Under a scarlet sky and dramatically framed by a cluster of industrial colossi, a great rally of workers, seemingly infinite in number, marches past the viewer. A banner announces its destination: "Forward toward the decisive speeds of the Five-Year Plan."

Often described as the pioneer of Soviet photomontage, Gustav Klucis (like Varvara Stepanova, Aleksandr Rodchenko, and El Lissitzky, among others) brings avant-garde credentials earned during the early 1920s to the task of representing the policies of the Stalinist leadership in the 1930s. As the latter decade progresses, however, his work in the medium changes dramatically. The multiple spatial systems and disjunctions of scale that we see in this poster yield in the lat-

er 1930s to the perspectival reorganization of space around a dominant horizon and more normative scale relations. In addition, the thematics of industrial production that dominate such photomontages as this one give way to an almost exclusive focus on Joseph Stalin himself. Despite his increasing accommodation to and glorification of the Soviet leader, Klucis, a member of the Latvian minority in Moscow, was summarily executed in 1938 by the Soviet secret police.
Maria Gough

Kill Counts

83

Artist unknown
Poland
Bolshevik Freedom (*Wolność Bolszewicka*), 1920s
$42^{7}/_{8}$ x $31^{1}/_{8}$ in.
Published by Wydział Propagandy
Hoover Institution Archives

• The Polish Republic began its existence in November 1918 and, almost immediately, the fledgling republic was embroiled in six concurrent wars, among them the Polish-Soviet conflict that witnessed the killing in combat of sixty thousand Poles and as many as eighty thousand Red Army troops.

Bolshevik Freedom portrays the Red Army's counteroffensive during this war as brutal and depraved. The nude red figure in the foreground, with his glasses and goatee, bears a striking resemblance to Leon Trotsky, the Red Army's commissar of war. In his left hand, he holds a pistol, another identifying feature of a Bolshevik revolutionary. The bloody knife in his right hand is a weapon more graphically symbolizing Bolshevik participation in Polish bloodletting. The figure, shown in profile to emphasize stereotypically Semitic features, sits on a growing pile of Polish skulls and surveys the activities of his troops while listening to the directives of a white-shrouded death's head whispering in his ear. The four Bolshevik soldiers depicted behind him are all engaged in ignominious acts of looting, removing boots and other possessions from an indistinguishable mass of dead or dying Polish soldiers. In the distance, separated from the violence by a field of snow, a recognizably Russian landscape, with an onion-domed church, is being consumed by the flames of its own revolution and civil war.

The nude figure's red coloring intensifies Trotsky's association with the Red Army (Bolshevik posters frequently depicted Russian soldiers dressed entirely in red), while simultaneously evoking the demon-

ic. Demonization of the Bolsheviks, particularly those of Jewish descent, was a constant theme in the Polish press and in Polish political rhetoric throughout the 1920s and 30s.

The poster's text underscores the duplicity of Bolshevik revolutionary slogans, both in its title "Bolshevik Freedom" and in the further explanation offered in a text box in the lower-right corner: "The Bolsheviks promised, 'We will give you peace, we will give you freedom, we will give you land, work, and bread.' They despicably deceived. They provoked war with Poland. Instead of peace they gave a fist; instead of land, requisitions; instead of work, poverty; instead of bread, hunger." Coupled with the unambiguous visual depiction of violence and destruction, the text reinforces the Polish government's vilification of an enemy whose despicable actions contradict high-minded revolutionary rhetoric.
Margarita Nafpaktitis

84

Artist unknown
United States
Über Alles, 1917
11 x 21 in.
Published by Barron Collier
Hoover Institution Archives (US1212.33)

• The kill counts from World War I were staggering. Caught in a two-front war, Germany suffered nearly two million deaths. More than 75 percent of the twelve million Russian soldiers mobilized were either killed, wounded, or went missing. More than one million French died, and nearly as many British. The United States did not enter the war until 1917 and during its relatively short involvement, more than one hundred thousand men lost their lives. As the fighting reached its conclusion, many wanted to know how this massacre could have happened.

With its depiction of a German commander as the devil, this poster effectively places the blame for the bloodshed on the German elite. The officer's hooved feet encased in shiny black boots and his tail clearly portray him as satanic. This is no ordinary soldier fresh from the trenches. His helmet, blood-stained cape, and sword, dripping with blood, all point to his demonic status.

The text *Über Alles* quotes from "Das Deutschlandlied," the national anthem of Germany, sung to the tune of the String Quartet in C Major (the Kaiser Quartet), composed in 1797 by Joseph Haydn. It suggests that this figure is the winner of the epic death match, but his expression complicates this reading. The words are here used ironically to trumpet the emptiness of a Pyrrhic victory. The officer frowns atop a mountain

of skulls, some small enough to be children's, but the reason for his grimace is unclear. Perhaps he wishes he could kill more, or perhaps the loss of human life was so great that even the devil feels regret. To be sure, he has reached the summit, but given the blackness surrounding him it seems that there is nothing to celebrate.

The exact circumstances of this poster's creation are difficult to ascertain, but, given the heavy cardstock on which it was printed and its relatively small size, it is probable that it was intended for placement in streetcars. Its publisher, Barron Collier, was a developer, hotel magnate, and advertising executive who made his fortune in streetcar advertising.
Heather Farkas

85

Sherman Raveson (1907–1974)
United States
Disarm or Be Destroyed! Write the President—The Disarmament Conference Must Succeed! 1931–32
11 x 21 in.
Published by World Peace Posters, New York
Hoover Insitution Archives (US5523)

• With more than three hundred thousand American dead and wounded, World War I took an extraordinary toll on the nations involved, threatening to wipe out an entire generation of young men. In this poster Sherman Raveson, art editor of *Vanity Fair* from 1929 to 1934 and of *Life* in 1935, plays on fears of repeat carnage. Under a looming skull and skeletal hands he presents the symbols of destruction on the western front. Barbed wire and tanks disfigure a desolate landscape punctuated by cannon barrels, bayonets, and tombstones. Wounded soldiers haunt this horrific environment, some wailing in distress, others calm in stony shock. At the center of this bottom register, a small hand reaches up, apparently calling for help. The message of the poster is unequivocal: make sure such atrocities never happen again.

One chief concern of the international community at the end of the war was disarmament. But the United States, due to its isolationist stance and abstention from the League of Nations, was not always at the forefront of those efforts. World Peace Posters, an organization formed by twenty New York women in 1931, commissioned works such as *Disarm or Be Destroyed!* to promote a more active engagement in world affairs. Chaired by Theresa Mayer Duilach, the group placed posters in public buildings, schools, clubs, and commercial organizations throughout

New York to rally public support for international peace-making efforts. In 1931 Duilach was one of sixty-six peace leaders who signed a plea to President Herbert Hoover to push for success at the 1932 World Disarmament Conference held in Geneva. They hoped he would accept cuts on arms expenditures, prohibit the use of biological weapons, and establish a disarmament watchdog commission. Not even Raveson's apocalyptic vision could foretell the level of suffering that would result from the ensuing conflict and arms race.
Heather Farkas

86

Artist unknown
Union of Soviet Socialist Republics
There Is Nothing to Eat! Nothing to Sow! (*Nechego est'! Obsemenit'sia nechem!*), c. 1921
27 x 42 in.
Published by Central State Publishing House (OGIZ), Moscow
Hoover Institution Archives (RUSU749)

• This early Bolshevik poster is designed to be read in a systematic fashion from top to bottom and left to right. The line of text at the top of the sheet announces the poster's subject: "There is nothing to eat! Nothing to sow! Next year it will be even worse if we don't supply the Volga!" In the center the gaping mouth of the Grim Reaper drips with victims of the Volga Valley famine of 1921–22 (just a handful of the five million or so who eventually died). Directly above his skull-like head, we read: "Carrion are eating people! People are eating the dead! Ten million will die if there is no bread." At upper left the poster exhorts the viewer to ponder some simple arithmetic: if 1,346 million *pud* (about 22 million tons) of grain are needed for sowing and food, but only 741 million (around 12 million tons) have been harvested this year, then there is a shortage of 605 million *pud* (about 10 million tons). Given that Russia itself cannot provide any more grain, the poster continues, from where is the shortfall to come? In the left vignette, we learn that the foreign bourgeois (the fat, frock-coated and top-hatted figure) have plenty of grain but are demanding payment in gold. From where will we obtain gold? Our worker-peasant treasury (signified by the small red figure proffering but one gold coin) is poverty-stricken. What, then, to do?

On the right side of the poster is offered the following solution: "In the churches there are many valuable things: gold, diamonds, and silver. We need to seize the treasures of the cathedrals, synagogues,

Roman Catholic churches, and mosques. We need to turn gold into bread." A Bolshevik remake of the sacrament of the Eucharist then follows. A large red figure stands in front of the gilded domes of an orthodox church. He holds a silver-encased icon in his left hand and, with his right, delivers a sack of grain to the starving people of the Volga prostrate before him. "Look here," the poster commands. A sign hung on the icon tells us that its casing comprises "one *funt* of silver" (about $14\frac{1}{2}$ ounces), which presumably buys the "25 *puds*" (roughly half a ton) of grain piled up behind him. "Each *funt* of silver will save a family of five until the next harvest." The final punchline runs along the bottom of the sheet: "What are the ecclesiastical riches giving??? Russia is supplied with bread both this year and next!!!" With this proposal the Bolsheviks hope to achieve two goals at once: provide famine relief and nationalize ecclesiastical property.
Maria Gough

87

Heinz Fuchs (1886–1961)
Germany
Worker: Hunger and Death Draw Near—Strikes Destroy, Work Nourishes—Do Your Duty, Work (*Arbeiter: Hunger Tod naht—Streik zerstört Arbeit ernährt—Tut eure Pflicht, arbeitet*), 1919
27 x 37 in.
Hoover Institution Archives (GE666)

• Created during the tumultuous early years of the Weimar Republic (1919–33), this expressionist poster urges striking workers to return to their jobs as "hunger and death draw near." A wildly distorted figure of death crushes the workers, while blood-stained words graphically convey the consequences: "Strikes destroy, work nourishes. Do your duty, work."

Following the unprecedented devastation of World War I as well as the political and economic upheaval after the November 1918 Revolution (which overthrew the Kaiser and led to the established of the Weimar Republic), the poster identifies work as a duty for the stability of the future. Using pictorial techniques pioneered by the expressionists—garish colors, harsh lines, distorted figures, and blunt graphic text—Heinz Fuchs, a painter who had studied with Louis Corinth, sought to enforce the work ethic as a way of preventing further disintegration. In sharp contrast to the message of this poster, the political sympathies of most expressionist artists (such as Käthe Kollwitz or Lionel Feininger) were unequivocally on the side of the striking workers.
Todd Presner

88

Artist unknown

Iran

The Power of an Awakened Nation Is Victorious over All the Arms of the Superpowers—Imam Khomeini, early 1980s

28 x 20 in.

Hoover Institution Archives (IR77)

• The poster is datable to the Iran-Iraq war (1980–88) and translates into graphic images the fundamental philosophy of the war as articulated by Ayatollah Khomeini. During this period the Islamic Republic of Iran found itself isolated on the international front. It was subject to an arms embargo, while its enemy-invader Iraq was receiving assistance from most of the world's major powers, including the Soviet Union and the United States.

Iran used human-wave assaults to counter the supremacy in firepower enjoyed by the Iraqi army during the conflict. The message of the poster is clear: an "awakened nation" can shatter any sophisticated weaponry. What is required, however, is the blood of martyrs. Once again, the severed bloodied hand, reminiscent of Imam Hussein's martyrdom in Karbala (see nos. 30, 47) and of the five saints of Shiism (see no. 30), is the force that can overcome the power of modern arms. The dominant red, white, and blue of the background discretely conjure the colors of the American flag even though the poster makes no explicit mention of U.S. support of Saddam Hussein.

Abbas Milani

89

Artist unknown

United States

This Is Our Only Vietnam Deadline, early 1970s

22 x 17 in.

Hoover Institution Archives (US8115)

• After openly condemning charges of Communism leveled at antiwar protesters in October 1965, some of the nation's leading clergy formed the group Clergy and Laymen Concerned about Vietnam. Disturbed by the escalating violence in Southeast Asia, the New York-based coalition pushed for an end to the American bombing campaign and an expedited peace settlement. By 1968 Clergy Concerned boasted sixteen thousand members, including Rabbi Balfour Brickner, director of interfaith activities for the Union of American Hebrew Congregations, and Rev. John C. Bennet, president of the Union Theological Seminary. Among the organization's most memorable activities were the 1967 Fast for

Peace, which lasted three days and drew participants from thirty-seven states, and the endorsement of Martin Luther King, Jr., in his 4 April 1967 speech "Beyond Vietnam: A Time to Break Silence." More sharply critical of the war was the group's 1968 publication *In the Name of America*, a 421-page volume signed by twenty-nine Catholic, Protestant, and Jewish leaders. The report paired the rules of warfare as set at the Hague and Geneva conferences with news accounts from Vietnam, concluding that American conduct had consistently violated almost every international agreement.

The primary focus of Clergy Concerned was to agitate for the safe return of American troops, and *This Is Our Only Vietnam Deadline* is emblematic of that effort. The choice to use the rhetoric of the deadline was not arbitrary. Presidents Lyndon Johnson and Richard Nixon both tried to set deadlines for peace and for withdrawal during the course of the war, but these dates often proved incompatible with their administrations' drive to emerge from Vietnam victorious. With its lines of dead stretching back as far as the eye can see, the grainy imagery visualizes the grim cost of such stubbornness. As the gravestones recede to the edge of the photograph, it becomes apparent that by the time of this poster's creation the numbers of dead soldiers had climbed dramatically. The poster's text calls on the viewer to take action to stem the tide of flag-covered coffins. This call to write Congress, to work within the existing governmental structure, demonstrates the moderate nature of Clergy Concerned. Although many members advocated conscientious objection to the draft, their most pressing concern was for an end to the violence in Vietnam.

Heather Farkas

Totems

90

Samuel Cherry (1908 – c. 1990)

United States

Join! Heed Their Appeal, 1939–45

30 x 20 in.

Hoover Institution Archives (US8533)

• The symmetrical red cross featured in this poster was established as the emblem of wartime relief under article 8 of the resolutions of the 1864 Geneva Convention: "they shall wear in all countries, as a uniform distinctive sign, a white armlet with a red cross." Its emblematic status was intended to shield wartime humanitarian workers from attack. The cross's resonance with a Christian humanitarianism is evident

in this poster by Samuel Cherry, one of America's most popular pulp illustrators, responsible for countless alternately saccharine and risqué book and magazine covers, ranging in genre from Westerns (*Ranch Romances* and *Zorro*) to detective tales and romance novels.

Here Cherry encourages the viewer to join the crowd in supporting a universal ideal. Since the backs of the people face us, we find ourselves located in the crowd. The lone exception is a small child, asleep on her father's shoulder. He is turned in the opposite direction, thereby granting an immediate point of sentimental access to the universal symbol. And access is exactly what the poster is meant to provide. Viewers are encouraged to identify with and support the Red Cross in any way they can. Additionally, the unearthly glow in the painted illustration, especially evident in the golden hair of the little girl, recalls imagery in Christian religious art. Here the supernatural light represents the light of God, even if the same light recurs in Cherry's nocturnal scenes of criminality and sin.

Alda Balthrop-Lewis
and *Jeffrey T. Schnapp*

91

Artist unknown

People's Republic of China

Loyal Compatriots of Hong Kong and Kowloon, Arise and Resolutely Fight Back the Provocations of British Imperialism! (*Gang-Jiu aiguo tongbao dongyuan qilai, jianjue fanji Yingdiguo zhuyi de tiaoxin!*), 1967

21³/₈ x 27¹/₈ in.

Hoover Institution Archives

• A picket line of extraordinarily well-muscled workers extends across the image, with hundreds of red flags whipping in the wind, Clouds of mist and smoke or tear gas add to the scene, set alongside Hong Kong Harbor, the territory's tall buildings in the distance. The foreground is occupied by a sailor, a man in a ragged shirt, and a young man and woman brandishing copies of Mao's Little Red Book. The sailor holds in his right hand a placard inscribed: "The Words of Chairman Mao: 'Be resolute. Do not fear sacrifices. Sweep ten thousand obstacles from your path. Garner the victory!'" With his left hand the sailor points an accusing index finger at a pale-faced, red-nosed colonial policeman in riot gear who backs away, one leather glove signaling desperately for mercy, and all but shrinks beneath the lower right-hand corner of the image. A banner hanging from a balconied building reads: "The Hong Kong English are sure to be defeated. We are sure to win!" The red inscription hovering in the sunset

sky announces: "Reactionaries of all countries are just one identical type of vermin in human form. The harm they do to all revolutionary masses, in the final accounting, only inspires the masses to make their revolution broader and more powerful. Mao Zedong."

The Cultural Revolution came to Hong Kong in the spring and summer of 1967, as factory lockouts and police repression touched off protests against the colonial government. Thousands of people assembled in demonstrations, led by local Chinese Communist Party officials aroused from their habitual moderation and newly outfitted with red armbands and copies of the Little Red Book. Bombs were planted, and at least fifty people were killed in clashes between crowds and police.

Rather than preparing the way for a mass revolt against British imperialism, however, the 1967 riots faded away, probably because of their cramping effects on Hong Kong business. The colony accounted for at least half of China's external trade at the time, and China could ill afford a long-term slowdown. In any case, support from Beijing vanished. The status quo was henceforth maintained by a consensus of business interests, the colonial government, and the mainland authorities. This coalition was still in effect thirty years later as "stability" and the fear of "Cultural Revolution-type activities" provided the justification for tightly circumscribing the sphere of democratic political action after the handover of Hong Kong to mainland China in 1997. The unrepresentative quality of its political institutions no doubt account for Hong Kong having been in recent years the theater of regular mass demonstrations in support of civil liberties.
Haun Sassy

92

Artist unknown
(East) Germany
The Free Association of German Unions. Over One Million Individuals Have Freely Joined for the FDGB (*Freier Deutscher Gewerkschafts-bund. Über 1 Million Mitglieder bekannten sich freiwillig zum FDGB*), 1946
34 x 24 in.
Hoover Institution Archives (GE2097)

• In this poster, four arms support the letters FDGB, the acronym for Freier Deutscher Gewerkschafts-bund (Free Association of German Unions). The text below the image reports that more than one million individuals have volunteered to aid in postwar reconstruction. The rhetorical question "Do you wish to remain outside?" (*Willst Du abseits stehen?*) indicates the breadth fore-

seen by the FDGB for its organization. The FDGB sought to unite workers in all industries across Germany, from heavy manufacturing to teaching.

The FDGB was created in February 1946 through the efforts of the German Communist and Socialist parties with the aim of representing workers in industries involved in rebuilding the nation materially, socially, and financially. Their program was explicitly democratic and antifascist, designed to eliminate all military-related production and monopolies as these were considered a primary force behind the rise of Nazism. The FDGB of Saxony, a state in the Russian occupation zone, produced this poster around the time of the June 1946 referendum in which nearly 78 percent of Saxons voted to transfer to public possession all industries belonging to war criminals or former Nazi Party members.

Although this poster was designed for a regional audience, its imagery is common to FDGB materials used throughout Germany. The poster highlights the strength of the union in the breadth of its membership. Only the collaborative effort of four hands can support and hold together the union logo.
Dan Hackbarth

93

Artist unknown
(East) Germany
KPD SPD Unity Guarantees Reconstruction! (*Einheit KPD SPD sichert Aufbau!*), 1946 (?)
23 x 16 in.
Printed by Werab, Dresden
Hoover Institution Archives (GE2040)

• Created shortly after the end of World War II, this poster depicts a pair of hands bringing together the new building blocks of eastern Germany: the merging of the Social Democratic Party (SPD, Sozialdemokratische Partei Deutschlands) and the Communist Party of Germany (KPD, Kommunistische Partei Deutschlands) to form the Socialist Unity Party of Germany (SED, Sozialistische Einheitspartei Deutschlands). Shaped into bricks, the letters illustrate the poster's message: unity secures rebuilding. This goal would be achieved when the antifascist resistance of the SPD worked together with the German Communists. Under Soviet rule the KPD and SPD were forcibly merged in April 1946 to govern the eastern zones of Germany and Berlin.

During World War II virtually every German city was damaged by Allied bombs, rendering millions of civilians homeless and countless structures in ruin. The SED espoused a platform based on the concept of

"building up" (*Aufbau*) Germany while establishing an antifascist, Communist political majority. The first step toward rebuilding Germany cities under Soviet control was to create a political party of unity, symbolized in this poster by the coming together of the two hands and the two bricks.
Todd Presner

94

Francisco Rivero Gil (1899–1972)
Spain
Orders from the P.O.U.M. until the End! (*Consignas del P.O.U.M. ¡Hasta el fin!*), 1937
39³⁄₈ x 27³⁄₈ in.
Printed by Atlántida, A.G., Barcelona
Hoover Institution Archives (SP173)

• During the Spanish civil war Francisco Rivero Gil made several posters for the Marxist Unification Worker's Party (POUM, Partido obrero de unificación marxista), a small anti-Stalinist Communist Party that emerged in 1935 when the Worker's and Farmer's Bloc (Bloque obrero y campesino) merged with the Communist Left of Spain (Izquierda comunista de España). Among Gil's designs for the POUM, this is among his strongest in the clarity of its message and iconic force. An outstretched hand grasps a red banner adorned with a hammer and sickle and the party's initials. Piercing the center of a swastika with the banner's pole, Rivero Gil visually connects the POUM's revolutionary goals with the defeat of Nazism. The slogan also indicates the POUM's insistence on social revolution, "until the end," as a necessary component of the civil war, to be fought with as much force as the defeat of fascism.

The poster may have been produced in Barcelona during the infamous "May Days" of 1937, when armed conflict erupted between the Communist-backed government and the anarchists. Some of the POUM leadership sided with the anarchists in a standoff with the government for control over the centrally located telephone company. Following the May Days, the POUM fell victim to Stalinesque trials that sent many to prison, including Andreu Nin, whose imprisonment and assassination were a source of controversy for the newly elected Communist government of Juan Negrín. Nin had been an important figure within Catalan politics and had worked for the Catalan government, the Generalitat. If Rivero Gil designed this poster in the spring of 1937, then it may have represented a call for support of the POUM's revolutionary goals, especially at a moment when the party was in danger of slipping from a position of power within Catalonia to being

Fig. 96a
Septimus Edwin Scott
National Baby Week, 1917
$29^{1}/_{2} \times 19^{5}/_{8}$
Temple University, George Tyler
War Poster Collection

outlawed shortly after the disastrous events of May 1937.

Rivero Gil was born in Santander and was a columnist for the newspaper *La libertad* in Madrid from 1930 to 1931. After the civil war he briefly lived in Santo Domingo before moving to Mexico where he remained until his death in 1972.
Jordana Mendelson

95

Bohumil Štěpán (1913–1985)
Czechoslovakia
United We Will Fulfill the Governmental Program (*Jednotní splníme vládní program*), 1945
$36^{1}/_{2} \times 24^{3}/_{8}$ in.
Printed by M. Schulz, Prague
The Wolfsonian–Florida International University, The Mitchell Wolfson Jr. Collection (TD1991.55.29)

• While dozens of political parties competed for votes in pre-1938 Czechoslovakia, the dramatic reduction of their number became an influential antiliberal goal after 1945. The poster is to be read against this background. It underscores the cooperation of four major political parties—Social Democrats, Communists, National Socialists, and People's Party—in their effort to fulfill the so-called Košice Program, a governmental initiative proclaimed at the moment of Czechoslovakia's liberation from German Nazi rule. The Communists had a strong say in this programmatic statement. The image shows four hands jointly holding a mast with the Czech flag. While strongly suggesting a gesture of unity, the political configuration invoked here changed fundamentally after 1948, when Social Democrats were unilaterally absorbed by the Communist Party. The background exploits a frequent cliché, a photograph of human faces in a rally.
Jindrich Toman

96

Septimus Edwin Scott (1879–1965)
United Kingdom
National Service. Defend Your Island from the Grimmest Menace that Ever Threatened It, 1917
40 x 30 in.
Printed by David Allen and Sons
Hoover Institution Archives (UK751)

• Inspired by a modestly dressed Britannia, Everyman rolls up his sleeves to address the Great War's need for men and munitions. As the number of trenches increased and the battles dragged on, the industrial workers and farmers who had been supporting the war by their efforts at home became needed at the front. To this end,

the newly founded Ministry of National Service formed the Industrial Army (IA). Under its emblem, a new wave of propaganda posters appeared to target civilians.

This lithograph highlights the often difficult balance between the verbal and the visual. It was designed by one of the most highly celebrated British poster artists of the time (see fig. 96a). Identical in format and conception to Scott's other work for the IA, the poster relies heavily on text to construct its appeal. The artist here imagines civilians uniting to guard the home front, as urged by Prime Minister David Lloyd George.

Contrary to standard works of propaganda, the poster sends a mixed message. Britannia, so forceful in protecting British children in Scott's image for National Baby Week, vies with the bleak washed-out landscape, the yellow oppressive sky so much vaster than the approaching volunteer army. Peter Stanley has argued that the successful war poster permits only one interpretation. In this case, the optimism and readiness of the gathering crowd compete with the sense of impending catastrophe. The picture suggests a menace so grim that it overwhelms the scattered men and evokes a battlefront where allegory and the Union Jack offer scant comfort.
Marie Louise Kragh

97

Georges Scott (1873– c. 1948)
France
For the Flag! For Victory! (*Pour le drapeau! Pour la victoire!*), 1917
48 x 32 in.
Printed by Devambez, Paris
Hoover Institution Archives (FR442)

• In one of the most famous French posters of World War I, Marianne, symbol of the French nation since the revolution, exhorts a mass of troops to battle. Dressed in Gallic headgear, belt, and sandals and wielding a sword and tattered national flag, she embodies the French martial spirit backed by the weight of a long history. As with Goursat's *To Triumph, Subscribe to the National Loan* (no. 10), this poster encouraged French citizens to lend to the war effort.

The symbolic figure of the nation, the collective as embodied in a mythic persona, is juxtaposed with a very different representation of a collective: the mass of soldiers. The soldiers are partly obscured by Marianne herself and by the laurel-strewn ground on which she stands. Filling the horizontal plane of the image, the troops thus seem to well up, as if from an underground spring. The orderly ranks of soldiers in the midground recede into an indistinct blur that suggests an infinite

source of manpower. Even the line of flags that establishes the horizon, echoing the key graphic component of the poster, shades into the crowd, creating the appearance of a unified martial force rather than a collection of soldiers with individual arms and standards. The combined imagery of symbolic aggression and collective strength proved very popular. Scott designed several other posters for the war effort, but this one was most widely used and is one of the most frequently cited World War I posters.
Matthew Tiews

98

Howard Chandler Christy (1873–1952)
United States
Fight or Buy Bonds, 1918
$32^{1}/_{8} \times 20^{3}/_{4}$ in.
Printed by Forbes
Hoover Institution Archives (US8533)

• More than thirty billion dollars was spent in the year and a half the United States was involved in World War I. To cover these costs the government launched the Liberty Loan campaign. This poster was created for the third of the campaign's five installments, initiated on 6 April 1918, the first anniversary of the American declaration of war.

The Third Liberty Loan was promoted by means of "honor flags" awarded to communities with the highest number of bond buyers. Silent-film stars appealed to fans at public rallies, and traveling exhibits gave Americans a look at military equipment and captured enemy trophies. In an especially successful ploy, President Woodrow Wilson claimed to be overextended in his personal purchases of bonds and challenged Americans to "match the president" as he bought another.

The core of the campaign was its posters. In the years before World War I several illustrators had achieved fame by creating images of women for the popular media: Charles Gibson's aristocratic "Gibson girl" dominated the magazines *Life* and *Collier's*; Harrison Fisher's more sensuously demure girl was used on the covers of *Cosmopolitan* and the *Saturday Evening Post*. In *Scribner's* magazine Howard Christy's outgoing "Christy girl" stood in stark contrast to the "Gibson girl." In April 1917 Gibson brought together the country's foremost illustrators and cartoonists to work for the newly created Division of Pictorial Publicity. Offering their services free of charge, these artists met weekly in Washington, D.C., to review poster requests from government agencies. By the war's end the organization had produced roughly seven hundred poster designs for fifty different agencies.

Fig. 101a
Abraham Bosse (1602–1676), France
Frontispiece to Thomas Hobbes,
Leviathan (1651)

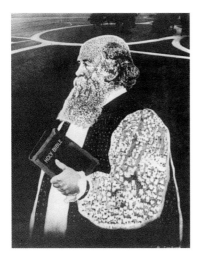

Fig. 102a
Arthur S. Mole
*Living Portrait of the Reverend Alexander
Dowie*, 1918
Photograph, 19³/₈ x 17 in.
Private collection

Although the use of cover girls was common among illustrators on the Gibson committee, Christy added more sex appeal to the women in his designs. The Christy girl seen in this poster wears a classically inspired white dress that suggestively clings to her body. Thrusting the American flag above her head with one arm, she gestures back toward a charging U.S. army with the other. Her expression is passionate, imploring viewers to "Fight or Buy Bonds." The success of the campaign's appeal to civilian patriotism was undeniable. More than eighteen million Americans subscribed to the Third Liberty Loan and raised over three billion dollars in revenues.
Candace Frazier

99
Harald Damsleth (1906–1971)
Norway
We Want a Land for Ourselves
(*Vi vil oss et land*), 1943 (?), 17 x 12 in.
Hoover Institution Archives (NO27)

• This World War II poster cites a nationalist song written by the nineteenth-century poet Per Sivle during the period leading up to Norwegian independence from Sweden in 1905. Its demand for "a land for ourselves" was deeply felt in a country emerging from centuries of Danish or Swedish rule. Here, however, Sivle's hymn to self-determination has been placed in the service of the Norwegian counterpart to the Nazi Party, the National Unity Party (Nasjonal samling). After the April 1940 German invasion, a succession of Nazi governments was established in Norway under the guidance of Vidkun Quisling, führer of the National Unity Party.

The party's foremost illustrator was Harald Damsleth, who, in addition to his poster work for the wartime regimes, also designed many of its postage stamps. In *We Want a Land for Ourselves* the artist tellingly sandwiches the Norwegian flag between the National Unity Party flag with its yellow cross superimposed over a red backdrop and the flag of the National Unity's armed forces, the Hird, with its red and yellow "sun cross" emblem (including two swords) profiled against a black backdrop. Below the triplet of flags idealized men and women, farmers and city folk, lock arms in a gesture of unity and strength.

The slogan "We Want a Land for Ourselves" was also the title of an underground newspaper edited by the Norwegian resistance hero Gunnar Sønsteby. The use of the same line of poetry to support opposing political causes is indicative of the variable ideological forms assumed by Norwegian nationalism in the early twentieth century.
Dean Krouk and *Jeffrey T. Schnapp*

Mass Leaders and Mass Deceivers

100
José Freire (lifedates unknown)
Mozambique
Frelimo: From Rovuma to Maputo, 3 February 1975 (*Frelimo: Rovuma, Maputo, 3 de fevereiro de 1975*), 1975
24 x 16 in.
Hoover Institution Archives (MZ9.16)

• This poster commemorates Hero's Day, a holiday held on 3 February in remembrance of the 1969 assassination of Eduardo Chivambo Mondlane, the first president of the Mozambique Liberation Front (FRELIMO, Frente de libertaçao de Mozambique). Mondlane's portrait hovers above the photographic image of a crowd demonstrating "from Rovuma to Maputo." The Rovuma River marks Mozambique's northern border with Tanzania, and Maputo, the capital city, is located at the country's southern tip. The phrase was commonly used during the Mozambican Revolution to suggest the unity of the nation.

Mondlane was killed only a few years after the beginning of Mozambique's bloody, decade-long struggle to be free from Portuguese rule. After earning a doctorate in sociology from Northwestern University in Evanston, Illinois, in 1957, Mondlane returned to Africa confident that the time was ripe for Mozambican independence. He set about organizing the already burgeoning independence movement into the unified force of FRELIMO, which began an armed campaign against the Portuguese in 1964. This continued until 1974, when Portugal's dictator, António de Oliveira Salazar, was overthrown. In the following year FRELIMO negotiated the end of colonial rule with the new Portuguese government. Mozambique declared its independence on 25 June 1975.
Nora Niedzielski-Eichner

101
Xanti Schawinsky (1904–1979)
Italy
1934-XII, 1934
Letterpress, 42⁷/₈ x 30³/₄ in.
Printed in Milan as an insert for *La rivista illustrata del popolo d'Italia* (April 1934)
Private collection

• A member of the faculty of the Dessau Bauhaus and a Swiss Jew, Xanti Schawinsky fled Germany as the Nazi's assumed power and sought refuge in Italy, where he worked for the Milanese design house Studio Boggeri, before continuing on to the United States. In Italy he devised advertising campaigns for Illy Caffè and Olivetti as well as political posters for the fascist

monthly *La rivista illustrata del popolo d'Italia*. He created *1934-XII* for the 1934 referendum on Benito Mussolini's rule. (The year 1934 marked the twelfth year of fascist rule.) It exists in two versions: one printed prior to the referendum (minus the *sì*, or "yes," superimposed over the crowd that makes up the dictator's body; fig. 4, p. 21); the other printed after the referendum and bearing the large *sì* into which are embedded the referendum's results—a landslide victory in Mussolini's favor—and a series of photomontages.

In this example the leader's body comprises a photograph of a mass rally with a sea of faces looking out diagonally toward the left. Mussolini's head is mounted atop this "body" at a right angle to the crowd's gaze. Its halftone pattern of black-and-white dots (ordinarily so fine that they would be invisible) have been enlarged to reinforce the sense that together they form a single body and to drive home the equation between modern mass politics and the modern mass medium of the chromolithographic poster. The dictator is quite literally portrayed as a mass man. Made up of the masses, he transcends them, becoming the glue that binds the body politic together, the face of the revolution, the nation's head. As such, he is the twentieth-century descendant of Thomas Hobbes's sovereign who, thanks to the principle of contractual political representation, is simultaneously understood as the power that forces individual citizens into a single body and as the expression of their collective will (see fig. 101a).
Jeffrey T. Schnapp

102
Arthur S. Mole (1889–1983)
United States
Living Portrait of Woodrow Wilson, 1918
Photograph, 19³/₈ x 17 in.
Private collection

• Inspired by the "living" flags and symbols organized by American veterans groups since the late nineteenth century, commercial photographers like Arthur S. Mole (and his partner John D. Thomas) developed a successful business during World War I by staging patriotic photographs such as *The Human Statue of Liberty* (1918; eighteen thousand sitters), *The Living Uncle Sam* (1919; nineteen thousand sitters), and *The Human U.S. Shield* (1918; thirty thousand sitters). In the Wilson portrait twenty-one thousand soldiers stationed at Camp Sherman, nicknamed the "Soldier Factory," northwest of Chillicothe, Ohio, were arrayed in a formation extending seven hundred feet across a landscape, shot from atop a seventy-five-foot tower, with adjustments

Fig. 104a
El Lissitzky (1890–1941), Union of Soviet
Socialist Republics
Lenin, 1931
Fotogram, 10¼ x 8½ in.
Hoover Institution Library

Fig. 105a
Otto Kummert
*His Name Will Live on through the
Centuries and So Will His Work* (*Sein Name
wird durch die Jahrhunderte fortleben und
so auch sein Werk*), alternate version, 1982
33 x 22½ in.
Hoover Institution Archives

made for perspectival recession. (One hundred soldiers were required to form the president's shoulder region and several thousand made up the top of his head.) The photographs were sold as novelty items and, to the sitters, as a group portrait of their battalion.

Mole's initial experiments with mass photography were evangelical, carried out in the service of the Christian Catholic Apostolic Church in Zion, Illinois (see fig. 102a). This religious backdrop points to continuities between secular and sacred images of how the many fuse into the one. Emblems of the faithful becoming one in the body of Christ may seem distant from the modern era of crowds, yet they prove readily translatable into emblems of the collectivity becoming one with the mass leader, irrespective of whether he is an elected president or the prophet of revolution.
Jeffrey T. Schnapp

103

Andrzej Dudzinski (born 1945)
Poland
Lech Wałęsa, 1982
Etching, 16½ x 13 in.
Edition 8/300
Private collection

• The leader of the August 1980 Gdańsk shipyard strike that sparked a national uprising against the Polish Communist state, Lech Wałęsa became the figurehead—the face—of the Solidarity trade-union movement. In December 1981 he was interned in a remote country house when General Wojciech Jaruzelski, fearing a Soviet invasion, declared martial law and suspended the union's legal recognition. Released in late 1982, Wałęsa was forced to operate under constant surveillance and to exercise his leadership role via the Solidarity underground. His consecration as an international symbol of the struggle for social justice and workers' rights was sealed in October 1983, when he was awarded the Nobel Peace Prize.

The etching was produced in the middle of this period of international celebrity by Andrzej Dudzinski, an expatriate artist who had moved to New York in the late 1970s but whose work was long featured in Poland's foremost satirical weekly *Szpilki* (always signed by a wingless bird named "Dudi"). The image originally appeared on the op-ed page of the *New York Times* to illustrate a poem by Czeslaw Milosz dedicated to Wałęsa.

This work literalizes the notion of the mass leader as the face of the crowd by forming his visage—the sign of the crowd's individuality, national identity, and historical particularity—out of abstract and anonymous multitudes. The modern leader is a mass

man. No longer a godlike being descending from on high, no longer the monarch invested with power based on dynastic succession, the modern leader emanates from the people. Once a face in the crowd, he is transformed into the face of the crowd.
Jeffrey T. Schnapp

104

Artist unknown
United States
*1A in Our Draft. CIO Political Action
Committee*, 1944
11 x 9 in.
Hoover Institution Archives (US7469)

• Established in July 1943 to support Franklin Roosevelt's reelection campaign, the Congress of Industrial Organizations Political Action Committee (CIO-PAC) marked the union's first sustained engagement in electoral politics. A lone example drawn from the eighty-five million posters, leaflets, and pamphlets printed by the CIO-PAC in 1944, *1A in Our Draft* superimposes the president's head on a crowd of rallying workers. In military parlance "1A" refers to the draft classification "fit for general active military service," the highest category of qualification. The poster's appropriation of a military metaphor seeks to capture Roosevelt's popularity as wartime president and dispel concerns over his health. The suturing of Roosevelt's head onto an enthusiastic body politic emphasizes the president's vigor while avoiding any reference to his being wheelchair-bound. Presented frontally, Roosevelt floats above a blue multitude that looks leftward, in contrast to explicitly socialist compositions, such as El Lissitzky's 1931 fotogram of Lenin, in which both leader and masses face the viewer directly (fig. 104a). Red typography completes the colors of the American flag.

The 1943 Smith-Connally Act restricted labor unions in two ways, by disallowing union contributions to candidates in federal elections and by limiting their ability to organize strikes. The CIO-PAC responded to both challenges. As the first political action committee, it established the precedent of collecting voluntary contributions from its union members separate from union dues (funds later referred to as "hard money"). As a pro-labor voice, the CIO-PAC sought to elect a pro-union Congress that would overturn the antistrike provisions. This focus on electoral politics was in keeping with the CIO's goal of cooperation, rather than conflict, with the state. Throughout the 1940s Roosevelt, in turn, had cultivated the CIO leadership to insure discipline among the labor ranks. As the CIO's organizing methods gained influence, the dominant agents of American labor organizing were less the as-

sembled workers than the political figures hovering above.
Jason Glick and *Jeffrey T. Schnapp*

105

Otto Kummert (active twentieth century)
(East) Germany
*His Name Will Live on through the
Centuries and So Will His Work* (*Sein
Name wird durch die Jahrhunderte
fortleben und so auch sein Werk*), 1982
22½ x 33 in.
Hoover Institution Archives

• To mark the hundredth anniversary of Karl Marx's death, the Socialist Unity Party (SED, Sozialistische Einheitspartei Deutschlands), the ruling party of the German Democratic Republic, declared 1983 Karl Marx Year. With nationalist vigor, the party dubbed Marx the "greatest son of the German people" and highlighted the connections between his ideas and East German socialism. For the occasion a political tract entitled *Theses of the General Committee of the SED* was released, which described the contemporary epoch as one of worldwide transition from capitalism to socialism. The anniversary, not surprisingly, was marked by many other tributes, including commemorative coins, stamps, publications, and lectures as well as by this and several related posters by Otto Kummert, a politically active East German graphic designer (fig. 105a).

The quotation in the poster's upper-left corner comes from Friederich Engels's eulogy for Marx delivered at London's Highgate Cemetery. The full text of Engels's remarks was printed in newspapers of the day and has since been reprinted in numerous Marxist publications and anthologies. The excerpt included here serves as a fitting caption for a poster intended to glorify Marx's lasting impact. Likewise, by superimposing Marx's portrait over a photograph of a crowd, Kummert suggests that the philosopher's aura lingers a century after his death. On the one hand, Marx's image suffuses the visual field formed by the masses. On the other, the individuals composing the crowd come together to form his likeness, implying an almost corporeal pervasiveness. It is as if their socialist existence reincarnated Marx as a physical entity. Here the translucency of Marx alludes not to a fading presence but to the power of his work to endure as both governing spirit and material influence.
Heather Farkas

106

Renato Bertelli (1900–1974)
Italy
Continuous Profile of Mussolini
(*Profilo continuo del Duce*), 1933

Fig. 106a
Julian LaVerdiere (born 1971), Canada
Continuous Profile of George W. Bush,
2004
Black resin bust on walnut base, 17 x 9 in.

Bronzed terra-cotta, 11³/₄ x 9 x 9 in.
The Wolfsonian–Florida International
University, The Mitchell Wolfson Jr.
Collection (84.6.4)

• This double-silhouette portrait of the
Italian fascist leader Benito Mussolini was
created by the futurist sculptor Renato
Bertelli during the celebrations of the fas-
cist regime's tenth anniversary. It spins
the profile of Mussolini 360 degrees along
its axis to yield a single, symmetrical
three- dimensional object composed of
an infinity of individual profiles. The myth
of the fascist mass leader who belongs
to and is animated by the masses is lit-
eralized. Mussolini had famously promised
to build a regime that would "reach out
toward the people" (*andare verso il popo-
lo*). Here it is a "people" of identical Mus-
solinis who form the head of the nation.
A head that gazes out vigilantly in all di-
rections at once.

Like many posters in *Revolutionary
Tides*, Bertelli's *Continuous Profile* was a
multiple, manufactured in various sizes.
The earliest version (found at the Imperial
War Museum in London) was executed in
black-glazed terra-cotta and reaches more
than nineteen inches in height. The pre-
sent version in bronzed terra-cotta is scaled
back by nearly one third. The work's suc-
cess was such that, with Mussolini's ap-
proval, Bertelli patented his design and hired
the firm Ditta Effeffe of Milan to manufac-
ture thousands of three-inch versions in
such materials as bronze, tin, terra-cotta,
and buxus.

The work has continued to fascinate
contemporary artists from Ed Ruscha, whose
recent experiments with palindromes and
mirrored landscapes draw their inspiration
from Bertelli, to Julian LaVerdiere, whose
Continuous Profile of George W. Bush (2004)
tries to suggest that the fascist past is not
dead and buried (fig. 106a).
Jeffrey T. Schnapp

107
Artist unkown
Germany
Yes! Führer, We Will Follow You! (*Ja!
Führer, wir folgen Dir!*), 1934
34 x 24 in.
Hoover Institution Archives (GE909)

• After the death of President Paul von Hin-
denburg on 2 August 1934, Adolf Hitler de-
cided to give himself the power of holding
both the office of the president and of the
chancellor. The cabinet passed a law that
radically consolidated the powers of the
Führer, and a referendum was held on 19
August 1934 to approve Hitler's increased
powers.

The poster depicts Hitler as the soli-
tary leader standing within and emerging
from the masses of jubilant supporters be-
hind him. The crowd pledges their alle-
giance to their leader: "Yes! Führer, we
will follow you!" Indeed, more than 90 per-
cent of the electorate voted for the mea-
sure. As a larger-than-life figure, Hitler
literally rises from the crowd and towers
above them. The masses of individual sup-
porters extend infinitely, filling the entire
space of the background, while Hitler's sin-
gular image is pressed up to the picture
plane. A single man epitomizes the will of
the people.
Todd Presner

108
Artist unknown
Austria
Lenin and Gandhi (*Lenin und Gandhi*),
1927
33³/₈ x 21³/₈ in.
Printed by Waldheim-Eberle A.G., Vienna
Hoover Institution Archives

• In his 1927 book *Lenin und Gandhi* René
Fülöp-Miller portrays the two men as great
inspirations but failed leaders. He argues
that despite their extraordinary efforts to
marshall the support of their people, neither
could effect the change they promised.
Gandhi did not end the British rule of India,
and Lenin ultimately compromised his ra-
tionalist ideals as he pushed for immediate
"technification." In addition to these par-
allels, Fülöp-Miller also analyzes the fun-
damental differences between the leaders'
worldviews. Lenin advocated the use of vi-
olence to secure power, while Gandhi be-
lieved that peaceful means must be
employed.
Despite this split, the book weaves to-
gether these two very different life stories
by arguing that the two leaders embody the
spirit of the contemporary age, an age in
which the masses are the actors of public
life.

In this advertisement for *Lenin and
Gandhi* members of the Bolshevik and In-
dian independence movements overrun
large swaths of the landscape. The image
of the world divided between Lenin's and
Gandhi's bands highlights the leaders' abil-
ities to galvanize populations as well as the
rift between their respective political
philosophies.

Figures pressing forward in a crowded
space cover the entire ground, but a clear-
cut hierarchy disrupts the forward mo-
mentum. Gandhi's followers trudge along
with their heads down, an amorphous mass
of indistinct "other" filling in behind the ho-
mogenous, faceless lines of the Red Army
and their bayonets. With signs high above

assigning each group to its respective
leader, the poster communicates a sense
of continuity and difference, as did Fülöp-
Miller's narrative.
Dan Hackbarth and Heather Falkas

The Man of the Crowd

109
Will Carson (lifedates unknown)
United Kingdom
*Vote Labour. You Could Not Make War
without Us—You Cannot Make Peace
without Us!* 1919
20 x 15 in.
Hoover Institution Archives (UK2646)

• The general election of 14 December 1918
occurred just one month after Germany and
the allies signed the armistice and put to the
test the wartime coalition government
formed by Prime Minister David Lloyd
George in 1916.
In this poster the sense of cooperation
among political parties that existed during
the war is visibly absent. Instead, the Labor
Party asserts its independence from the
Liberal Party (with which it had been aligned
during the war) in the form of a bold, proud
worker. He breezes his way into the Paris
Peace Conference held at Versailles and
reaches a hand toward his fellow com-
moners following behind him. This mes-
sage of universality is in keeping with the
Labor Party's socialist-inspired 1918 mani-
festo demanding "complete adult suffrage,
in industry for equal pay and the organiza-
tion of men and women workers in one
trade union movement." (The 1918 elec-
tion was the first in which women were
permitted to vote.)
The Labor Party's foreign policy stance
also takes center stage in Will Carson's
poster. The reminder "you cannot make
peace without us" alludes to the party's op-
position to secret diplomacy and to war
reparations, a position that would eventu-
ally fail as Prime Minister Lloyd George at-
tempted to steer a middle course between
American and French positions at Ver-
sailles.
Although the Labor Party did not win
the 1918 election, it emerged as a power-
ful force in British politics. The growth of
trade unions during the war had strength-
ened its electoral base, and the return of
four million troops also swelled party ranks.
A decline in the postwar economy signaled
the disintegration of Lloyd George's coali-
tion government, which, combined with
the decline of the Liberals, left the Labor
Party as the main opposition to the Tories
for the remainder of the century.
Candace Frazier

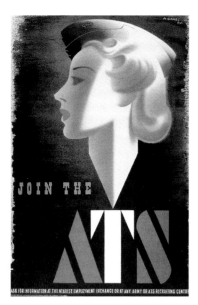

Fig. 110a
Abraham Games (1914–1996),
United Kingdom
You Are Wanted Too! Join the A.T.S.,
first version, 1941
28³/₄ x 19 in.
Printed by Her Majesty's Stationery Office

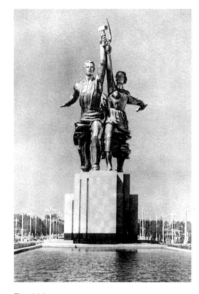

Fig. 114a
Vera Mukhina (1889–1953), Union of Soviet
Socialist Republics
Worker and Collective Farm Worker, 1937
Stainless steel, height 77 ft
Reinstalled at the entrance to the 1939
USSR Agricultural Exhibition, Moscow
Hoover Institution Library

110

Artist unknown
United Kingdom
You Are Wanted Too! Join the A.T.S., 1941
30 x 20 in.
Printed by Her Majesty's Stationery
Office, London
Hoover Institution Archives (UK1805)

• The Auxiliary Territorial Service (ATS) was the women's branch of the British army. It was formed in September 1938 to fill gaps in the domestic defense as men were sent overseas (by war's end, however, many of the 212,500 women serving in the ATS at its peak were stationed abroad). Britain came to rely so heavily on their service that, in addition to active recruitment, it began conscription for childless women in 1942, offering them a choice between the ATS (or another of the women's branches of the air force or navy) and factory work or farming. ATS soldiers served as cooks, bakers, clerks, and orderlies as well as truck and ambulance drivers, wireless operators, and antiaircraft gunners. (They were not permitted to fire weapons, on Winston Churchill's orders, but they could clean, load, and cock them.) At least 335 were killed over the course of World War II.

You Are Wanted Too! was designed to replace an earlier ATS recruitment poster by Abraham Games that, despite its success, was judged by a Conservative member of Parliament, Thelma Cazalet-Keir, as too "glamorous" and too much like an advertisement for beauty products (fig. 110a). Whereas the first featured an illustrated depiction of an alluring ATS soldier, this second example relied on a black-and-white photograph of Private Mary Catherine Roberts in uniform. The pitch devised by the anonymous artist, however, remained much the same as that of Games. Recruits were wooed by underscoring the glamor and elegance of service in the ATS. To seventeen-year-old girls trying to decide whether to join, Private Robert's short skirt, tight-fitting jacket, and good looks would not have passed unnoticed. The favorable ratio of men to women graphically highlighted in the poster was another enticement.
Nora Niedzielski-Eichner and
Jeffrey T. Schnapp

111

Hans Schweizer [Mjölnir] (1901–1980)
Germany
The Coordinated Will (Der organisierte Wille der Nation), 1930s
34 x 24 in.
Hoover Institution Archives

• Nazi cartoonist and poster artist Hans Schweizer worked closely with Joseph

Goebbels and produced some of the Third Reich's most powerful images. Schweizer, who employed the pseudonym Mjölnir— the name of the hammer used by the Norse god Thor—published frequently in *The Attack (Der Angriff)*, a small weekly launched by Goebbels in 1927. By 1930 the paper began daily publication, and readership continued to grow as the Nazis demonstrated their strength in national elections.

The text for this image speaks to the central importance of the Nietzschean concept of the coordinated will, which Goebbels addressed in his speeches and early strategizing for the Reich. Goebbels carried this faith over into his work as Adolf Hitler's propaganda minister. In 1931 he published a statement entitled *Will and Way (Wille und Weg)* as the lead article for the first issue of the monthly bulletin of the Central Office for Propaganda of the Nazi Party. In that document he made clear his intentions to show active party members the most effective methods to win over the souls of the German people. Their support was necessary for the party to enact its far-reaching program, and the means to reach this political goal, according to Goebbels, was political will power. In this poster the three soldiers depicted in crisp profile embody that drive to unify under Nazi ideology. The uniformity of their facial structure suggests the sort of highly disciplined and homogenous society that would result from its implementation.
Heather Farkas

112

Artist unknown
United States
American Democracy / Private Enterprise—And They Said Our System Was Crumbling! 1943
27¹/₈ x 20 in.
© Kelly Read & Co., Rochester
The Wolfsonian–Florida International University, The Mitchell Wolfson Jr. Collection (XX1990.2973)

• Produced in the years immediately following the Allied invasion of Italy during World War II, this poster was one of more than one hundred produced for the Think American Institute for posting at workplaces. It foregrounds symbols of collective political identity in the form of two male bodies. The caption instructs the viewer to see the two persons as representations of "systems"—amalgamations of national identities, geographic territories, populations, political ideologies, and economic structures.

The identification of American democracy and private enterprise with the stoic white male worker exemplifies the ideal-

ization of "free" labor. Having pinned the dismembered image of Benito Mussolini beneath his sledgehammer, he stares out confidently. He epitomizes the utopian undercurrents of an independent workforce that are further evinced by the golden industrial city rising in the background. In contrast, the cartoon quality of the dismembered statue parodies the image cultivated by Mussolini as a populist leader. The rubble surrounding him recalls black-and-white photographs of bombed-out European cities.

Sharp visual divisions recur throughout the piece and evoke military circumstances at the time of its creation. The violent relationship between the two figures suggests an allegorical narrative of national characters engaged in an epic battle. Their opposition is emphasized by the contrast of the vibrant colors of the upper section of the image and the drab gray-green tones below. In addition, the confrontational tone of the text—"they said *our* system was crumbling"—grammatically interpolates spectators into the struggle as well. The triumphant proclamation develops a sarcastic edge. The harsh aspects of aerial bombardment and cutthroat capitalism are passed over in silence.
Aaron David Shaw

113

Vasilii Elkin (1897–1991)
Union of Soviet Socialist Republics
Every Collective Farmworker, Every Brigade, Every MTS Must Know the Plan for Bolshevik Sowing (Kazhdyi kolkhoznik, kazhdaia brigada, kazhdaia MTS dolzhny znat' plan bol'shevistskogo seva), 1931
40³/₄ x 28⁷/₈ in.
Published by State Publishing House for Art (IZOGIZ), Moscow and Leningrad, authorized by Glavlit, the state censorship authority
Hoover Institution Archives (RUSU1994)

• This poster instructs agricultural workers to familiarize themselves with the new plan for crop sowing, which was announced by the Soviet government in early spring 1931. Along with new policies on plowing and harvesting, the Plan of Bolshevik Sowing demands an intensification of agricultural production. Three specific groups are targeted by the poster. First are the collective farm workers (*kolkhozniki*). Manual in hand— presumably the plan itself—a farmer surveys the field before him. Gigantic and solitary, he is the ultimate icon of the newly collectivized peasantry. (A *kolkhoznik* is a peasant who works on a collective farm [*kolkhoz*]—an agricultural cooperative governed by party-approved plans and leaders— and whose wages are largely based on the

Fig. 115a
Lester Beall
Radio, 1937
Offset color lithograph and screenprint,
40 x 30 in.
From the first series produced for the Rural
Electrification Administration

Fig. 115b
Lester Beall
Now I'm Satisfied, 1939
Offset color lithograph and screenprint,
40 x 30 in.
From the second series produced for the
Rural Electrification Administration

success of the cooperative's harvest.) Second are the brigades of shock farmers, who listen intently to a presentation of the plan, chins clasped in hands. Third are the machine-and-tractor stations (MTS). The MTS are state-owned and state-operated depots from which farmers can borrow tractors and other agricultural equipment to cultivate their soil by mechanical means and thereby fulfill the production norms dictated by Moscow. (In 1931, there are about 1,228 MTS, and some 120,000 tractors in use.)

The Plan of Bolshevik Sowing is intended to solve the grain crisis of the late 1920s, but it is problematic in two senses. It projects unrealistically optimistic increases in the amount of land that can feasibly be sown in any one season. The plan disrupts the pattern of crop rotations established in the 1920s, thereby causing soil exhaustion. Historians argue that it was a major contributing factor in the 1931–33 famine that claimed the lives of an estimated six million people.

Vasilii Elkin received his training as a graphic designer under Vladimir Favorskii at the Higher State Art and Technical Institute (VKhUTEMAS). In 1928 he joined the October group and in the early 1930s divided his time between designing posters commemorating the achievements, real or projected, of the Five-Year Plans, and editing two magazines, *The Construction of Moscow* (*Stroitel'stvo Moskvy*) and *Moscow Worker* (*Moskovskii rabochi*). In this lithograph Elkin produces an oscillation between groundedness and dynamism. The vertical and horizontal axis of the pictorial field serves to stabilize the highly disjunctive scale relations of the montaged photographs and diagonally positioned text.
Maria Gough

114

Viktor Klimashin (1912–1960)
Union of Soviet Socialist Republics
USSR Agricultural Exhibition, 1939, 1939
40 x 26³/₈ in.
Printed by Mezhdunarodnaja Kniga,
Moscow
The Wolfsonian–Florida International
University, The Mitchell Wolfson Jr.
Collection (85.4.108)

• A designer of political and film posters in the 1930s, Viktor Klimashin advertises another kind of spectacle in this photolithograph: the All-Union Agricultural Exhibition. A mammoth celebration of the achievements of Soviet agriculture, the exhibition opened on 1 August 1939 on three hundred acres in the northern outskirts of Moscow. More than 145 pavilions and other structures represented the productivity of all sixteen Soviet republics and also the Union's

various territories and regions. Some 15,000 collective farms, 795 state farms, and 268 machine and tractor stations had displays. Participation was subject to the fulfillment of a production quota: a farm in a non-black-earth region, for example, had to have produced about three thousand pounds of wheat for every two and half acres of land to be eligible.

In a pictorial field burnished with the golds and reds of a late-summer harvest, this poster features what the organizers chose as the exhibition's main emblem: a male tractor operator (*traktorist*) and a female collective farm worker (*kolkhoznitsa*) triumphantly holding aloft a shaft of wheat. This image is also found in the exhibition's catalogue and on medals and diplomas issued to prize-winning participants. A 42-foot sculptural version, mounted on a 170-foot tower attached to the main pavilion, was visible from everywhere within the site: a monument in grand socialist-realist style to the new Soviet men and women contributing to the exhibition's dazzling success. While the sculpture is unattributed, it is clearly a reworking of Vera Mukhina's 77-foot stainless-steel sculpture of a youthful, hammer- and-sickle toting male industrial worker and female collective farm worker. Originally made for the 1937 World's Fair in Paris, Mukhina's sculpture was reinstalled at the entrance to the 1939 exhibition and reproduced in its catalogue (fig. 114a).

With its text only in English, the poster was designed to lure foreign visitors to Moscow in a year crowded with international expositions. Sumptuous, yet available en masse, Klimashin's poster also served as a souvenir for visitors.
Maria Gough

115

Lester Beall (1903–1969)
United States
A Better Home, 1941
Lithograph and screenprint, 40 x 29⁷/₈ in.
The Wolfsonian–Florida International
University, The Mitchell Wolfson Jr.
Collection (TD1991.174.5)

• *A Better Home* belongs to the third series of posters designed by Lester Beall for the Rural Electrification Administration (REA). An agency within the U.S. Department of Agriculture, the REA was charged with ensuring the integral electrification of the United States. A key aim of Franklin Roosevelt's efforts to revitalize the national economy in the wake of the great crash of 1929, electrification meant not just providing running water, heating, and light to rural areas but also creating a fully interconnected, "networked" America in which

space and time could be overcome through mass media like the radio and the new medium of television. Thanks to electrification, it was hoped that rural men and women would be transformed into exemplary participants in the era of industry.

Beall's first set of six posters for the REA dates to 1937 and employed an elementary vocabulary of geometrical forms, arrows, color fields, and lines. The works were of such communicative efficacy and visual refinement that the Museum of Modern Art in New York featured them in the museum's first solo exhibition of work by a graphic designer (fig. 115a). A second series followed in 1939 in which this vocabulary was expanded by recourse to photomontage (fig. 115b). In the third series cutout photographs and slanted overhead typographical bars are played off against densely constructed fields of solids, stripes, and polka dots in the colors of the American flag in ways that suggest the excitement of a fully electrified world. Even a farmer's wife thus becomes a producer whose productivity is insured by a clean, reliable, efficient, and readily available source of power.
Jeffrey T. Schnapp

116

Attributed to Bohumil Štěpán
(1913–1985)
Czechoslovakia
*West Czechoslovak Communists Will
Donate Half a Million Hours of Work to
the Republic* (*Půl milionu pracovních
hodin darují republice západočeští
komunisté v měsíci zóří*), 1945
36¹/₄ x 26¹/₈ in.
The Wolfsonian–Florida International
University, The Mitchell Wolfson Jr.
Collection (TD1991.55.21)

• The poster addresses an important agenda item in the post-1945 Communist program: namely, labor donated for the benefit of society. Its backdrop is the premise that society belongs to all and that distinctions between public and private will be abolished over time. The image is based on a visual cliché shared by various political persuasions since the late nineteenth century: a lean worker with a bare upper body engages in physical work. Sobriety and functionality prevail. This is not a sinewy man with six-pack abs cultivated by means of middle-class sports such as tennis or skiing. Rather, he is a serious, somewhat consumed member of the working class. The face is back-staged as is appropriate in a political program that highlights the idea of collectivism. The anonymous photographer obviously liked rich surfaces that border on grotesque. Note, for instance, the

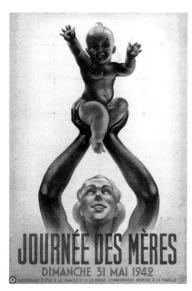

Fig. 117a
Philippe Grach
Mothers' Day (*Journée des mères*), 1942
47¹/₄ x 31 in.
Printed by Secrétariat d'état à la famille
et à la santé
Hoover Institution Archives

correspondence established between skin folds and those of the fabric of the worker's pants. Parts of the image are out of focus, implying the unstaged, authentic, quality of work shown.
Jindrich Toman

After the Crowd

117

Philippe Grach [Phili] (lifedates unknown)
France
Freedom (*Libération*), 1944
45 x 30 in.
Hoover Institution Archives (FR1113)

• In this jubilant image a female figure wrapped in the French flag lifts the lid off a coffinlike box, freeing an abstracted mass of her compatriots, who raise their arms and faces to freedom. The image celebrates France's liberation from German occupation in August 1944.

Philippe Grach came to prominence as the principal designer of propaganda for Marshall Philippe Pétain's collaborationist regime. His primary task was to design the poster for Mothers' Day, an annual holiday introduced in 1941 as part of the Vichy regime's celebration of traditional domestic values.

To this end he employed a visual style derived from the popular "Images d'Épinal," a narrative series named after the city in which they were produced in the Lorraine, which lent a homey comfort to his posters of beatific mothers and angelic children. The most famous of his Mothers' Day posters features a woman raising an infant over her head and smiling with the same radiance as the figure in this poster (fig. 117a).

Grach had an excellent instinct for self-preservation. This poster was produced in the final days of German occupation by the Provisional Government of the Republic of France (GPRF, Gouvernement provisoire de la république française)—established by the resistance in the summer of 1944. The same gesture that raised the Vichy infant in exultation is used here to lift away the weight of the occupation. With a few minor modifications the ideal Pétainist mother becomes the symbol of freedom. Grach's political flexibility helped position him on the winning side of history, and indeed he continued working for the GPRF after the war despite his collaborationist activities.

Grach repeated in this poster many graphic elements from his Vichy propaganda: a vivid primary color scheme, a geometric simplicity, an unabashed idealization of the female visage. *Freedom* also draws on more general political iconography. The female figure is a variant of Marianne, the symbol of the French nation, arms upraised and victorious.

The huddled masses that follow her up into the radiant light of liberty stand in for the French populace. An abstracted figure in the background echoes the victorious V of the female figure's pose, even as the broken chains dangling from its outstretched arms remind us of the travails of occupation. The line of raised hands receding to a vanishing point represents the mass as an undifferentiated source of celebratory arms lifted in a collective gesture of freedom.
Matthew Tiews

118

Andy Warhol (1928–1987)
United States
Mao Tse Tung, 1972
Screenprint, 36 x 36 in.
Edition 184/250 (green background version)
On loan to the Cantor Arts Center from the The Marmor Foundation (CAC L7.191.1996)

119

Andy Warhol (1928–1987)
United States
Mao Tse Tung, 1972
Screenprint, 36 x 36 in.
Edition 184/250 (blue background version)
On loan to the Cantor Arts Center from The Marmor Foundation (CAC L7.191.1996)

• By 1972, when these prints were made, the face of Mao Zedong (Tse Tung) was quite possibly the world's most widely reproduced visage. The glory of Mao was central to the Cultural Revolution's rhetoric and there was no reticence about a cult of personality. All over China, propaganda posters, Red Guard buttons, silk hangings, and ceramic busts repeated the chairman's image, which was also de rigueur for the title pages of Chinese periodicals, even the archaeological journal *Wenwu*, and, of course, Mao's *Selected Works* and *Quotations* poured forth by the millions in an assortment of languages, always with the same unsmiling sepia frontispiece. When Richard Nixon made his 1972 trip to China, the Mao brand was launched for American consumers, no longer threatening but homely, like the Quaker Oats elder.

The source of Warhol's multiple (250 sets of ten images) was the cover of the 1967 U.S. paperback edition of Mao's *Quotations*. An enlarged photocopy of the chairman's head formed the basis of ten silkscreen prints, each differently colored and adorned with different squiggles. The standard, instantly recognizable image is thus individualized with traces of the hand (traces that are nonetheless not manual, but silkscreened). The garish colors and their blocky application to the paper recall popular woodcuts or hand-colored tintypes from the nineteenth century, or perhaps they are a reaction to the plushy, saturated, chromolithographic look of most Soviet and Chinese color photography of the 1950s and 1960s. The original's uniformity opens into a series of variations. Warhol, the experienced fashion artist, dresses up the chairman: replacing the gray of his jacket with pink, trying different colors of lipstick, highlighting his hair and eyes to enliven the staid official portrait.

By the late 1980s Warhol's enhancement (or defacement?) of Mao's image was well known in China. But books and magazines often reproduced it in black and white, returning it to a condition barely indistinguishable from the standard image it parodied. Since the end of the Cultural Revolution Chinese artists, among them Wang Guangyi and Zhang Hongtu, and commercial firms like Shanghai Tang have continued to work the Mao brand, principally for export.
Haun Saussy

Selected Bibliography

General

Ades, Dawn, et al. *The Twentieth- Century Poster: Design of the Avant-garde*. New York, 1990.

Barnicoat, Joan. *A Concise History of Posters*. London, 1972.

Bénézit, Emmanuel. *Dictionnaire critique et documentaire des peintres, sculpteurs, dessinateurs, et graveurs de tous les temps et de tous les pays*. 14 vols. Reprint ed. Paris, 1999.

Bredhoff, Stacey. *Powers of Persuasion: Poster Art from World War II*. Washington, D.C., 1994.

Chapelle, Josée, Marsha Emanuel, and Claude Eveno, eds. *Images d'utilité publique*. Paris, 1988.

Clark, Toby. *Art and Propaganda in the Twentieth Century: The Political Image in the Age of Mass Culture*. New York, 1997.

Cull, Nicholas J., David Culbert, and David Welch. *Propaganda and Mass Persuasion: A Historical Encyclopedia, 1500 to the Present*. Santa Barbara, Calif., 2003.

Cunningham, Stanley B. *The Idea of Propaganda: A Reconstruction*. Westport, Conn., 2002.

Darracott, Joseph, and Belinda Loftus. *First World War Posters*. London, 1972.

———. *Second World War Posters*. London, 1972.

Ellul, Jacques. *Propaganda: The Formation of Men's Attitudes*. Translated by Konrad Kellen and Jean Lerner. New York, 1971.

Gallo, Max. *The Poster in History*. Translated by Alfred and Bruni Mayor. New York, 1972.

Gervereau, Laurent. *Terroriser, manipuler, convaincre! Histoire mondiale de l'affiche politique*. Paris, 1996.

Gourévitch, Jean-Paul. *La politique et ses images*. Paris, 1986.

Lasswell, Harold D. *Propaganda Technique in the World War*. New York, 1972.

McQuiston, Liz. *Graphic Agitation: Social and Political Graphics since the Sixties*. London, 1993.

Paret, Peter, Beth Irwin Lewis, and Paul Paret. *Persuasive Images: Posters of War and Revolution from the Hoover Institution Archives*. Princeton, N.J., 1992.

Philippe, Robert. *Political Graphics: Art as a Weapon*. Translation. New York, 1980.

Rhodes, Anthony. *Propaganda: The Art of Persuasion in World War II*. Secaucus, N.J., 1987.

Rickards, Maurice. *Posters of the First World War*. London, 1968.

———. *Posters of Protest and Revolution*. New York, 1970.

———. *The Rise and Fall of the Poster*. New York, 1971.

Rothschild, Deborah, Ellen Lupton, and Darra Goldstein. *Graphic Design in the Mechanical Age: Selections from the Merrill C. Berman Collection*. New Haven, Conn., 1998.

Schockel, Erwin. *Das politische Plakat: Eine psychologische Betrachtung*. Munich, 1939.

Stanley, Peter, comp. *What Did You Do in the War, Daddy?: A Visual History of Propaganda Posters*. Melbourne, 1983.

Stermer, Dugald, and Susan Sontag. *The Art of Revolution*. New York, 1970.

Taylor, Philip M. *Munitions of the Mind: A History of Propaganda from the Ancient World to the Present Era*. 2d ed. Manchester, UK, 1995.

Thomson, Oliver. *Easily Led: A History of Propaganda*. Thrupp, UK, 1999.

Timmers, Margaret, ed. *The Power of the Poster*. London, 1998.

Weill, Alain. *L'affiche dans le monde*. New ed. Paris, 1991.

———, ed. *Affiches politiques et sociales*. Paris, 1995.

Wilke, Jürgen. *Propaganda in the Twentieth Century: Contributions to Its History*. Cresskill, N.J., 1998.

Yanker, Gary. *Prop Art: Over One Thousand Contemporary Political Posters*. New York, 1972.

Zbynek, Zeman. *Selling the War: Art and Propaganda in World War II*. London, 1978.

For Annotated Entries

Allentown Art Museum. *Howard Chandler Christy, Artist/Illustrator of Style*. Allentown, Pa., 1977.

Arnold, Friedrich. *Anschläge; Politische Plakate in Deutschland, 1900–1970*. Ebenhausen bei München, 1972.

Arsenieff, Marie-José, and Marie-Christiane de La Conte. *Collection Lafond: Affiches et documents iconographiques guerre de 1914–1918*. Rouen, 1997.

Aynsley, Jeremy. *Graphic Design in Germany, 1890–1945*. Berkeley, 2000.

Baburina, Nina Ivanovna, ed. *Sovetskiii politicheskiii plakat: Iz kollektsii Gosudarstvennoi biblioteki SSSR imeni V. I. Lenina*. 3 vols. Moscow, 1984.

———, ed. *The Soviet Political Poster, 1917–1980: From the USSR Lenin Library Collection*. Harmondsworth, UK, 1985.

Boisdron, Matthieu. *Propagande! Presse et Radio françaises pendant la guerre*. Available at www.1939-1945.org.

Bonnell, Victoria E. *Iconography of Power: Soviet Political Posters under Lenin and Stalin*. Berkeley, 1997.

Butnyk-Siverskii, Borys Stepanovich. *Sovetskii plakat epokhi grazhdanskoi voiny, 1918–1921*. Moscow, 1960.

Cantwell, John D. *Images of War: British Posters, 1939–45*. London, 1989.

Carulla, Jordi, and Arnau Carulla, comps. *La guerra civil en 2000 carteles: República-guerra civil-posguerra*. 2 vols. Barcelona, 1997.

Cetnarowski, Antoni. *Polski plakat polityczny: Opracowanie graficzne*. Warsaw, 1980.

Daly, Sidney. "The Washington Hunger March of 1932." *Class Struggle* 3, no. 1 (January 1933). Available at http://www.weisbord.org.

Davies, Norman. *God's Playground: A History of Poland*. 2 vols. Oxford, UK, 1981.

DeNoon, Christopher. *Posters of the WPA*. Los Angeles, 1987.

Dickerman, Leah, ed. *Building the Collective: Soviet Graphic Design, 1917–1937: Selections from the Merrill C. Berman Collection*. New York, 1996.

Dower, John W. *War without Mercy: Race and Power in the Pacific War*. New York, 1986.

Dumont, Fabienne, Marie-Hélène Jouzeau, and Joël Moris, eds. *Jules Grandjouan: Créateur de l'affiche politique illustrée en France*. Paris, 2001.

Evans, Harriet, and Stephanie Donald, eds. *Picturing Power in the People's Republic of China: Posters of the Cultural Revolution*. Lanham, Md., 1999.

Feldman, Frayda, and Jörg Schellmann. *Andy Warhol Prints: A Catalogue Raisonné, 1962–1987*. 4th ed. New York, 2003.

Fülöp-Miller, René. *Lenin and Gandhi*. Translated by F. S. Flint and D. F. Tait. New York, 1930.

———. *Lenin und Gandhi*. Zurich, 1927.

Games, Naomi, Catherine Moriarity, and June Rose. *Abraham Games, Graphic Designer: Maximum Meaning, Minimum Means*. Aldershot, UK, 2003.

Hahn, Peter, ed. *Xanti Schawinsky: Malerei, Bühne, Grafikdesign, Fotografie*. Berlin, 1986.

Hennessey, Maureen Hart. *Norman Rockwell: Pictures for the American People*. Atlanta, 1999.

Horn, Emil. *Mihály Biró*. Hannover, 1996.

Laba, Roman. *The Roots of Solidarity: A Political Sociology of Poland's Working-Class Democratization*. Princeton, N.J., 1991.

Laird, Roy D., Darwin E. Sharp, and Ruth Sturtevant. *The Rise and Fall of the MTS as an Instrument of Soviet Rule*. Lawrence, Ks., 1960.

Lamonaca, Marianne, and Sarah Schleuning. *Weapons of Mass Dissemination*. Miami Beach, Fl., 2004.

Landsberger, Stefan. *Chinese Propaganda Posters: From Revolution to Modernization*. Armonk, N.Y., 1996.

Laurie, Clayton D. *The Propaganda Warriors: America's Crusade against Nazi Germany*. Lawrence, Ks., 1996.

Kämpfer, Frank. *Der rote Keil: Das politische Plakat: Theorie und Geschichte*. Berlin, 1985.

Kubik, Jan. *The Power of Symbols against the Symbols of Power: The Rise of Solidarity and the Fall of State Socialism in Poland*. University Park, Pa., 1994.

Mace, Rodney. *British Trade Union Posters: An Illustrated History*. Stroud, UK, 1999.

Malhotra, Ruth. *Politische Plakate, 1914–1945*. Hamburg, 1988.

Marshall, Alan, Thierry Gouttenègre, Gérard Blanchard, et al. *L'affiche en révolution*. Vizille, 1998.

Memmi, Dominique. *Du récit en politique: L'affiche électorale*. Paris, 1986.

Middleton, Ruth, ed. *Lewis Rubenstein. A Hudson Valley Painter*. Woodstock, N.Y., 1993.

Milani, Abbas. *Creating an Islamic Republic: The Iranian Collections from the Hoover Library and Archives*. Stanford, 2003.

Pachnicke, Peter, and Klaus Honnef, eds. *John Heartfield*. New York, 1992.

"Politique familiale de Vichy." The Edmond Michelet Study Centre: The Second World War. Available at http://www.centrem-ichelet.org/gallerieb.htm.

Popitz, Klaus. *Plakate der Zwanziger Jahre aus der Kunstbibliothek Berlin*. Berlin, 1977.

Pospelov, P.N., A.V. Gritsenko, and N.V. Tsitsina, eds. *Vsesoiuznaia selskokhoziaistvennaia vystavka, 1939*. Moscow, 1939.

Rawls, Walton. *Wake Up, America! World War I and the American Poster*. New York, 1988.

Remington, R. Roger. *Lester Beall: Trailblazer of American Graphic Design*. New York: c. 1996.

Romano, Luca, and Paolo Scabello. *C'era una volta la DC: Breve storia del periodo degasperiano attraverso i manifesti elettorali della Democrazia Cristiana*. Rome, 1975.

Ross, Stewart Halsey. *Propaganda for War: How the United States Was Conditioned to Fight the Great War of 1914–1918*. Jefferson, N.C., 1996.

Rubenstein, Harry R., and William L. Bird, Jr. *Design for Victory: World War II Posters on the American Home Front*. New York, 1998.

Rubenstein, Lewis. "Travels with Sketch Pads and Paint Brushes: The 1930's Labor Artwork of Lewis Rubenstein." *Labor's Heritage* 7, no. 3 (winter 1996): 36–55.

Schoch, Rainer, ed. *Politische Plakate der Weimarer Republik, 1918–1933*. Darmstadt, 1980.

Staatliche Kunsthalle Berlin. *Heinrich Vogeler: Kunstwerke, Gebrauchsgegenstände, Dokumente*. Berlin, 1983.

Stavitsky, Gail. *From Vienna to Pittsburgh: The Art of Henry Koerner*. Pittsburgh, 1983.

Streib, Gordon F. "Idealism and War Bonds: Comparative Study of the Two World Wars." *Public Opinion Quarterly* 12 (summer 1948): 272–79.

Sylvestrova, Marta. "The Art of the Street." In *Art as Activist: Revolutionary Posters from Central and Eastern Europe*. New York, 1992.

Termes, Josep, ed. *Carteles de la República y de la guerra civil*. Barcelona, 1978.

Tupitsyn, Margarita, ed. *Gustav Klutsis and Valentina Kulagina: Photography and Montage after Constructivism*. Göttingen, 2004.

Welch, David. *The Third Reich: Politics and Propaganda*. 2d ed. London, 2002.

White, Stephen. *The Bolshevik Poster*. New Haven, Conn., 1988.

Winkler, Allan M. *The Politics of Propaganda: The Office of War Information, 1942–1945*. New Haven, Conn., 1978.

Wlassikoff, Michel, and Philippe Delangle. *Signes de la collaboration et de la résistance*, Paris, 2002.

Yass, Marion, ed. *This Is Your War*. London, 1983.

Illustration Credits